Professional Manga

Professional Manga

Digital Storytelling with Manga Studio EX

Steve Horton & Jeong Mo Yang

Routledge
Taylor & Francis Group

LONDON AND NEW YORK

First published 2008

This edition published 2015 by Focal Press

Published 2017 by Routledge
2 Park Square, Milton Park, Abingdon, Oxon OX14 4RN
711 Third Avenue, New York, NY 10017, USA

First issued in hardback 2017

Routledge is an imprint of the Taylor & Francis Group, an informa business

Library of Congress Cataloging-in-Publication Data
Horton, Steve.
 Professional manga : digital storytelling with Manga Studio EX / Steve Horton, Jeong Mo Yang.
 p. cm.
 Includes index.
 ISBN 978-0-240-81028-7 (pbk. : alk. paper) 1. Comic books, strips, etc.—Japan—Technique.
2. Comic books, strips, etc.—Authorship. 3. Comic books, strips, etc.—Marketing. 4. Cartooning—
Technique. 5. Digital art—Technique. 6. Manga Studio EX (Computer file) I. Yang, Jeong Mo. II. Title.
 NC1764.5.J3H67 2008
 741.5′10285—dc22

 2008014746

British Library Cataloguing-in-Publication Data

A catalogue record for this book is available from the British Library.

ISBN 13: 978-1-138-40326-0 (hbk)
ISBN 13: 978-0-240-81028-7 (pbk)

Typeset by Charon Tec Ltd., A Macmillan Company.

Steve Horton's Dedication

This one's for Steve, Sue, George, and Sue, with love.

Jeong Mo Yang's Dedication

My family.

CONTENTS

CONTENTS

ix

ACKNOWLEDGMENTS

STEVE HORTON'S ACKNOWLEDGMENTS

Hey, we made it!

This book would not be in your hands without the assistance of the following people: Matt Wagner at Fresh Books. Stellar artist Jeong Mo Yang. Laura Lewin, Chris Simpson, and Georgia Kennedy at Focal Press. Tech editor Chrissy Delk. Von's Comics in West Lafayette for initializing my anime and manga fixation back at Purdue. The many wonderful and bizarre friends at the IMWAN comics forum. And, of course, Lori, Andrew & Zoey.

JEONG MO YANG'S ACKNOWLEDGMENTS

First, I'd like to thank my Mom for keeping my belly full all the time with some of the best Korean dishes, so I could keep drawing feverishly, and my Dad for providing a roof over my head. My brother Simon for putting a pencil in my left hand when I was 3 years old, and my brother Shawn for playing Gears of War all the time and begging me to take a break from my drawing desk.

I'd like to thank Steve Horton for being so patient with me and believing in my art.

My friend Donny for his delicious orange chicken, and Marcos for being my number one fan for the last 19 years...though he has never bought any of my books! G-ho for sending me weird links over MSN, Kevin, Wonpho, and Zoon for loving basketball as much as I do, and Q for getting all the rebounds. Thank you, Kevin, for being my personal CPA, and Edu for your Argentinean asados. Thank you Professor Jose, Seung Joon aka Cooking Man, artist Steve Kim, and Yerim for believing in me. If you think you are my friend and your name is not mentioned in here, buy me some Korean BBQ and I'll remember you next time.

Last but not least, God, thank you.

Introduction

So you want to be a manga-ka, or manga creator! You're fresh out of art school and you want to make some money writing and drawing manga. You're involved in Western comics art, but are excited about the possibilities in the medium of manga. Or, you're a dynamo self-taught artist looking to take your manga skills to the next level. *Professional Manga* is a great step toward those goals.

First Half

The first half of the book is all about learning to master specific manga-building blocks and how to design those building blocks using Manga Studio™ EX. Among these concepts are line art, shading, speed lines, perspective, backgrounds, technology, and lettering. Getting a handle on each of these core concepts is crucial for making your manga creation the best it can possibly be. The first half is filled with original art and screenshots from our artist, Jeong Mo Yang.

Middle Section

The middle 20 pages in this book contain a brand new short manga story called *Other Side of the Tracks*, written by Steve Horton, drawn by Jeong Mo Yang, and lettered by Johnny Lowe. It's a sci-fi manga with mecha, explosions, tragedy, conflict, and true love. What more could you ask for?

Second Half

The second half of the book is all about taking the concepts of the first half and applying them toward sequential manga storytelling. Examples from *Other Side of the Tracks* are used throughout the second half to illustrate specific examples of storytelling techniques. Among the examples you'll learn in the second half of the book are how to compose a panel, how to flow from one panel to another, and how to effectively transition from scene to scene.

The second half also contains sections on how to plot and script manga, a discussion of manga formats and sizes, and finally, how to pitch and sell your creation to all the major Original English Language (OEL) manga publishers.

Pro Manga Examples

Throughout this entire book, you'll find special sections called *Pro Manga Examples*. In the first half, these examples will take you straight into Manga Studio EX. In the second half, the examples come from *Other Side of the Tracks*. Watch for the Pro Manga Example so you can learn to do it yourself!

The Software

This book is based on Smith Micro's Manga Studio 3.0 EX (http://graphics.smithmicro.com/go/mangastudio/ex). Manga Studio EX is available for both PC and Mac.

Many of the tips and tricks work in the entry-level Manga Studio Debut, but there's a lot you won't be able to do. You're in luck, though. In the back of this book is a coupon for $100 off Manga Studio EX 3.0, redeemable only at Smith Micro's website.

Manga Studio 4.0 is planned for late 2008, and Appendix 1 in the back of this book goes over some of the new features planned for the new version. Everything in this book will also work in Manga Studio 4.0.

The CD

In the enclosed CD, which can be found at www.routledge.com/9780240810287, you'll find high-res images for every piece of art in this book. We've also included the 20-page *Other Side of the Tracks* story in high-res, so you can really check out the detail. The CD also has a 30-day demo version of Manga Studio EX, so you can try it out before redeeming that sweet coupon.

Get To It!

What are you waiting for? Turn the page and get started. Your future in professional manga creation awaits.

Line Art

Many manga artists using Manga Studio will do a rough sketch on paper, scan in the sketch, and finish the drawing from there. Still others do the entire work, beginning to end, in Manga Studio. And then there are those who prefer to do the penciling, pen or brush inking on paper, and use Manga Studio solely for tones, letters, and other graphical effects.

Those in the first two camps will find this chapter useful. Here, we're going to focus on the manga line; in other words, the inking step. You've already sketched out the drawing, whether on paper or in Manga Studio with a mouse or tablet. Now, you're ready to ink it. Since most manga is devoid of color, the inking step (along with tones) is where manga art gains its depth of field, its emotion, and its full power.

One of the most important concepts to master when inking in Manga Studio is line weight. Simply put, objects in the foreground must have a thicker and more defined line than objects in the background. Objects in the background have less of a line weight. This creates a three-dimensional effect by pulling the foreground objects closer to the viewer.

In order to achieve this weight, you'd use a variable line with a brush or nibs, thicker pens, or different ink techniques. In Manga Studio, it all comes down to the choice of pens or brushes. There are several pre-set pens that mimic traditional nib-and-ink pens or calligraphy brushes that manga artists use. These pens can be modified in the **Pen Options** window once you become more familiar with how they respond.

SMOOTH LINES

Manga creators often latch on to a particular method of drawing and stick with it throughout their career. Sometimes that means drawing on paper and scanning; some pick up a mouse and never put it down; others purchase their first graphics tablet and fall in love. It's up to you whether you want to stick to the tools that got you to where you are today, or if you want to experiment, as each approach has advantages and disadvantages.

Among digital manga creators, there are stellar examples that have gone with any of the above three approaches and made it work well for them. You should use whatever tool you're most comfortable with, whether it's pen and paper, a mouse, or a graphics tablet. Whatever gets you the smoothest line.

Manga Studio comes with many pen options, including an auto-smoothing feature for those who wish for assistance in crafting that ultra smooth inking line.

This feature may need to be turned off or adjusted on occasion to create a more "natural" feel to the artwork. To toggle it off and on, go to **Pen → Tool Options** and click **Correction**. You can also adjust this correction value from 0 to 20. This value controls how severely you want the program to correct your line.

Here's an example of a line drawn without and with Manga Studio's pen correction option, followed by a screenshot of the pen tool options where you turn on and off line smoothing. In the first image, the one without the line smoothing, notice the lines are wobblier and vary in their line weight or thickness. Using the **Correction** option drastically reduces these in the second image.

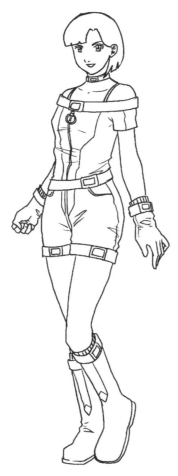 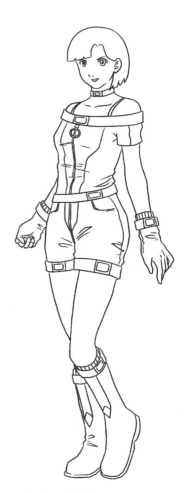

A drawing of a pretty girl, with line smoothing turned off.

The same drawing, with line smoothing on. Notice the subtle differences in line quality.

THICK LINES

As mentioned previously, thick lines are used for foreground objects to distinguish them from the background. It's even possible to have more than two planes in the art—extreme foreground objects can have a thicker line than middle foreground objects, and the background objects can have an even thinner line. One example of this is a panel where a man is pushing aside some underbrush in a rainforest to reveal a lake. The camera is way in, and the arms and foliage are in the extreme foreground. Forest elements in between

Go to **Pen** → **Tool Options** and click **Correction** to turn on and off line smoothing.

5

the hands and the opening have a medium line, and the lake a few yards away has the thinnest line.

Pens that work well for thick lines in Manga Studio EX are the Kabura pen and the Brush pen. The Kabura pen will give you a very uniform look, while the brush pen is good for times where you need a natural brush look for the thick lines.

THIN LINES

Often the thinnest lines are reserved for facial detail, especially when drawing women. Lines that are too thick achieve a masculine effect, or facial features blend into the hair and background. Also, thin lines are used for distant objects, such as sky elements and the horizon. Try the Maru pen or the School pen in Manga Studio EX for a good thin line. The School pen is similar to the Kabura pen, but thinner; the Maru pen is designed for fine detail work.

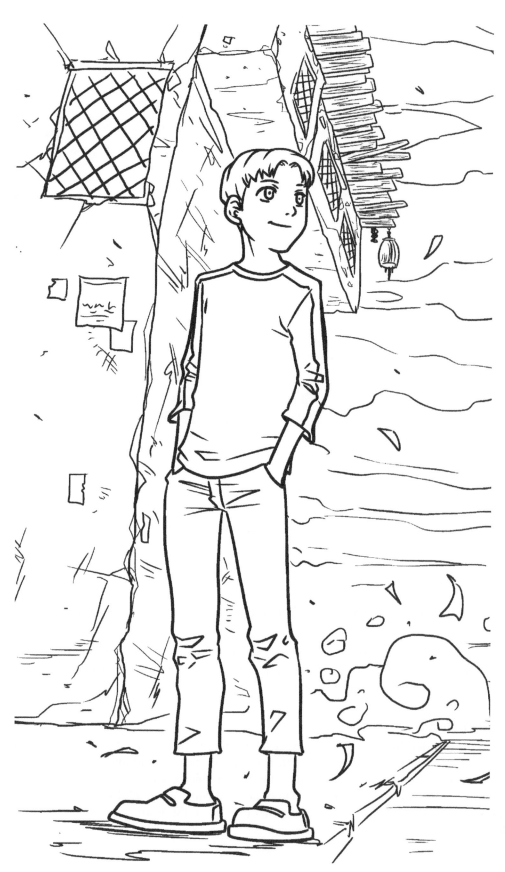

Here's a drawing with a thick foreground drawing that separates it out from the thin background drawing, inked using the Kabura or Brush pen.

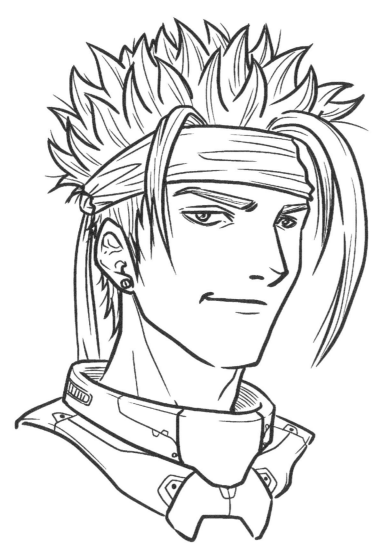

Here's a human face with the facial features detailed using the School or Maru pen.

COMBINATION BRUSHES

Though the previous two pen examples specialize in thick and thin lines, the G pen is good for all-purpose work. This pen will create a thick or a thin line depending on pressure on a graphics tablet. When using a mouse, a few simple adjustments to the **Tool Options** settings will create the necessary effect.

The Gray Use Pen

The final preset pen is called the Gray Use pen. It's a thick pen used for assistance in shading. Our shading techniques in the later chapters don't use the Gray Use pen; however, you may find some use out of it by experimenting.

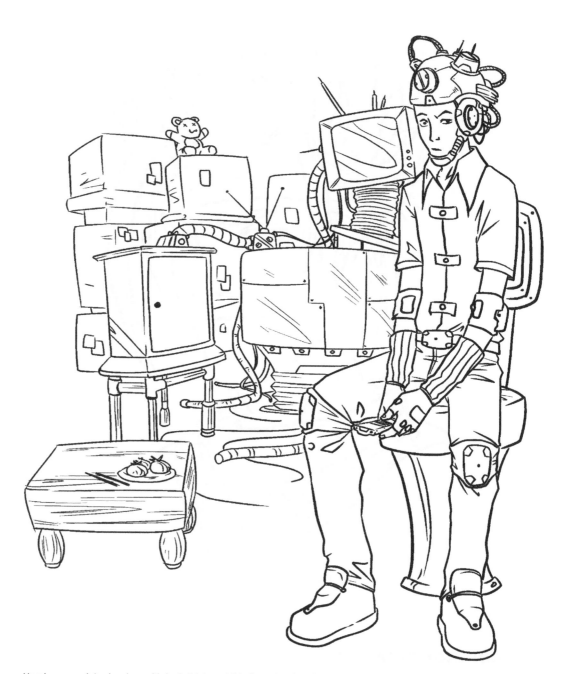

Here's a complete drawing, with both thick and thin lines, rendered entirely with the G Pen.

Shading and Textures

Traditional manga is printed in strict black and white on paper that's not the highest quality in the world. Not only are you working without color, you're often working without shades of grey. That means everything needs to be toned or shaded in black and white in order to provide contrast and definition to the panel. Toning and shading are interchangeable terms; we use both words throughout the chapter to mean the same thing.

DIGITAL TONING REVOLUTION

While in the past you may have had to cut out tones from a toning sheet and paste it on the drawing, those days are long gone. Computer-based shading is now the manga standard, and Manga Studio provides the least hassle when toning. The basic Manga Studio Debut includes over 1,800 tones, and Manga Studio EX ups the ante by providing over 3,000 tones!

TONES MAKE THE DIFFERENCE

Here are three example drawings we'll be using throughout the chapter. First, we'll show you the inked, but untoned drawing. It is a warrior with a detailed suit of leather armor.

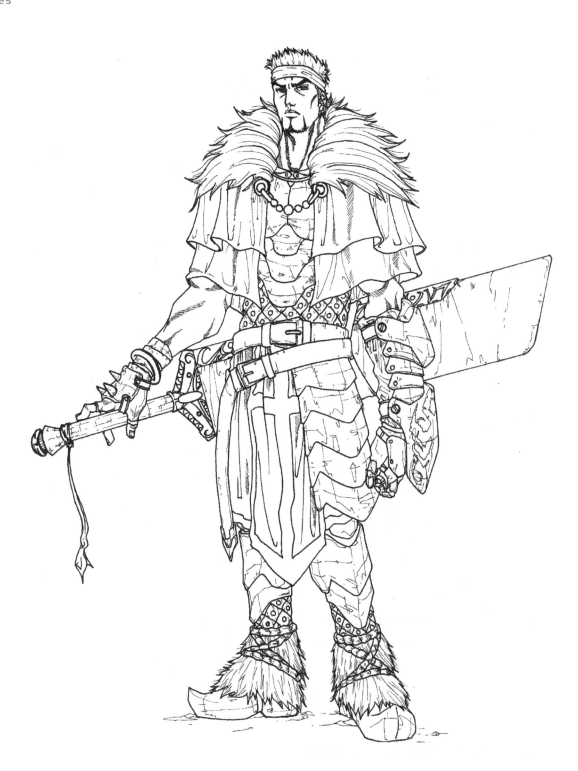

The second drawing is of a man in the background pushing a man in the foreground into the water. In the extreme foreground is a laughing woman.

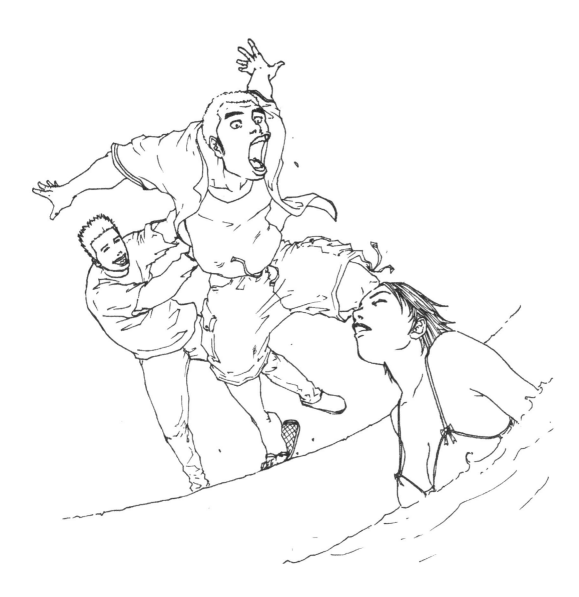

The third drawing is a street fighter in the middle of a fight with multiple opponents.

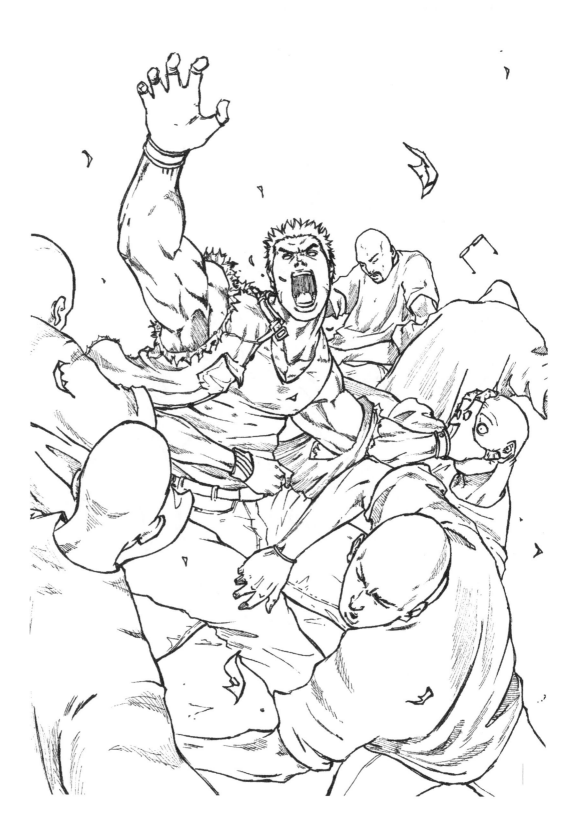

12

As you can see, without tones the details and elements in each drawing run together. It's difficult to tell specific parts of the drawing apart from one another. Tones help bring out each individual element and make it shine.

Here are some example drawings after specific tones have been applied to them.

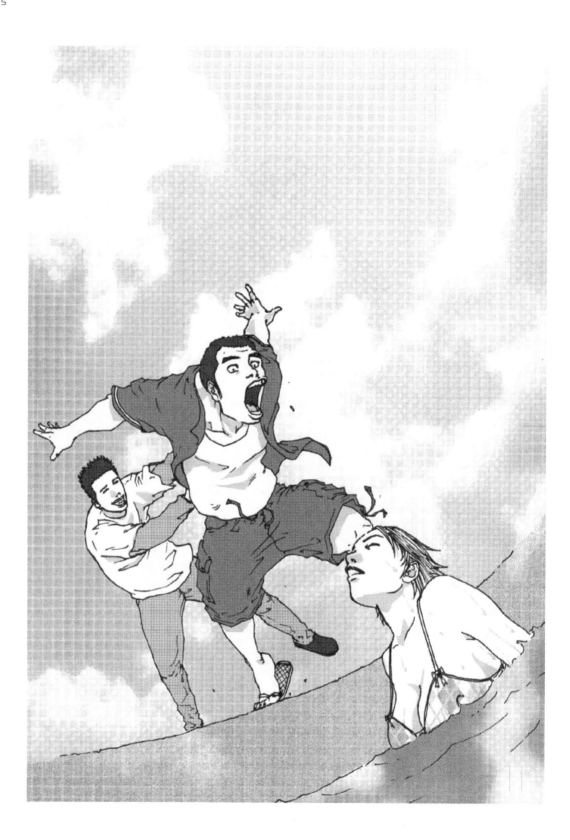

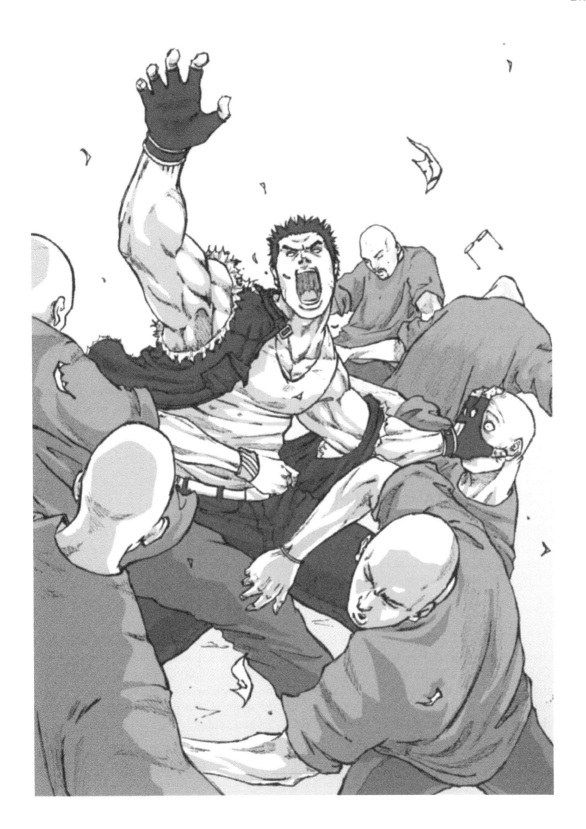

CHOOSING THE RIGHT TEXTURE

It's not enough to apply a random tone to a drawing. It's important to choose the right texture for the job.

There are two things to consider when toning: the lightness or darkness of a tone, and the toning pattern. The next chapter will go into more detail about how the light source can affect a tone, but it's clear that a light and fun scene should not have dark tones all over it. Similarly, a noir manga should tend toward the dark end of the scale as far as tones go.

The lightness and darkness, or values of tones are distinguished by the percentage of black in the tone. Thus 5% is very, very light, while anything over 75% is very, very dark.

The darker the tone, the harder it is to distinguish the difference. After 60% or so, it's important to be picky and not put numerous extremely dark tones in.

Many tones are not simply grey tones, but have patterns in them appropriate for different textures. These textures mimic different surfaces, such as wood, metal and concrete. Often, tones are placed over a piece of clothing to indicate a pattern in the garment. Again, choosing the right pattern in the tone is key. When toning clothing, don't give the grim hero a polka-dotted shirt. Similarly, a plaid tone is correct for a school uniform.

Usually, tones are made up of a series of black and white dots. These dots, in print, appear to the eye to be grey in value. By using only black and white ink, not even grey, printing costs are cheaper. Manga Studio specializes in creating solid black and white art, but also has options for grey output as well.

16

THE IMPORTANCE OF LPI

Dot tones in Manga Studio are first organized by how many lines are in the tone. Lines Per Inch (LPI) is a measurement unit for a halftone. The number of lines of dots in a diagonal square inch is the LPI or L of the tone. What this means in real terms: the lower the L, the fewer dots it has, and the bigger the dots are. Inversely, the more L, the smaller the dots, and the tone appears closer to a solid grey. A widely used solid grey is 65L and is a good default.

To understand how real-world objects translate into appropriate tones, it might be wise to draw from real life and see what fits. When deciding on a tone pattern, look through recent fashion catalogs. The more your tones match what a person would see in reality, the more they'll blend into the overall scene and the less jarring they'll be. After all, you want the reader to focus on the story and the art itself, not the shading. The paradox is that the better the shading is, the less it will be noticed, and that's a good thing.

Here are the previous three drawings without tones, and then with a series of tones applied to them. The first drawing in each set is the untoned drawing, followed by the "good" tone, and then two "bad" tones.

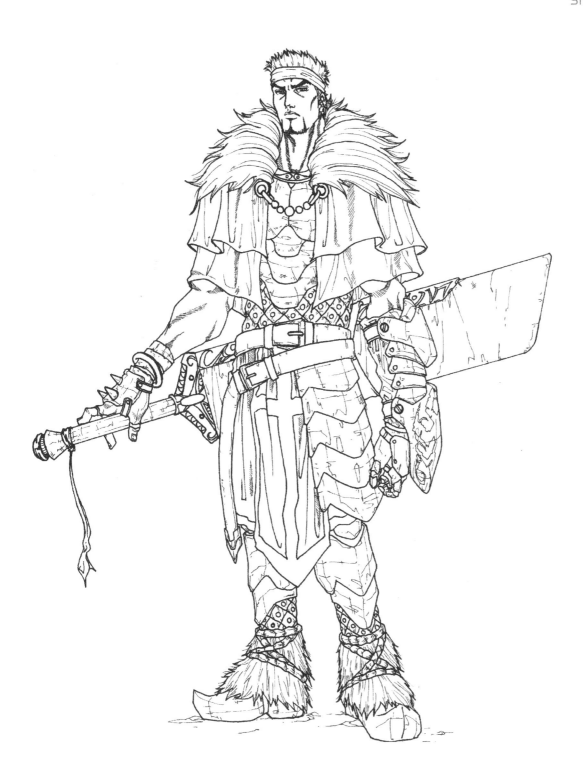

18

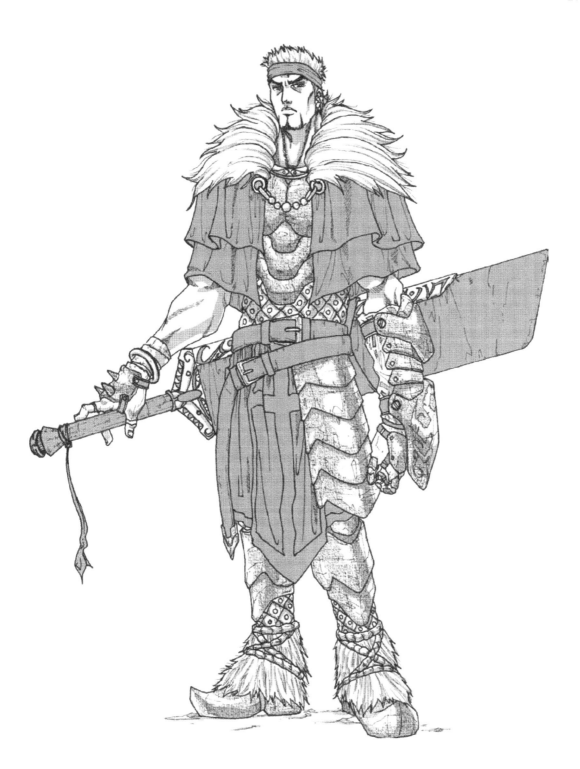

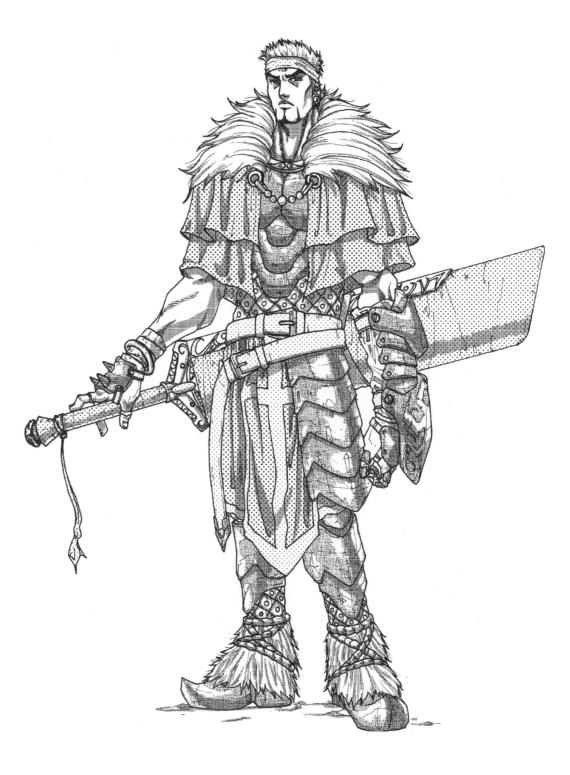

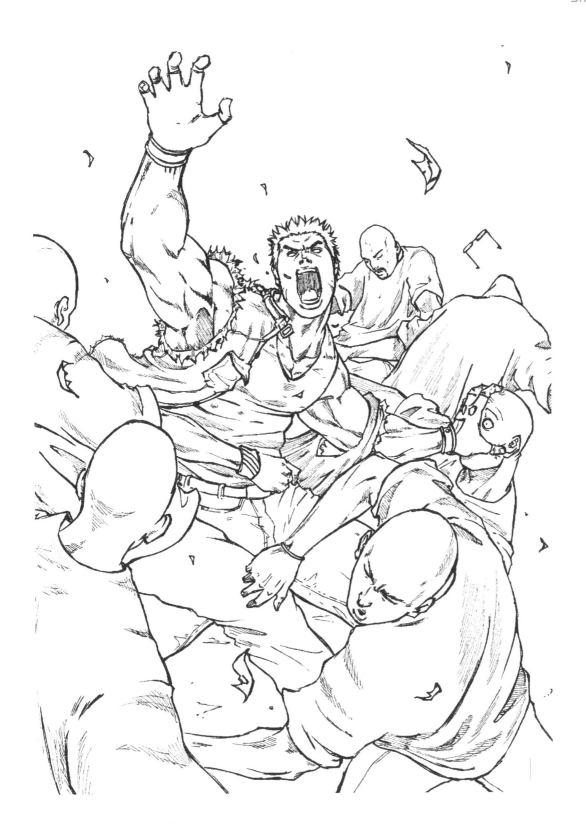

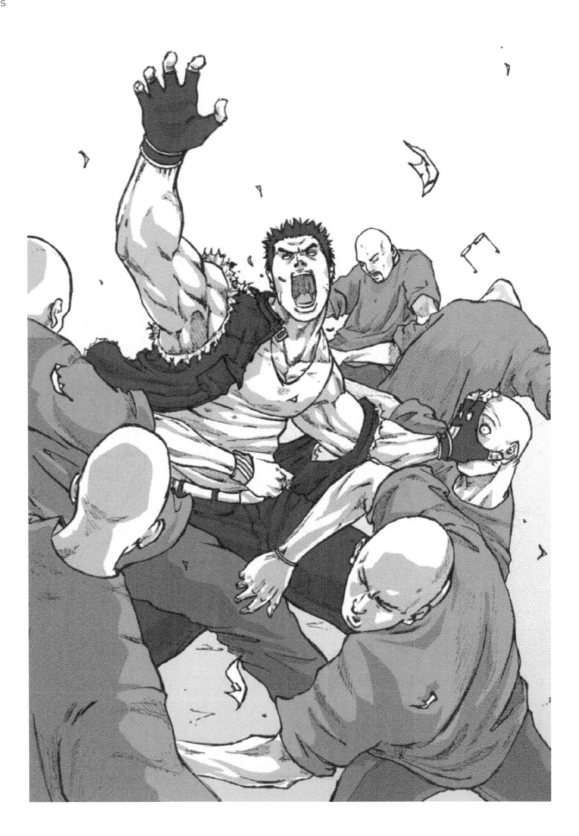

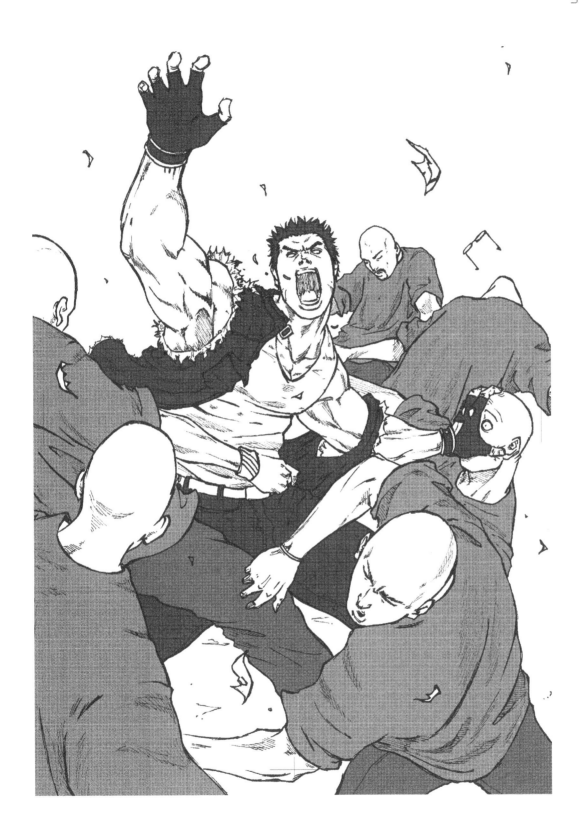

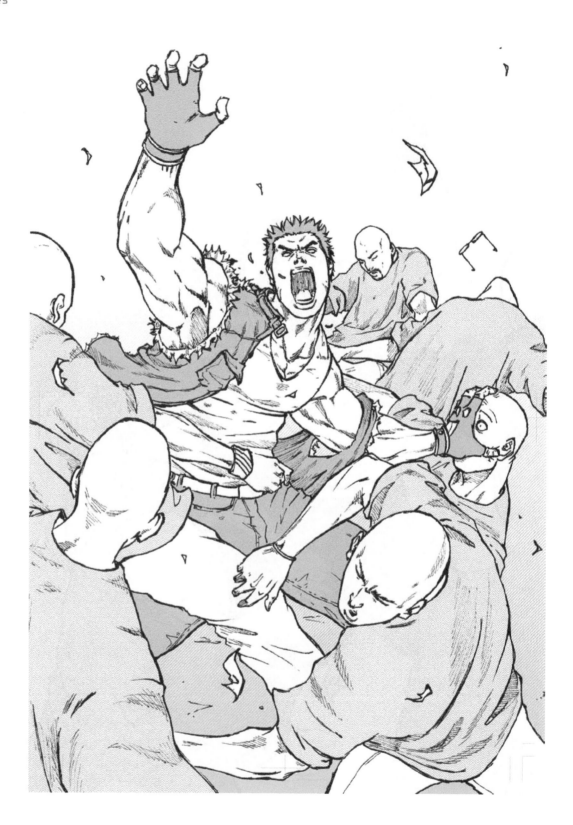

Pro Manga Example

Now we're going to tell you the best technique for applying these tones in Manga Studio.

Step 01

Once you have your drawing open, you are going to use the "magic wand" tool to select the areas we want to tone. Under the **Magic Wand Tool Option**, check **Expand/Reduce Area** and then set the number to 0.2 mm, and also check **All Layers**. If you can't find the tool option, have the "magic wand" tool selected, then go to **Window → Tool Options**.

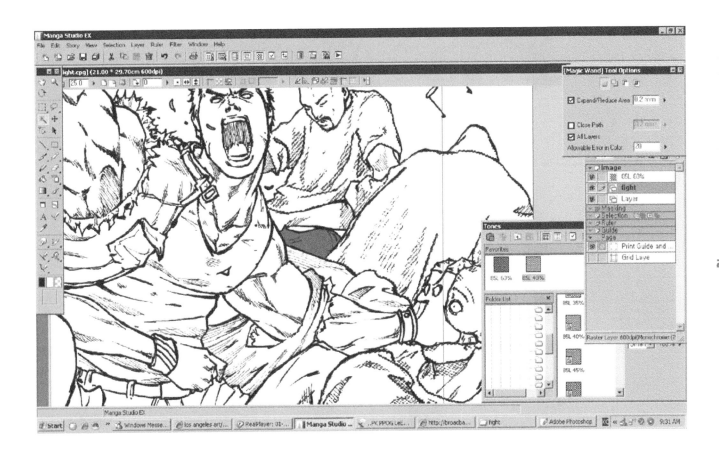

Step 02

Once you have the areas you want to tone selected, drag and drop the tone you want into the selection on the page.

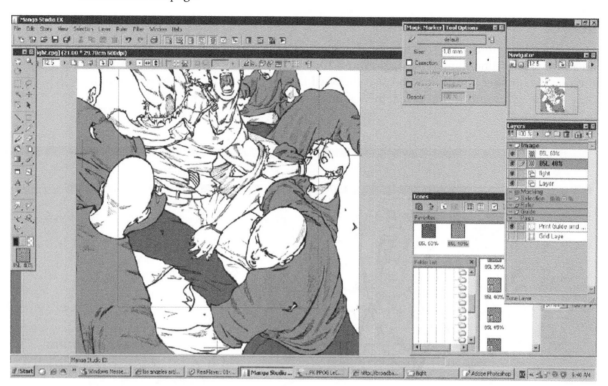

Step 03

Repeat Steps 01 and 02 to different areas you want to tone, using different tones.

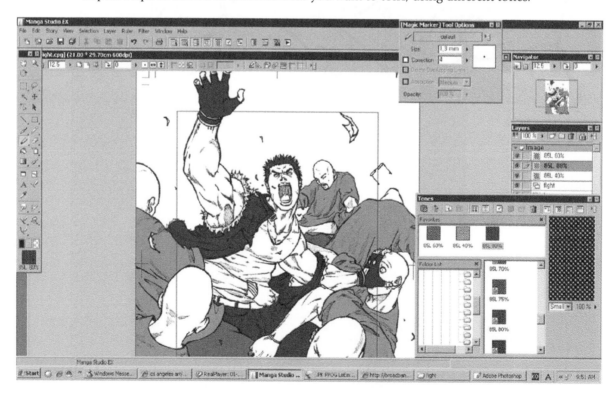

Step 04

To add shadow, use the "lasso tool." Draw a selection using this tool, then drop the tone into the new selection. Repeat this step until you've shaded all the characters.

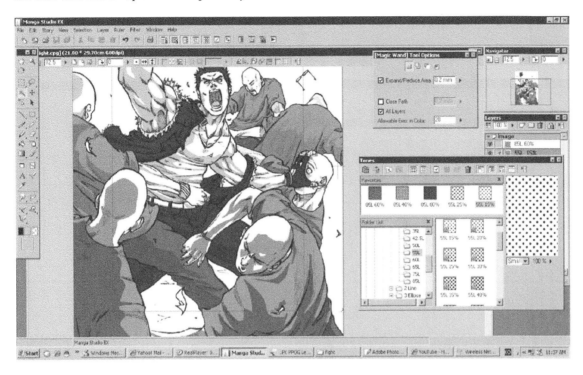

Step 05

To tone the background, double-click on a gradient tone. I chose **Basic → 2 Gradation → 1 Dot → 42.5L**. A window called **Tone properties** will pop up. Click the **Paste on Page** button on the bottom left. This will cover the entire page with the tone.

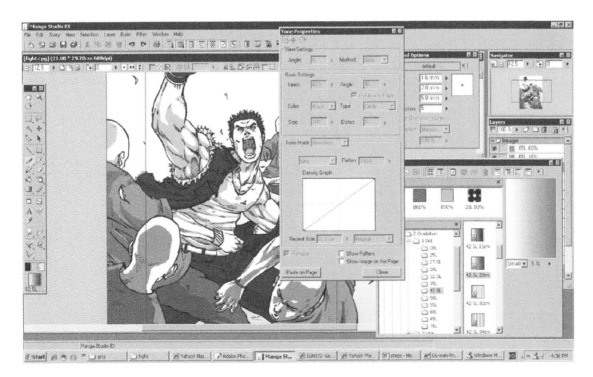

Step 06

Open the **Layer Properties** window if it's not already open. Open the tones tab at the top of the window. This will allow you to make changes to the tone type. Change the angle to "90" in the **View Settings** and increase **Repeat Size** so the gradient takes up the entire page. Once you are done, click **OK**.

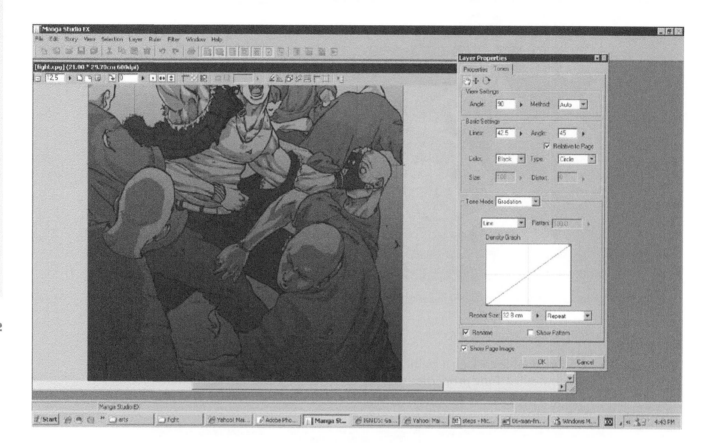

Step 07

We only want the background tone to be the background and not cover the entire page, so we need to hide the background gradient layer by clicking the eye by the layer. This will make it easy to select only the background. Then use the "magic wand" tool to select the background—make sure the **All Layers** option is selected. Then go to, **Selection → Invert Selection**. This will select only the figure in the foreground in this case. Turn the layer visible again by clicking the eye icon by the layer and press the **Delete** key.

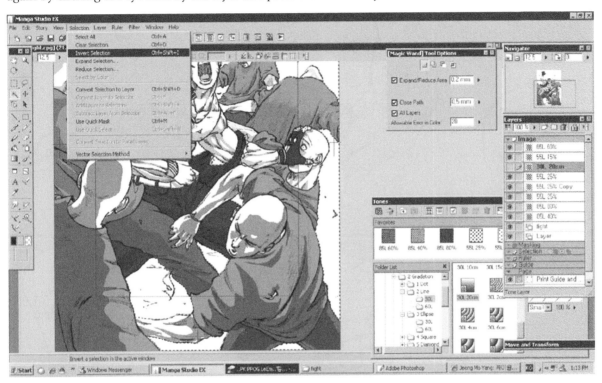

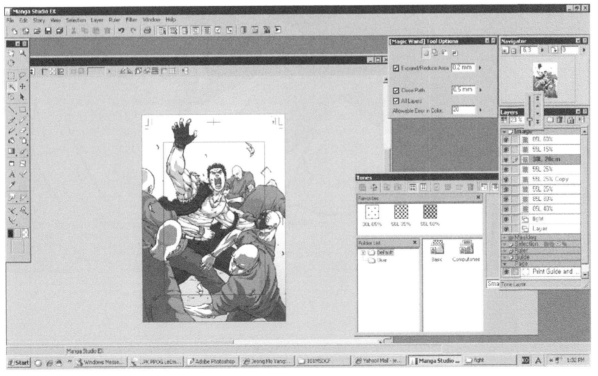

Finished!

34

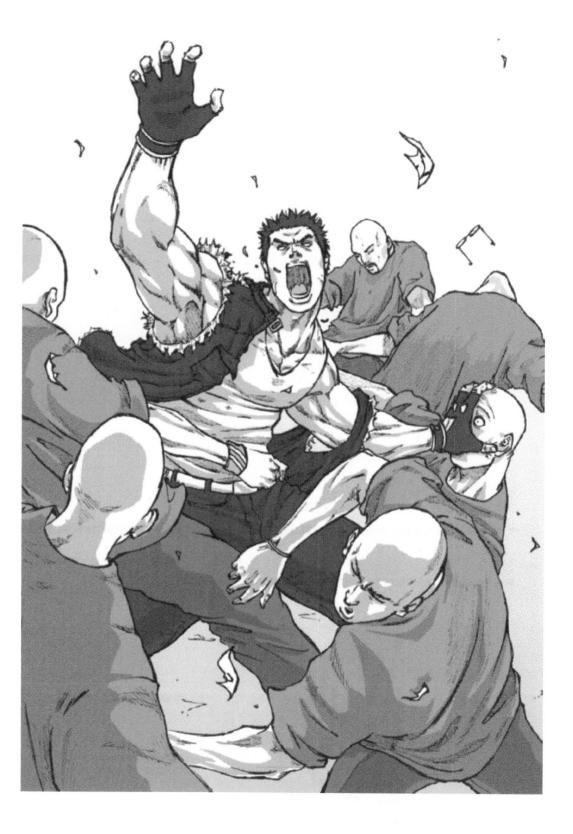

VALUE AND THE LIGHT SOURCE

The choice of value often comes down to the lighting and mood in the particular panel. Before shading, inkers often pick one or more light sources on the page and ink their drawing with those sources in mind. Places where the light strikes are not shaded, and, on the other side of the objects, shadows occur.

In manga, texture and even solid tones are often used as a graphical element. Using solid blocks allows for easy identification. If a jacket is dark grey, making the entire jacket a solid grey is called using the *local value*. Local value has nothing to do with light, but is the natural color or value of an object.

Often, a character will have only one or two elements of its design with a solid, local value or texture and that will be consistent throughout the manga. This gives the characters and the objects a strong, easily recognizable shape. There are artists across the spectrum, such as Satoshi Shiki, who use tone to create form with shading; but, the majority of artists from shounen to shoujo manga frequently use tones in a graphic manner. There are often panels for drama, mood, and establishing shots with additional shading to show form.

In toning, form can be created by using multiple tones. On a dark piece of clothing, the local value would first be applied. Then, a shadow tone can be applied over the local value in the areas away from the light. This will create the illusion of form and still have a recognizable silhouette and good design. Always make sure the L of the tones is the same when overlapping.

MOOD

The tone or mood of a particular story also dictates the type of tones used. A light-hearted shoujo story will have fewer shadows in a panel, and therefore will be toned much lighter than a hard sci-fi story. Cute backgrounds such as flowers or animals may be used to further the mood. In contrast, a grim and gritty tale taking place outside on a dark rainy night will have dark tones all over the place. Shadows will be black, or nearly so, and often tones can even be foregone in favor of spot blacks, or large areas of black in a panel.

If a character in a panel is feeling depressed, the tones can darken to reflect his or her mood. Similarly, a character finding his or her way out of a bad situation can symbolically "lighten up" with lighter tones on the page.

The reader's eye tends to concentrate on where the most contrast is, or the focal point. Manga uses a lot of negative space, large white areas, so the darkest areas are often where the focal point is. Keep this principle in mind when toning both the page as a whole and individual panels. If you're going for a dramatic pause in a panel, it often helps to make that panel stand out from the other panels on the page by use of tones.

Here are two examples of drawings that have lightened and darkened tones depending on the presence or absence of light. The first image is the untoned drawing; the second is the drawing with a strong light source; and the third is the drawing with a weak light source and strong shadow.

35

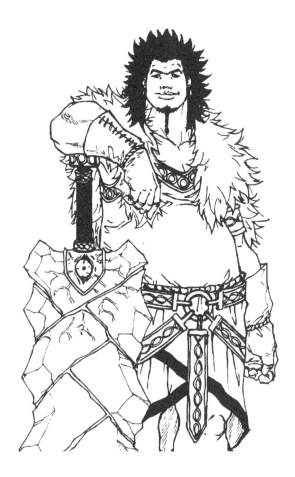

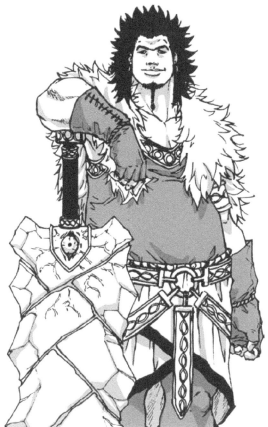

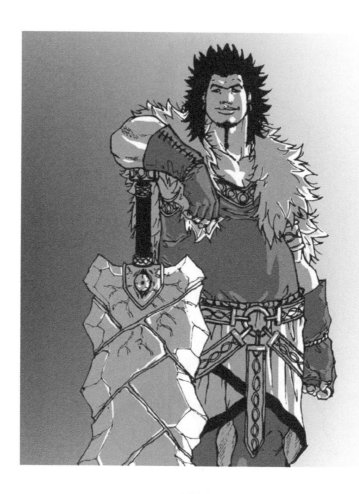

AVOIDING MOIRÉ PATTERNS

One common mistake with tones is that they create these unsightly patterns in them in the actual comic. These are called *moiré patterns*. What are they, and where did they come from?

Simple: moiré patterns are like optical illusions and are created when the dots of tones are resized or overlapped improperly. It's important to tone on an original, uncompressed file and know what the print size and resolution will be, whether it's the native Manga Studio file format, a native Photoshop PSD file, or a TIFF file. The resolution needs to be around 600 DPI (Dots Per Inch) to 1200 DPI depending on the printer. Toning on a high-res file means that when the page appears in the print manga, the toning appears exactly how you intended and not with weird patterns in it.

Preventing moiré is easy in Manga Studio, but there are times where you need to be cautious. When layering tones that are in black and white, the tones must be the same L, or they will cause moiré patterns. Watch the angle of the overlapping tones as well; certain combinations of different angles could cause moiré as well.

Never save a drawing as a JPG and then attempt to tone on it. The only time to save separately in the JPG format at all is when the page is completely done, and the only reason to save in this format is to do a webcomic or for other Internet use such as on MySpace or an online portfolio. When resizing a black and white toned image for the web, moiré can occur as you try to shrink it to a size less than printing size. This can be resolved by reducing it to 75% repeatedly until you get to an appropriate web size.

Also, never save a drawing in a resolution below 600 DPI and attempt to tone on it, as again this will create the moiré patterns in the actual work. Tone as high-res as you can or as high-res as the DPI output of the printer. Toning a high-res document requires at least 1.5 gigabytes of cache space by Manga Studio, so make sure there is at least 2 gigabytes free on your hard drive to cover this cache and whatever else Windows or OSX needs.

Another way to get around moiré is to export the tone as grayscale. This means the grays will actually be grey instead of being comprised of dots. In this case, it is important to make sure the book printer will print in grayscale.

Here's an example of how toning at low resolution will look on the printed page, and the same drawing toned at the correct, high resolution.

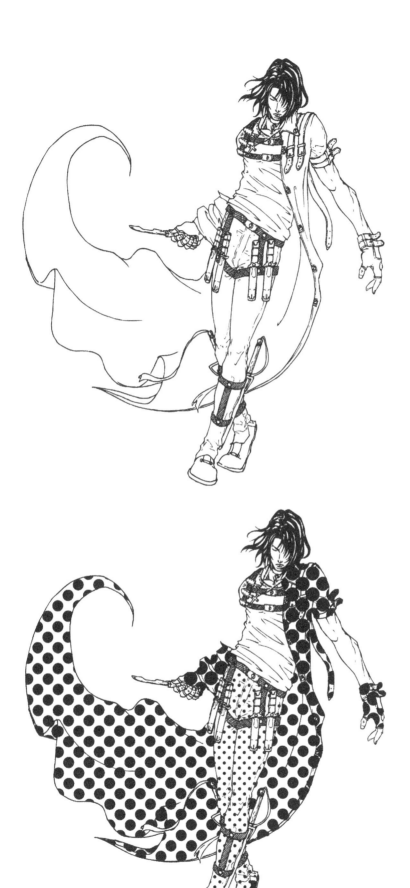

44

WHEN NOT TO USE TONES

It's not always appropriate to tone a panel. There are several specific cases where toning is not advised and would actually detract from the drawing.

- An intentionally flat drawing done for comedic effect. When characters become "Chibi," or intentionally small, cute versions of themselves, often the entire panel, or at least the Chibi characters themselves, are not toned at all to draw attention to the cartoony nature of the transformed character.
- An extreme close-up of a face, eyes, hand or other object. In this case, a tone is applied to the background, while the object is left intentionally open.
- A "thought balloon" panel. The entire panel is taken up by a character's thoughts in text form; there may be a shadow effect around the balloon, but technically the panel has no tones in it.
- Panels where the dark elements are spotted blacks rather than tones. Instead of a grey effect, the shadows or dark objects are rendered entirely in black for a stark contrast.

Note that even if most of the elements in a panel are untoned, there may still be a bit of tone added to the background. It's quite common for a figure to be left untoned; it's less common for a whole panel to be that way. Without some dark element on the page, a reader's eye glosses over it too much.

Here are two examples of panels where toning is not appropriate and would detract from the panel if it were present.

This is a heavily shaded pencil drawing of a pirate. The pencil shading provides all the tones that the drawing needs.

45

This is the same pencil drawing with a layer of tones over it. As you can see, the tones severely detract from the art.

This is a rough-inked sketch of a caped character. Toning is premature at this stage.

If tones are applied to an unfinished drawing, the result never looks correct.

A FINAL NOTE ON TONES

Toning is the manga artist's bread and butter. Without color or complicated computer shading effects, a manga artist must master toning to add mood, depth, realism and humanity to his or her work. Though it's not as much fun to tone a drawing as it is to render a facial expression, flower or mecha, it's important to master this step. Also, if you actually happen to enjoy toning in and of itself (our condolences!), it's possible to find work in the manga industry as a toning specialist.

Speed Lines

In a lot of manga, characters can express movement, show great excitement, or receive an epiphany within the space of a single panel. Since a comic panel is a single snapshot in time, how best to express that movement or excitement? One solution that manga partakes in frequently is speed lines.

These lines of varying weight are drawn directly on the background behind any character elements, often taking the place of the background. Speed lines can be straight or circular, parallel or concentric, thick or thin. It all depends on the kind of motion that needs to be expressed in a panel.

Note that these lines may also be called *motion* or *action lines*, especially when speed is not involved. For simplicity's sake, we're going to call them speed lines in every instance.

ACTION, EXCITEMENT, AND EPIPHANY

Speed lines are used in three distinct cases in manga, though not every scene using one of these cases will have speed lines.

Action

The most common use of speed lines is in the case of action. Speed lines are used during the wind-up to an important attack connecting; during a fast race toward some specific goal, whether on foot, in a vehicle, or flying; to show a specific limb or weapon moving quickly through the air; and many more examples.

Since a panel captures a specific moment in time and can't show a full range of movement, the speed lines are a special effect that simulates that movement. Often, speed lines can follow the motion of the character or direct the reader's eye toward the next panel, but this is not always the case. Sometimes they're done a certain way just because it looks cool!

The action variant can also be used when a character is falling or crashing to the earth. Nothing's better to show a hapless mecha's approach toward terminal velocity. Or maybe just a short fall off a tall cliff, as in this panel in *Other Side of the Tracks*.

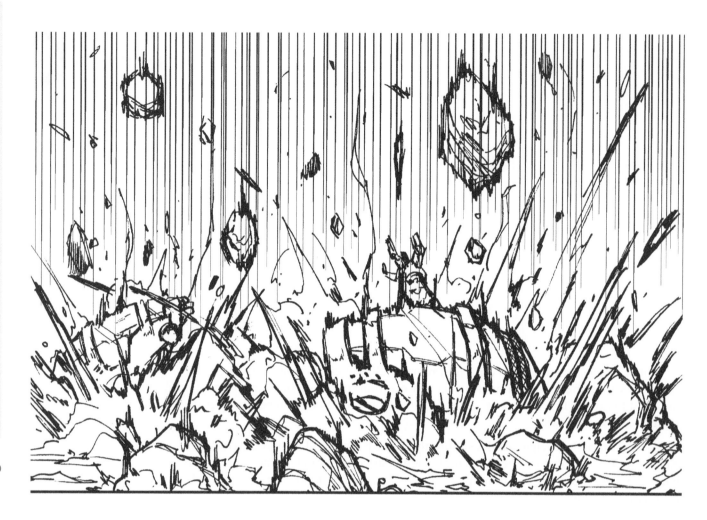

Scott McCloud points out two types of speed lines in his book *Understanding Comics*. The type used in most manga, he calls *subjective action*. It's the speed replacing the background. In this case, the moving character, prop, or vehicle is the object in focus. With this focus on the subject, the background blurs while the swing of the punch or the vehicle moving forward is an entirely sharp precise moment in time. The focus is entirely on the object in motion and is represented by the speed lines of the background.

The other type of action speed lines is more similar to Western motion lines and much less common in manga. These speed lines act opposite, blurring the object in motion against a static unmoving background. These blurring speed lines surround (and are often on top as well as behind) the object or person in motion. Often they are only over part of the object in motion with only a few short speed lines to show the direction of motion—a stark comparison to the heavier background speed lines. In action, they are sometimes paired with background speed lines.

This blurring technique is also visible on the mecha and rocks in the panel we just showed, and is covered in more detail in Chapter 5, "Blurring."

Excitement

Speed lines can be used to show excitement. In a shoujo, or girls' manga, speed lines can show embarrassment, anger or other extreme emotion, almost as if the feeling is enough to induce fast motion inside the character's head that radiates outward.

Speed lines can also show a character gaining power from something or someone, or from himself or herself. Action manga, especially, often includes scenes of characters powering up using their chi, or inner energy. This power-up moment is often accompanied by vertical, parallel speed lines, or sometimes circular speed lines.

These speed lines can often go over the character because they are intended to bring the eye to the focal point of the panel—often the character's head or eyes, since that's where most expression is shown. It is important, though, that they don't cover up the focal point—they should create a halo and emphasize it.

This panel from *Other Side of the Tracks* is a good example of excitement. The main character, Keil, is about to release a deadly barrage of missiles from his mech. He's on the verge of explosive action, and the speed lines are meant to indicate that moment of pure excited energy.

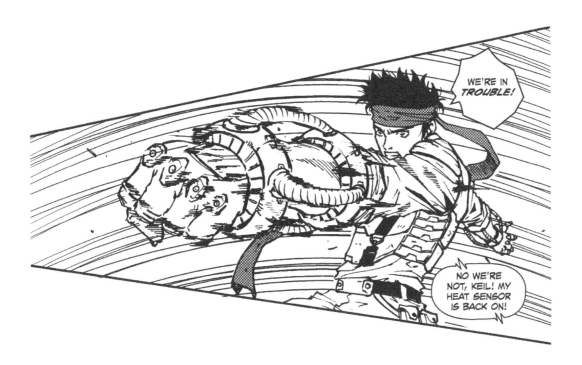

Epiphany

Finally, speed lines are used as epiphany: when a character discovers his Big Idea; when he finally gets to kiss the girl; or when he finally solves the clue and determines the culprits behind the mystery. Any sudden realization can lead to speed lines, usually with a center point on that character and radiating outward. Like the excitement lines, these can, and often, go over the foreground in order to highlight the important subject of the epiphany.

Often the climactic moment of the entire story arc is rendered with a big full-page panel or splash page that includes speed lines in lieu of a background.

Epiphany can also include the negative. A character coming to a sudden, horrible realization is a terrific time to radiate speed lines outward from that person's head, as in this panel from *Other Side of the Tracks*. Artist Jeong Mo Yang elected to use a single, thick speed line to indicate this.

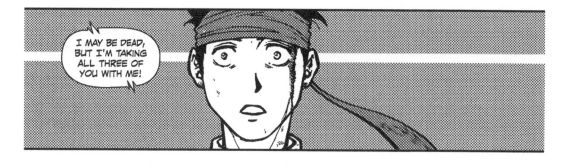

Pro Manga Example

Do you feel the need, the need for speed? Manga Studio has anticipated this and has included a built-in speed line tool. Here's a step-by-step guideline for using this tool to create the best-looking speed lines in your panel. Advanced users will want to tweak the settings or even create the lines manually, if the tool isn't getting the effect you really want.

Step 01

Create a new page by going to **File → New Page**. Here, you can set up the template measurement setting that matches your need. I use Tokyopop's manga template measurement.

Step 02

After you have a new page open, go to **File → Import → Image File**. Your file should open on a different layer. Adjust your image size to match your template, if required.

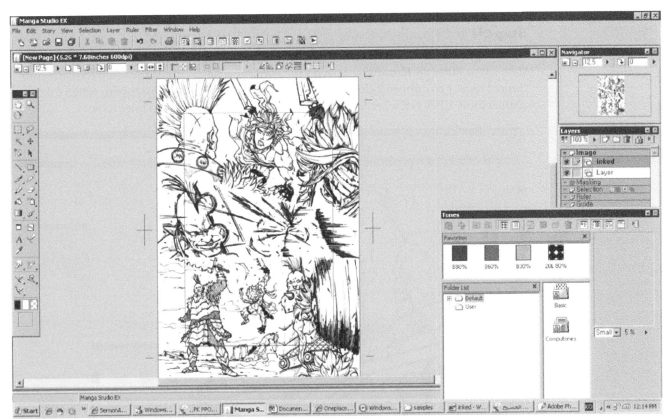

Step 03

Now, it's time to separate the panels. Create a new **Panel Ruler Layer** by **Layer → New Layer** and in the window change the **Layer Type** to **Panel Ruler Layer**. Use the **Panel Ruler Cutter tool** to separate the panels by dragging a line across a giant panel to divide it into halves. Keep cutting until your panels are separated.

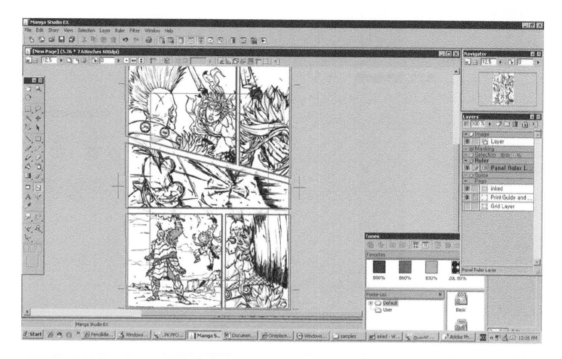

54

Step 04

To add speed lines, select the panel you want to add speed lines to, using the Magic Wand tool. Go to **Filter → Render → Speed Lines** on a new layer. Adjust the setup to reach your desired look. I recommend clicking Random Length, Width, and Distance to achieve a more natural look. Click **OK** when you're satisfied with the way the speed lines look.

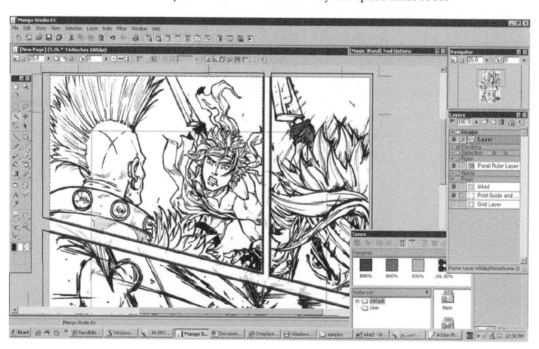

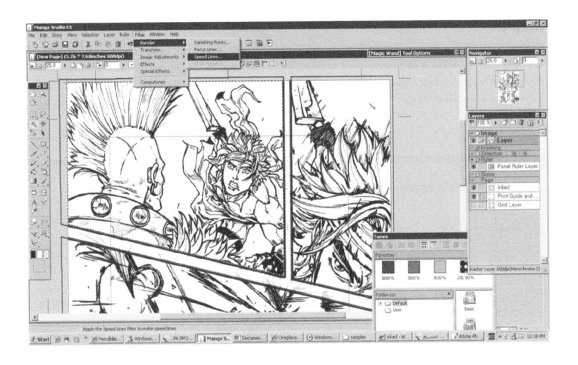

Step 05

Erase the speed lines that cover the objects in the panel. I recommend setting the opacity of the speed lines layer to about 40% so you won't get confused between the speed lines and your own line art.

55

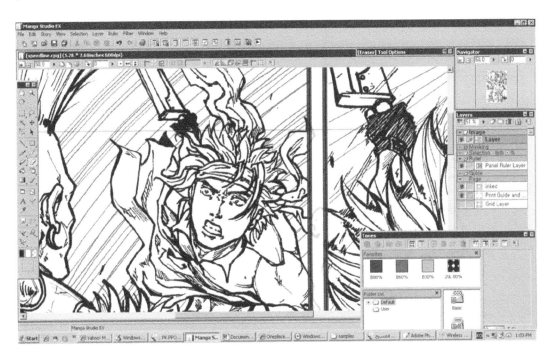

Step 06

Repeat Step 05 for all other panels that need speed lines, but make sure that you do each set of speed lines on a different layer, so you'll have an easier time erasing and editing them later on. Once you have the speed lines looking the way you want, right-click the **Panel Ruler Layer** and select **Rasterize Panel Ruler**. Check **Convert All Rulers into One Panel Layer** and click **OK**.

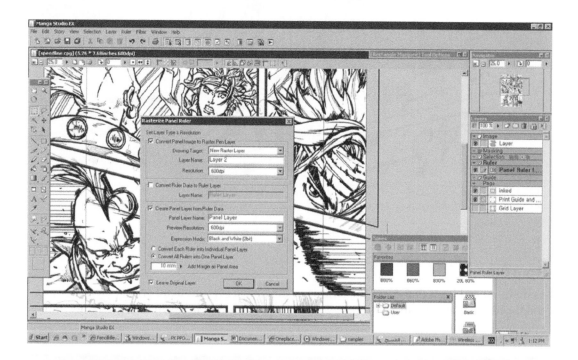

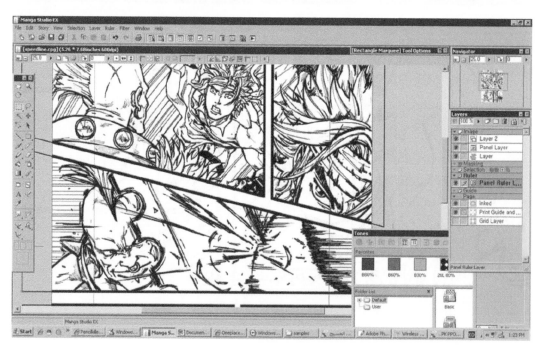

Finished!

Here's the final page. Note how the speed lines are circular in panel 1, as the lines follow the protagonist's movement. The speed lines in panel 2 radiate out from a vanishing point, to show that the character is traveling forward. In panel 3, the speed lines are horizontal to indicate that the attack is blocked by the antagonist's weapon. Panel 4 has no speed lines,

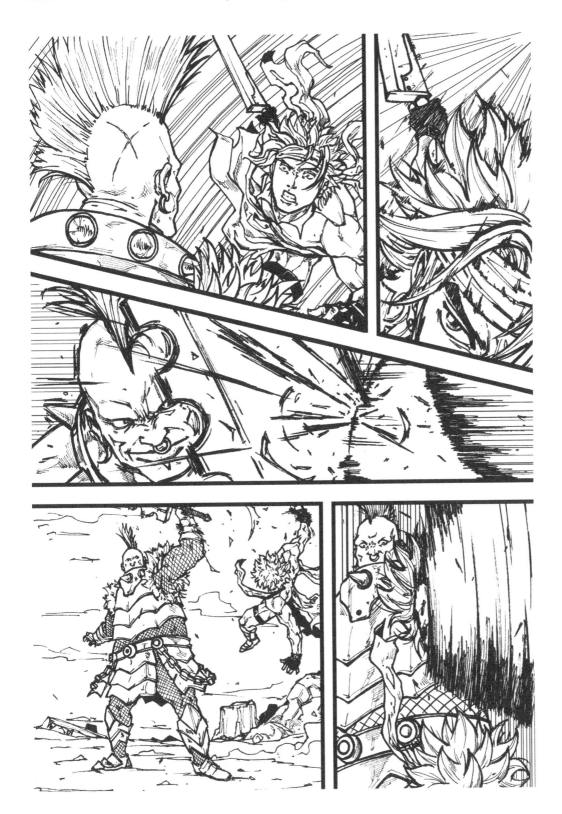

57

which is good—the page would be far too busy, and the reader's eyes must catch their breath, so to speak. In Panel 5, the speed lines return, but vertical—to show that the antagonist is bringing his weapon down on the protagonist's head.

DON'T OVERDOSE ON SPEED

It's important not to rely too much on speed lines as a crutch. Even in an action-oriented manga, characters are not always in motion, and in some cases, showing a high-impact scene with a stark white background can have a greater impact.

For example, the climactic moment when a punch connects with an enemy should not have speed lines, as you'll want this scene to be "frozen in time" and have as little distraction from other linework as possible. In such cases, background elements and even non-participating characters can disappear, so the panel relies totally on the movement between the attacker and the defender (and the defender's poor chin).

The idea is to create a rhythm and pacing both on a page and in each scene. Varying the use of speed lines is important, so that even in long battles, nothing is repetitious. Different action scenes can have different feelings by using only one particular type of speed line such as straight, long, and thin for one scene, while another scene has short, thicker, curving speed lines. Consider the type of action and emotion of a scene and choose speed lines accordingly.

If a page has multiple panels with speed lines, they should not touch or be similar in style and direction, as this will cause tangents and reader confusion. A tangent between panels will make the panels look like one singular panel.

Remember that speed lines take the place of backgrounds. If the background is important in that particular panel, such as an establishing shot, an important object or person, or a scene change, then it's important not to use speed lines, as the lack of background will confuse the reader. Once setting and important scene elements are already established and in the reader's consciousness, then bring out the speed lines.

Don't forget to re-establish the background at least every few pages especially in a long action scene. Action doesn't happen in a void, and showing even just one object from an already-established shot will help remind the reader where the characters are.

Speed lines are one of the most useful tools in manga to increase the level of excitement in your manga. Just think of them as another tool in your arsenal. Over time, you'll know instinctively when and where to use speed lines most effectively.

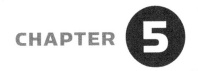

Blurring

Blurring is an advanced technique used in a lot of manga to indicate speed and motion. It's not something you can accomplish with one click, though. Blurring in Manga Studio is a bit more involved than that. Here's a bit about how blurring works, and then here's how to pull it off in Manga Studio.

ALTERNATIVE TO SPEED LINES

There are several cases where speed lines won't do the job for showing motion. You really need to show an object is moving fast, and speed lines aren't making it seem fast enough. You could try drawing the speed lines over the object, but this tends to obscure it and clutter the panel.

Or, the background is really necessary in a certain panel where an object is moving fast. You haven't established the scene recently enough and taking out the background to put in speed lines really wrecks the setting.

In a third example, you've used speed lines throughout a page and don't want to in the panel you're working on now. It's fast moving, but you need another option.

Consider blurring the objects in the panel instead. This is typically called *motion blur*, though we're shortening it to just blur as Manga Studio 3 doesn't have native support for motion blur. Blurring is a neat trick that can really jazz up a fast moving scene.

USE THIS TECHNIQUE WISELY

Blurring is a technique best used in extreme moderation. You might typically blur a panel about half as often as you would put speed lines on it. Why? Excessive blurring is discomforting. Above all, a reader needs to be able to see the majority of the art clearly and distinctly. Expect to blur a panel once a page or once every other page, maximum. That doesn't mean it's not a useful and important tool in your bag of tricks—just one that you'll be using infrequently.

Pro Manga Example

Here's the Manga Studio trick for blurring. It's a bit tricky, so read the screenshots and the directions closely. (Manga Studio 4 promises native support for motion blur, so this should get much easer in the new version!)

Step 01

Duplicate the layer by right-clicking on the layer and click **Duplicate Layer**, or go to **Layer** → **Duplicate Layer**.

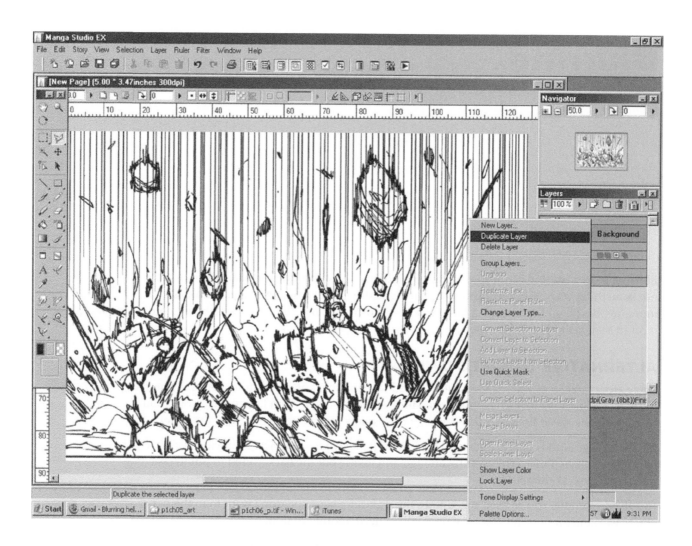

Step 02

Open the **Layer Properties** window in the advanced view and make sure the duplicated layer
is set to Expression Mode: Gray (8 bit) and Subtractive Method: Does not subtract colors. If
it's not, go to **Layer → Change Layer Type** and change the layer to the proper settings.

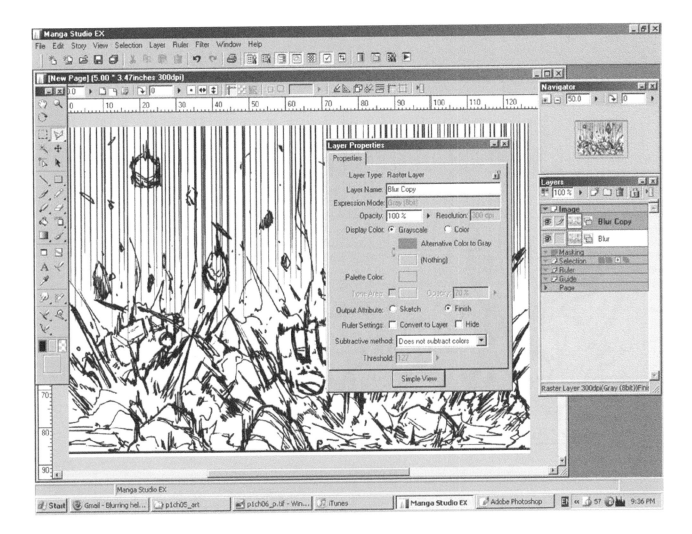

61

Step 03

Go to **Filter → Effects → Gaussian Blur**, and it will open the option window for Gaussian Blur. The larger the number of the Range, the more blurred it will be. In this case, I set the range to 2.0. Click **OK**.

Step 04

Here, I reordered the layer so the Gaussian Blurred layer is below the original line art. Click and drag the blurred layer lower in the list in the Layer Window. This will allow the original line art to still be readable above the blur. Next, it's time to give the illusion of a motion blur from above. Use the Move Layer tool to move the Gaussian Blurred layer just a small amount up, so it's offset from the original line art.

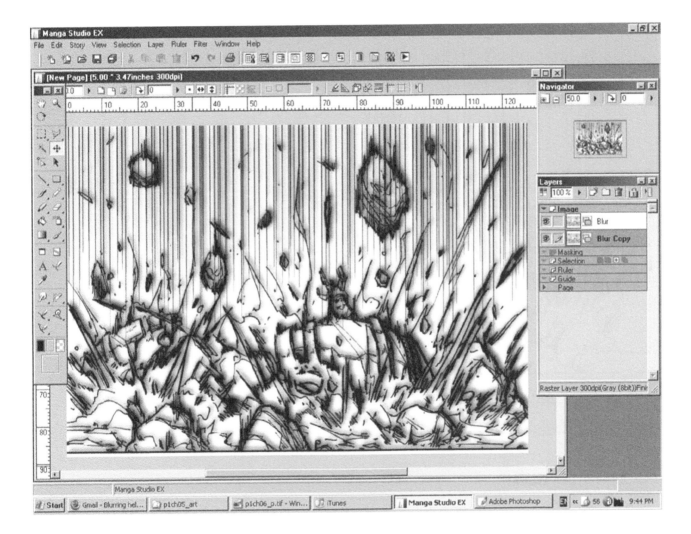

63

Step 05

Adjust the opacity down so it will be less obtrusive by opening the **Layer Window** in **Advanced Mode**.

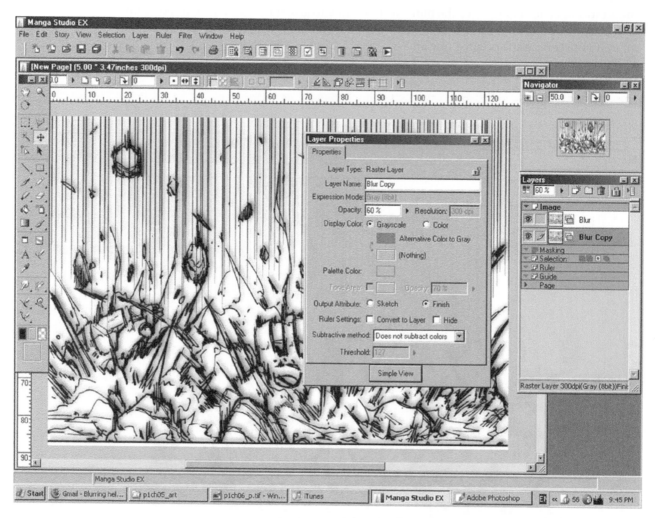

Done!

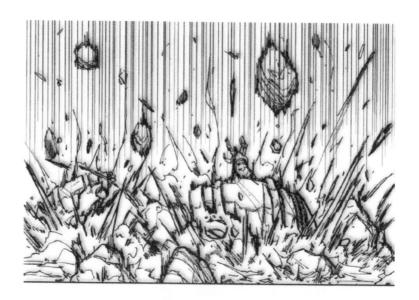

Perspective and Backgrounds

Mastering both perspective and backgrounds is essential for moving beyond pinup work and into serious, professional manga sequential art.

PERSPECTIVE

Perspective is an extraordinarily important tool to master. Perspective lets you properly show forms in three-dimensional space. Bad perspective means that objects tend to float in midair, people stand in holes, or pages become too abstract and indecipherable.

Before we dive in, there are a few terms to define. The *horizon line* is a horizontal line that represents the eye level of the artist. If the artist is looking down on a scene from above, the horizon line is also up above the line.

To draw an object in perspective, the edges—like the edges of a box—must recede back into space. These edges or lines always will recede to one or more points. These imaginary points are called *vanishing points*. Vanishing points, with the exception of three-point perspective, will always be found on the horizon line.

ONE-POINT PERSPECTIVE

One-point perspective is a system whereby a panel has a single vanishing point. It's useful for close-ups and hallways, where not too much of the scene is visible.

Pro Manga Example

Here is a drawing done in one-point perspective. You can see that all edges in the drawing tend to converge on one point on the horizon line. The faces of the building that point to the audience are drawn parallel to the horizon line.

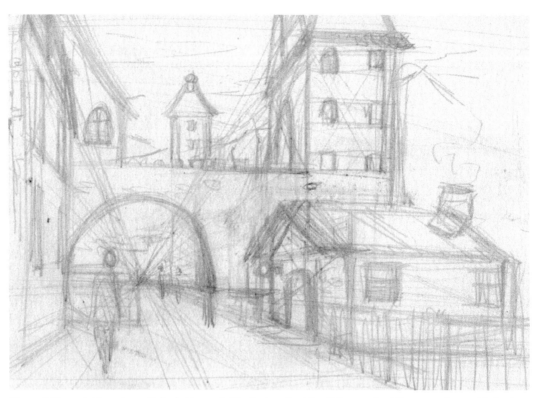

The vanishing point is underneath the bridge arch. The horizon line hits all the people at the same place, mid-chest. This means the artist's eye (if it was a real scene) would be at chest level. It's easy to tell that all the angles in the drawing converge on that point.

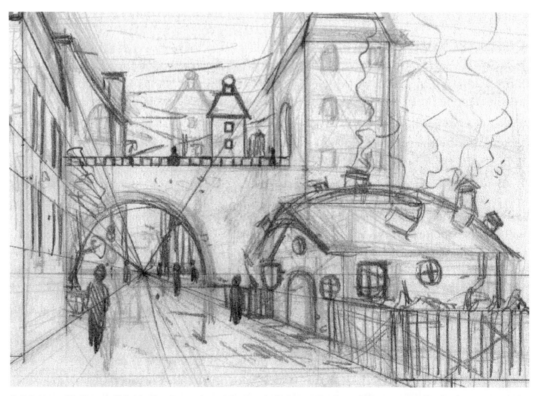

Artist Jeong Mo Yang builds his drawing on top of these ruled perspective lines. When perspective is done correctly, it creates a believable space.

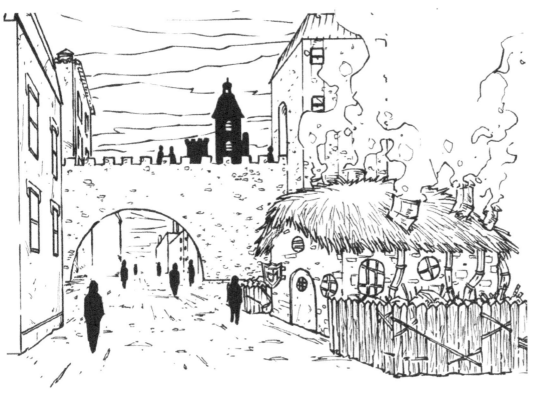

In the inked drawing, the vanishing point, horizon line and all perspective lines are erased and a natural, finished background is created. The work that went into it, however, still shows, because the town is in correct perspective.

TWO-POINT PERSPECTIVE

Two-point perspective tends to be more interesting, so many medium and long shots are two-point perspective instead of one-point. Instead of viewing an object from directly in front, two-point looks at the corner. This causes two vanishing points on the horizon line, very far apart from one another.

Pro Manga Example

Here's a drawing done in two-point perspective. As you can see, everything converges on the two vanishing points. Note that one or both of the vanishing points must be off-panel, or the perspective will be strange.

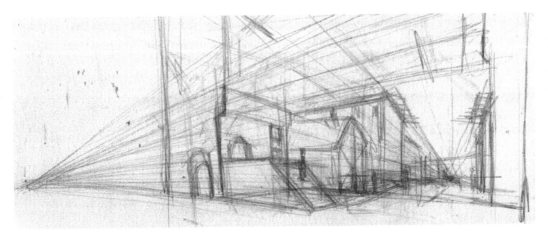

In this case, the left vanishing point is well off the side of the finished art and far away from the other vanishing point. However, it is still on the horizon line. The right vanishing point is where the adjacent sides of the buildings recede to. As long as all lines go to either point, the perspective will work.

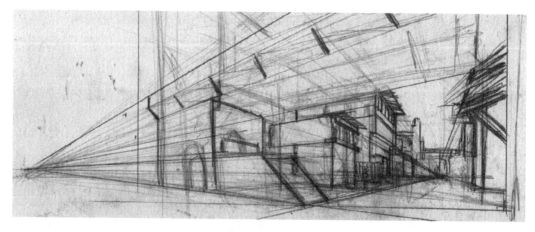

Jeong Mo Yang changes his mind on several shop facades as he tightens up the drawing.

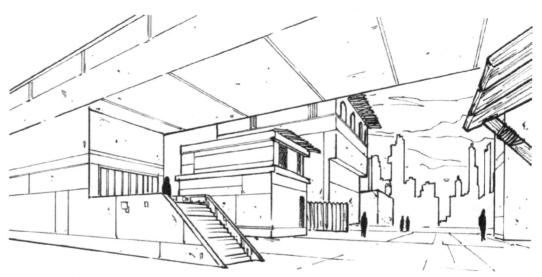

Yang finishes inking the two-point perspective background, erasing the vanishing points in the process. As you can see, the far left vanishing point is no longer in the panel.

BACKGROUNDS

Once you consider yourself an expert on laying out a page with the correct perspective and vanishing points, it's time to create the background. Now, this is often the least favorite element in an artist's repertoire. Rendering buildings, desert, forests and rooms isn't as fun for many artists as eyes, faces and mecha. However, backgrounds are important, and they are important to do well. Many the beginning manga artist didn't spend enough quality time on backgrounds and ended up with great figures on crummy, indecipherable backgrounds.

That's not you. So here's some tips on rendering backgrounds effectively.

Backgrounds and Establishing Shots

One of the most important uses for quality backgrounds is the establishing shot. An establishing shot is a panel that contains the outside setting of wherever the scene takes place. Before beginning the scene inside, it's necessary to show first what it is the inside of. A beautifully rendered establishing shot can set the tone for the entire body of work, so make it count.

Pro Manga Example

Here are several establishing-shot examples in different settings.

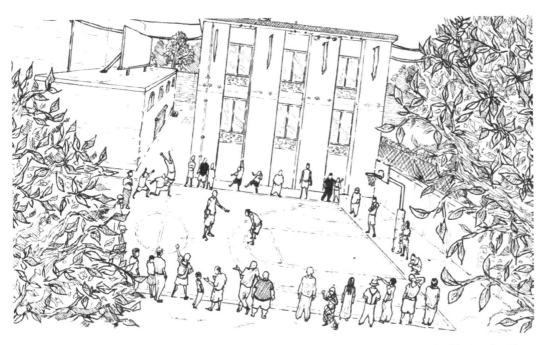

The basketball half-court at an apartment complex. This panel is in one-point perspective on a tilted horizon line. The next panel will focus on the two b-ballers playing one-on-one.

A street scene establishing shot, where militant police are patrolling the streets. The next shot might be a hiding place or corner alley where a rebel is observing this show of force.

ESTABLISHING SHOTS EXPLAINED

Now that you know how to do an establishing shot, you're going to want to know why to do them. For the answer to that, see Chapter 10, "Single Panel Elements."

BACKGROUND VS. FOREGROUND

It's a good idea to clearly distinguish background from foreground. This is usually done by giving the foreground elements thicker, more defined linework, as the foreground is closer to the camera. Backgrounds have thinner, but detailed lines. This clear delineation between background and foreground can also be accomplished through good panel composition.

Pro Manga Example

Here are two poorly drawn panels where background and foreground elements are running into each other.

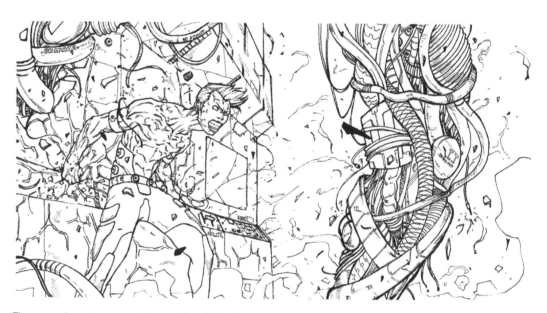

The angry character seems to be merging with the background, which isn't the intended effect.

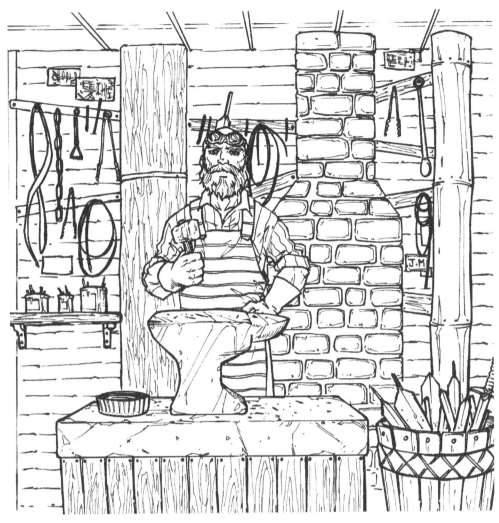

The stripes on the smith's coat are far too similar a pattern to the brick chimney.

Here are the same two panels, but differently composed. The background and foreground are easily separated and clearly distinct from one another.

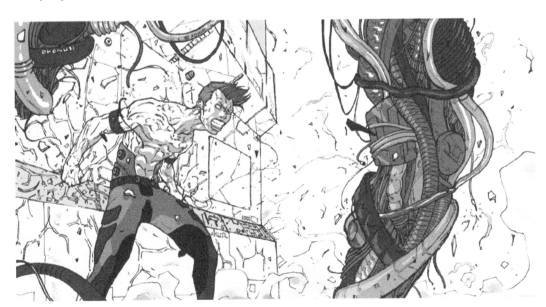

Toning has gone a long way toward popping the characters out of the shot. By making the foreground elements darker and more dramatic, they pop from the lighter background.

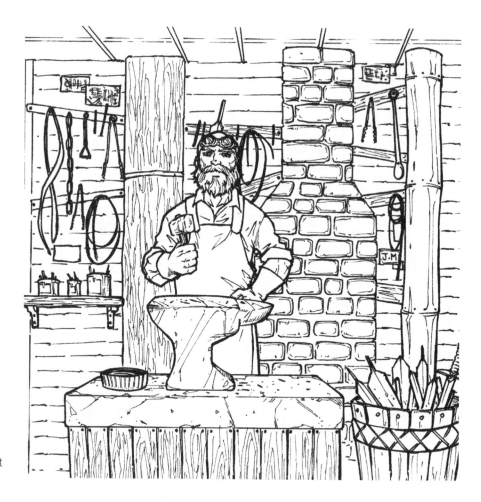

Removing the textures from the smith and increasing the line weight has made a world of difference. The background here has more smaller details and the smith is a simple, large space. This contrast helps the eye focus.

72

This character has spotted his lost love across a crowded courtyard. This shocking revelation is better with no background. It doesn't matter where he is, nor does it matter who is around him. All that matters are his feelings.

WHEN NOT TO USE BACKGROUNDS

There are many cases in a manga panel—or a whole page—where backgrounds should be dropped. Instead, a stark white or stark black color replaces the background. This focuses the entire attention of the reader on the foreground character or characters. It's important not to go backgroundless for more than a page at a time, because readers will forget the setting and lose their focus in the story.

Pro Manga Example

Here are two panels that look great without a background, and would simply be obscured with one.

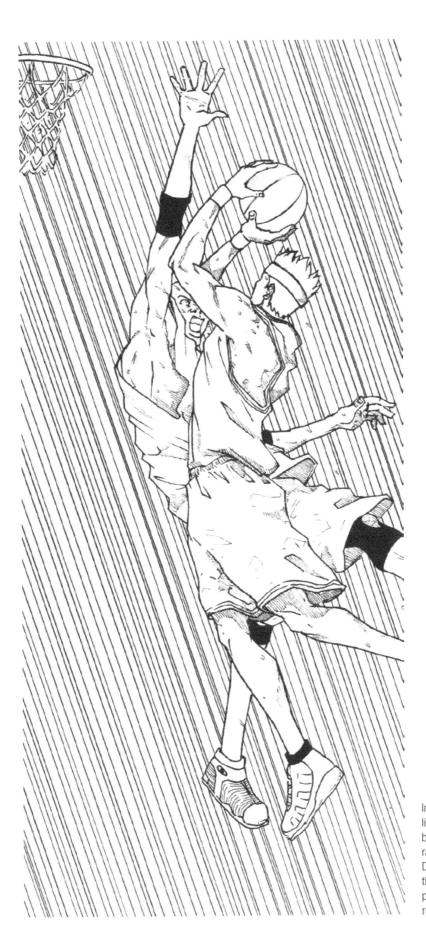

In this case, speed lines take the place of backgrounds and really ratchet up the moment. Does the opponent block the shot, or does he get posterized by a nice reverse layup?

Pro Manga Example

It is possible to create perspective rulers entirely in Manga Studio and have your rendering snap to those grids. Simply add a ruler layer, then go to **Ruler → Create Perspective Ruler**, then move the vanishing point to the desired spot. Turn on **Snap to Perspective** and draw away. However, it's not the approach that our artist Jeong Mo Yang decided to go with. Yang is far more comfortable penciling perspective lines and backgrounds entirely by hand before inking the backgrounds with Manga Studio.

That said, here is a trick for importing a hand-drawn background and integrating a Manga Studio drawn character with it, placing him behind some elements and in front of others.

Step 01

Go to **File → Import → Image File** and select your scanned background image.

Step 02

On the Layer Setting, make sure layer type is on Raster Layer.

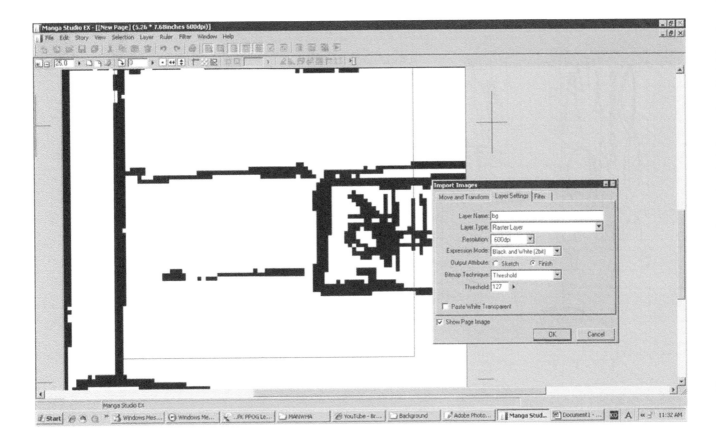

Step 03

Go to Move and Transform → Auto Adjust → Direction Down → OK.

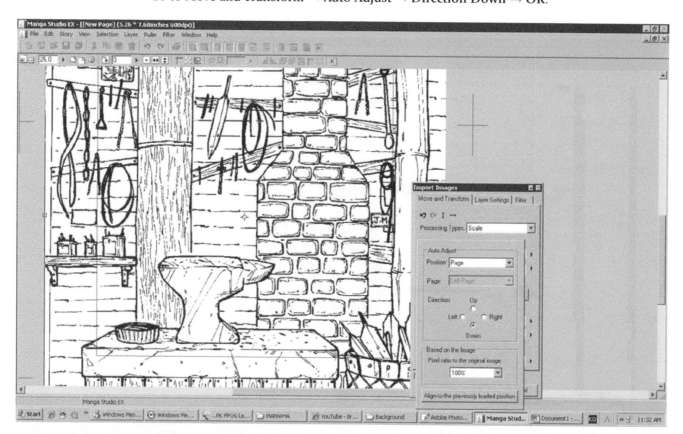

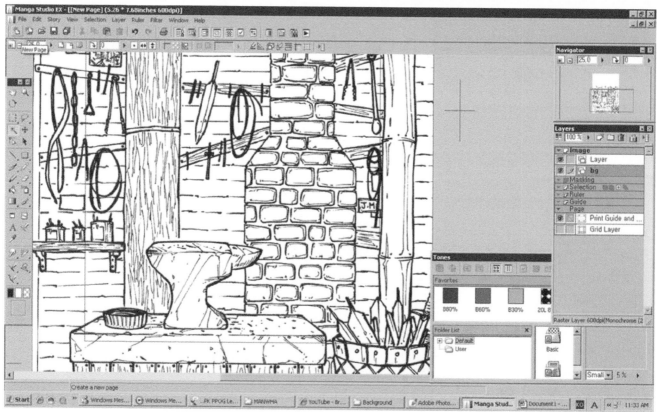

Step 04

Repeat steps 1-3 and import another image.

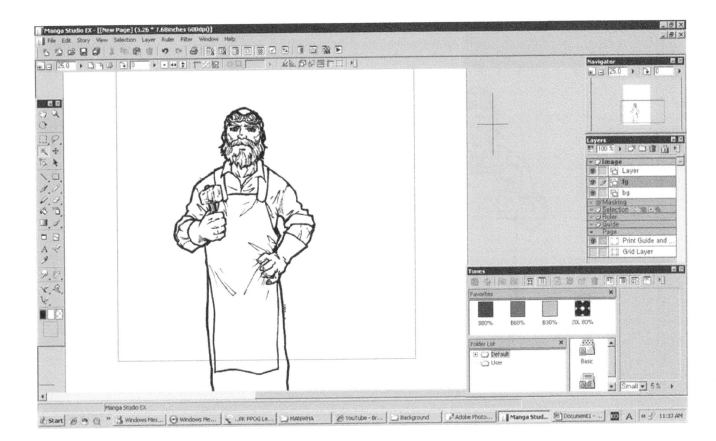

Step 05

Use the Magic Wand Tool to select the empty white background → **Click Delete**.

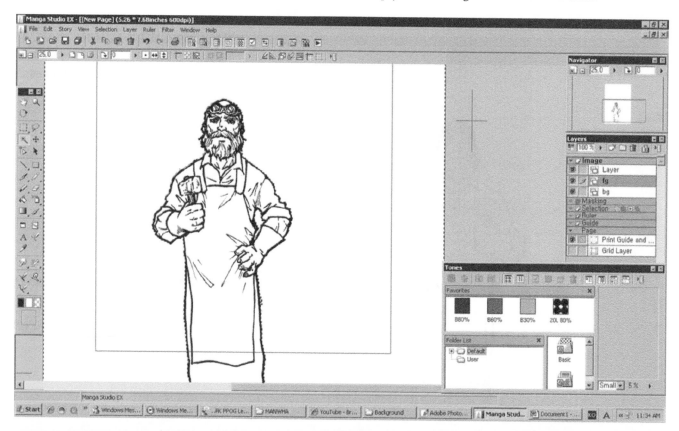

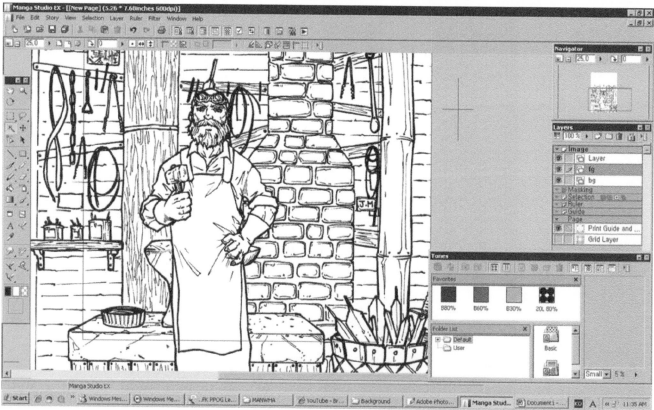

Step 06

Change the opacity of the character. Use the Erase Tool to delete part of the character so he appears to be standing behind the anvil.

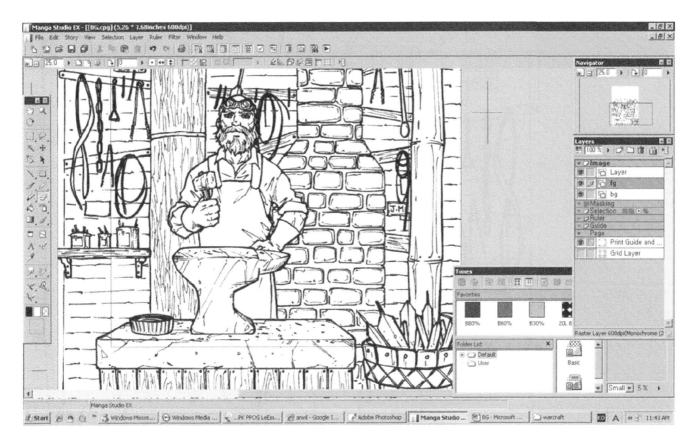

Finished!

Once you are done, change the opacity of the character back to 100%.

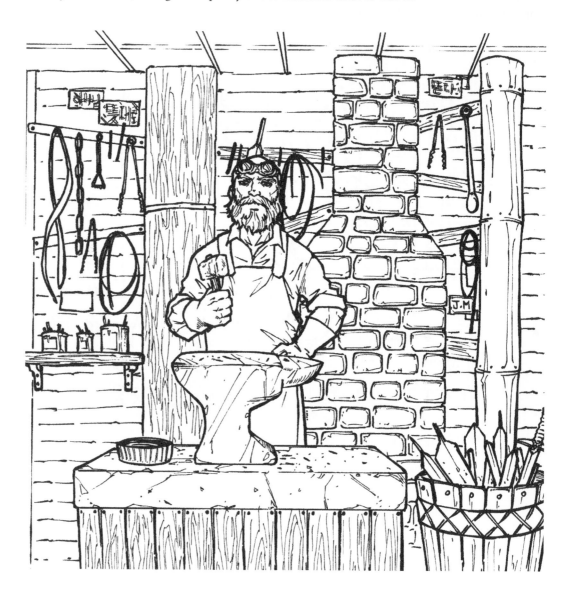

PERSPECTIVE & BACKGROUNDS: FINAL NOTE

We admit it. Perspective and backgrounds aren't really exciting. But, they are essential. Some have described getting into serious background detail as a Zen experience. Allow yourself to get swept away in the detail and intricacy of quality background work and your manga art will stand out far above the wannabes. You will never be the guy or gal who shows his or her portfolio to an editor at a convention and makes excuses for poor backgrounds. Because you won't have any.

Technology

While a manga character is deliberately drawn with simple features to be more iconic, the technology in manga, such as vehicles, weapons, armor, mecha—and even background elements like buildings—are drawn highly detailed, for opposite effect. In fact, there's juxtaposition between the simplicity of a manga character and the complexity of the technology that might exist in his or her world. The technology in manga is often where most of the detail and time is spent.

In contrast to real-world technology, which trends toward miniaturization, streamlines, and smooth edges, manga technology tends to be big, bulky and full of moving parts, as if the technology of the past ran into that of the future. One striking example of this is Space Cruiser Yamato, one of several classic anime series to feature a space vehicle that looks just like an old-fashioned battleship!

Of course, there has to be a balance: your deadlines may not allow you to spend too much time on any one piece of tech. The tech has to be easily reproducible from panel to panel, especially if it's involved in a fight scene and has to be shown over and over again from many angles. Nothing's worse than getting bogged down with one object that just takes too long to draw or is impossible to depict from certain angles.

There are four important things to remember when creating technology in your manga story. Understand the relationship between iconic characters and specific technology. Use photo reference in such a way that it serves you, not the other way around. When not using reference, settle upon your own design and keep it consistent from one panel to the next. Lastly, it's possible to create brilliant technology from the ground up using Manga Studio and a pencil sketch.

ICONIC VS. SPECIFIC

Manga characters are drawn with simplified features so that more readers can subconsciously relate to them. In contrast, technology is meant to be foreign, to stand apart, and to have little or no humanity. Therefore it is drawn detailed, to distance itself from the reader. Also, highly detailed technology just looks cool. Especially tech that is way more complicated than anything that actually exists.

The combination of a simple human being and a complicated mecha in the same panel evokes many themes, such as nature's design versus man's design; humanity and its reliance on technology; and artificial intelligence versus human intelligence. And this is all in the art, without a single word on the page! This beautiful contrast can already kick-start your narrative, simply in how you present it. This means that it's important both to leave detail out of characters, and to make sure that the technology is detailed, is not glossed over, and looks good, again without wasting too much time.

A manga character will often pilot a mecha or other big piece of technology by sitting inside it, as one would a tank. This leads to a striking image of the cockpit, where the simplified character is surrounded on all sides by tubes and wires.

In some cases, the technology actually merges with the character, increasing that theme of dichotomy even further. The manga and anime SaiKano featured a young girl who was engineered as the ultimate weapon and capable of unlimited destruction.

Pro Manga Example

1. I start by drawing rough thumbnails. I mostly draw thumbnails using reference images from online and/or magazines.

2. Once I find a thumbnail that I like, I proceed by drawing a rough of that one single thumbnail.

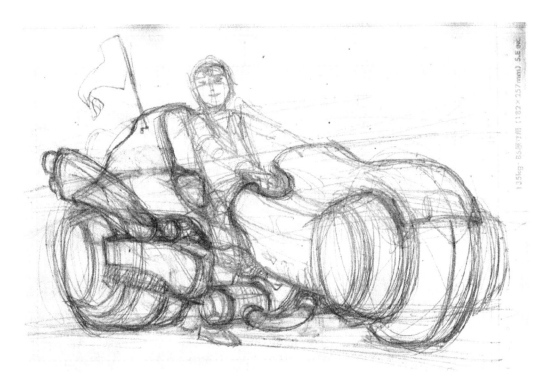

3. Once I've established the overall shape of the bike, I pencil over my rough. This time, I focus on the details.

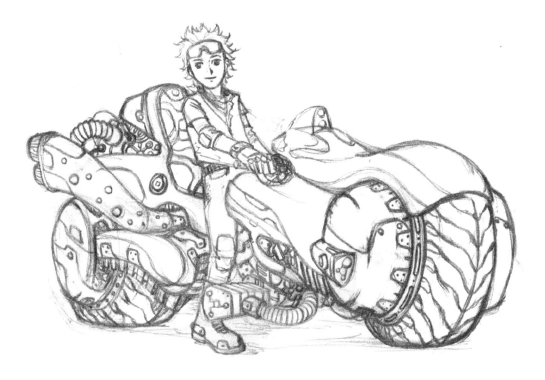

4. Now, I ink over my pencil. I start inking what's in the foreground; in this case, it will be the front wheel.

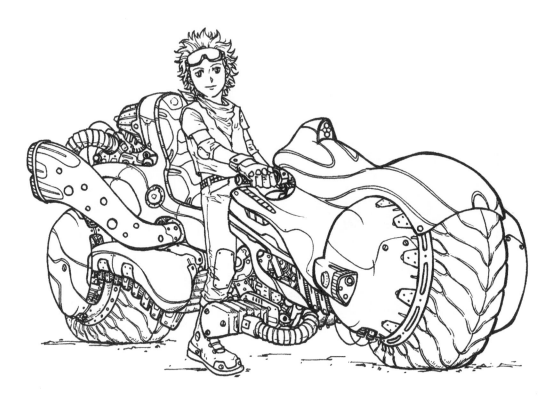

5. I scan my work to Manga Studio EX by going to **File → Import → Twain**. Manga Studio will create a new page for my drawing. I set the new page to **600 DPI** and the **Page Size** to A4 in the drag down menu. I **uncheck** the **Inside Dimensions** box. Click **OK** and Manga Studio opens the scanner software. I scan my drawing in at **600 DPI**. After scanning the image, make sure to select **Normal** at the **Import Method** dialogue box.

6. Now I can adjust the position and placement of the scanned image on the page with the options in the **Move and Transform** tab in the **Import Images** window. In the **Layer Settings** tab, change the **Layer Name** to "Ink." Check that the **Layer Type** is a **Raster Layer** and the **Resolution** is set at **600 DPI** Set the **Expression Mode** to **Black [1bit]** so the ink lines will be clear and not pixilated. I click **OK** to render the layer.

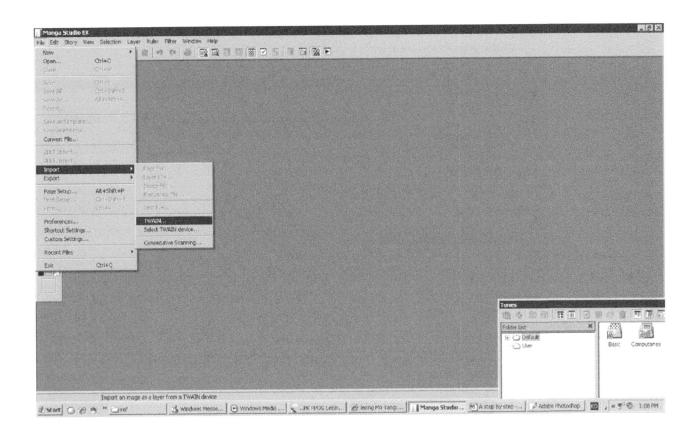

7. I start toning the lighter part of the bike first. I use the **Lasso tool** to select the area I want tone. I can add to the selection by holding SHIFT to add and ALT to subtract.

8. Once the area is selected, I drop a light grey screen tone into the image. Screen tones are found in the **Tones** window. The **Tones** window, if it isn't open, can be found by going to **Window → Tones**. The screen tones I use frequently are found in the **Tones** window. Inside the **Tones** window go to **Default → Basic → 1 Screen → 1 Dot → 50L**. I choose a light grey such as 15%. The higher the percentage of black, the darker the tone is. I *drag and drop* the tone I want to the selection and create a new layer for the tone.

9. Clear the Selection by selecting **Selection → Clear Selection** or **CTRL + D**. I use the **Erase** tool to erase all the grey screen tone that extends beyond the bike. I *zoom* in and out by using the plus and minus buttons in the **Navigator** window (if it's not open, go

to **Window** → **Navigator**). I also use the **Erase** tool to add *highlights* by erasing some of the grey screen tone within the bike.

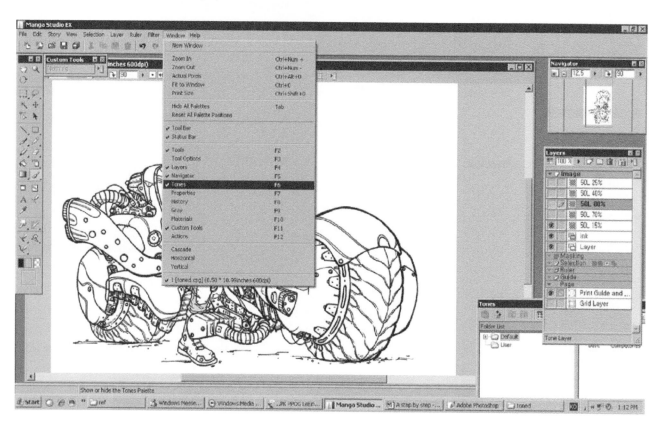

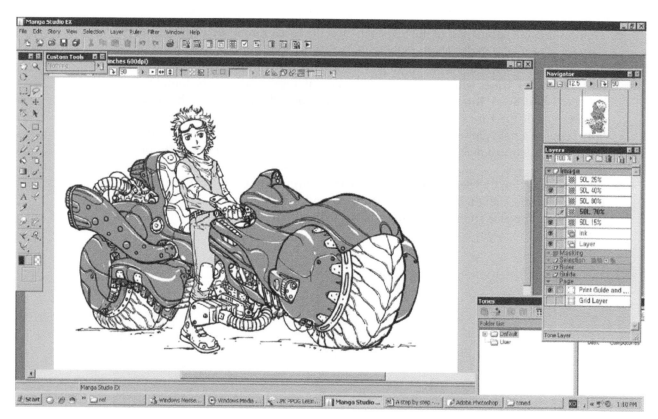

10. Now I tone the darker areas of the bike. This time, I use the Magic Wand tool to select the areas that I want to tone. Make sure the **Close Path** box is checked in the **Tools Options** window (if it's not open, go to **Window → Tool Options**). This will make sure that if there are any small breaks in the ink, the Magic Wand tool will ignore them. For small areas it may be necessary to uncheck the Close Path or use the Lasso tool. I select multiple areas by holding down the SHIFT key. Once the areas are selected, I choose a darker screen tone and *drag and drop* it into the selection. This will create a new tone layer for the darker tone. I use the Erase tool on the new layer to add highlights.

87

11. I continue to use the Lasso tool to add additional tones for shading. Once I select an area, I drag and drop in a dark screen tone. For shading, I prefer to use the Pen tool

instead of the Lasso tool. The Pen tool will draw with the tone of the layer. Make sure to deselect the selection before using the Pen tool.

12. Done!

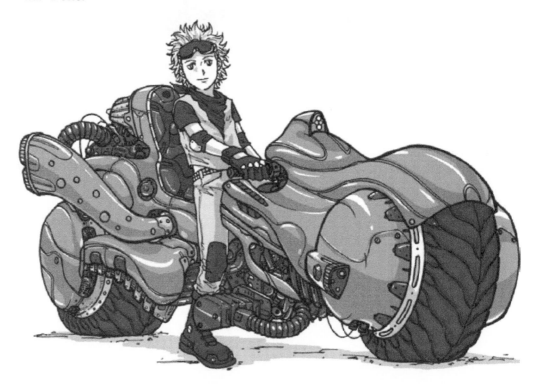

PHOTO REFERENCE: TOOL, NOT CRUTCH

Photo reference is important in art in order to get a specific piece of real-world technology to look exactly as it should. Weapons, especially, tend to call for real-world accuracy if set in the present day. If an AK-47 doesn't look like an AK-47, a weapon that's ubiquitous throughout television and movies, the reader is going to sense something's wrong and be pulled out of the story. A story set during a specific conflict in the real world, especially, is going to require a ton of photo reference to get everything exactly right.

Real-life skyscrapers and other technological landmarks are more things that require reference. The Western comics artist Dan Spiegle was once able to recreate Grauman's Chinese Theatre totally from memory, but don't think you can do it. Instead, use photo reference.

That's not to say you should just overlay and trace the photo to provide you with the realism that the story demands. This is far from the truth. You should not be a slave to that photo reference and trace it or copy it exactly and maybe change its angle or light source. Instead, take the photo reference and use it to inspire your actual drawing. Your final art will be the same make and model as the technology in the photo, but it will be, unmistakably, your drawing and not what looks like a traced photo.

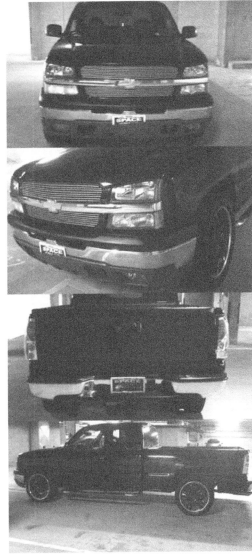

Another reason to be inspired by a photo reference and not take your drawing directly from it is because the photo you're working from is likely copyrighted. The objects inside the photo are fair game, as long as your art is different enough from the photo.

Photo reference can also become part of your research. Say you're after specific technology that a bounty hunter might use. Flip through *Soldier of Fortune* and rip out the appropriate pages. After you've paid for the magazine, of course. After a flashy new car, but not picky about the make and model? Check out *Car & Driver* for some concept cars.

Where else to find photo reference, other than magazines? Often, an entire range of photos is as simple as a Google Image search away. Again, almost all the photos you'll find belong to someone, so don't trace. Photo reference is a starting point, not an endpoint.

For this example, artist Jeong Mo Yang took a photo of his Chevy Silverado, and used it to create his own truck.

Pro Manga Example

1. I start out with photographs of my truck. In this case, a Chevy Silverado.

89

2. I then draw a rough sketch to get the right perspective and the silhouette of the truck.

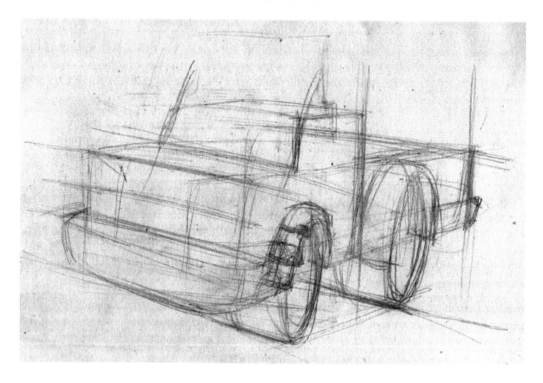

3. I keep polishing my rough....

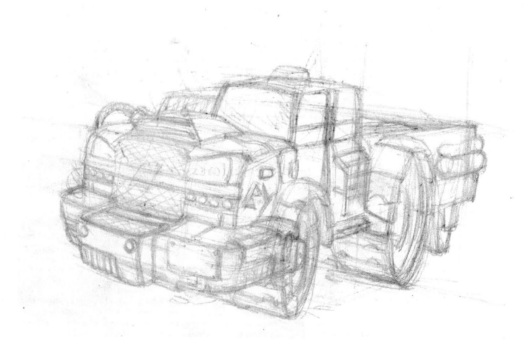

4. To a point where I can ink over it.

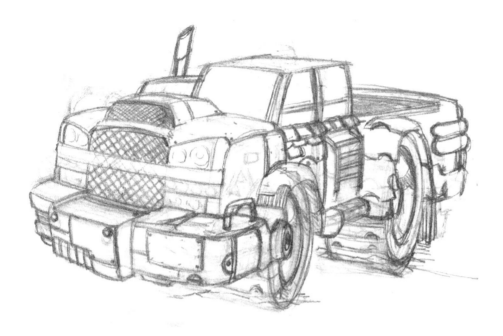

5. I ink over my pencil. Then I scan my work to Manga Studio EX by going to **File →
Import → Twain**. I scan my drawing in 600 DPI just like before.

6. I want my truck to pop-up from the drawing, so I use the **Magic Wand tool** to select
the background. Make sure the **Close Path** box is checked in the **Tools Options**
window (if it's not open, go to **Window → Tool Options**). Then, I *drag and drop* a
dark screen tone in the selection. The screen tones I use frequently are found in the
Tones window. Inside the **Tones** window, go to **Default → Basic → 1 Screen → 1
Dot → 50L.** I *drag and drop* the tone I want into the selection. I use the Lasso tool to
select the shadow below the truck and add the tone following the same steps.

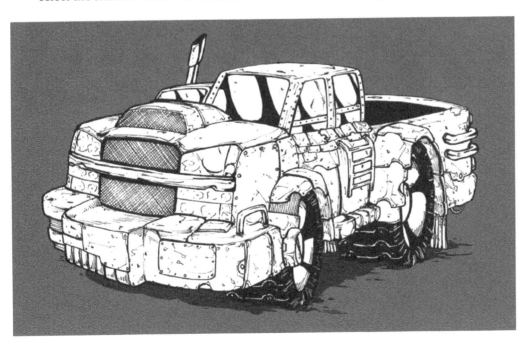

PHOTO REFERENCE: A STEP FURTHER

Of course, you don't have to draw the same type of object that's in the photo reference you're using. Instead, try using the photo as a springboard to something fantastic, just as you would any other source of inspiration. A piece of photo reference can be a good starting point for a brilliant piece of technology.

In this case, Yang took the same photo of the Chevy Silverado and used it to springboard into a truck creature! It still vaguely resembles the truck, Chevrolet symbol and all, but, on the other hand, it's very different! The original drawing mutated into this piece of art.

Some artists even take their love of photography and use it to serve their needs as a manga creator. Not only can photographed technology lead to artistic inspiration, but, as you'll see in the chapter on backgrounds, photographs of scenery are extraordinarily helpful when constructing well-crafted background art.

Here's how Yang created the Chevy Creature in Manga Studio.

Pro Manga Example

1. I started off by drawing thumbnails. My focus for these thumbnails is the silhouette.

2. Once I found a thumbnail that I liked, I drew a rough sketch followed by more detailed pencil work.

3. I ink over my pencil. Then I scan my work to Manga Studio EX by going to **File →
Import → Twain**. I scan my drawing in 600 DPI just as before.

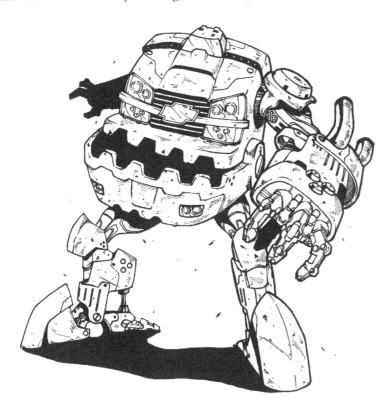

4. I want my robot to pop-up from the drawing, so I use the **Magic Wand tool** to select the background. Make sure the **Close Path** box is checked in the **Tools Options** window (if it's not open, go to **Window → Tool Options**). Then, I *drag and drop a dark screen tone* into the selection. The screen tones I use frequently are found in the **Tones** window. Inside the **Tones** window, go to **Default → Basic → 1 Screen → 1 Dot → 50L**.

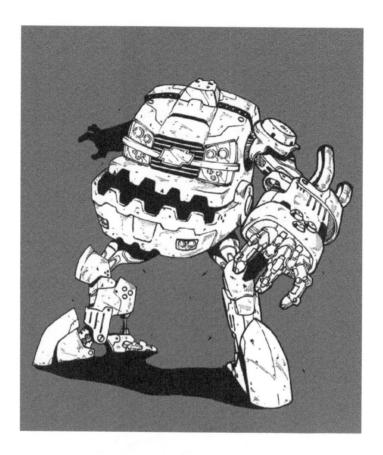

CONSISTENCY OVER ACCURACY

One thing about representing a modern-day piece of technology, such as a modern motorcycle: unless the story calls for a specific make and model (such as a biker gang that only rides Harleys), feel free to make up something that has the look and feel of something real. The tech on your motorcycle doesn't even have to match up to actual working parts on an actual working motorcycle.

Sticking with this example, remember that the left and right side of a motorcycle do not have exactly the same look—the kickstand is on one side, to use one glaring example. Make sure that once you stick with a design in the first panel that this tech appears, that you're consistent with this same design throughout the story, in each panel where it appears. Do these things, and it doesn't have to be all that real-world accurate. As long as the reader believes it's true, that's enough. This concept is called *verisimilitude*, or *the appearance of truth*.

Not only does this save time, but it also allows the artist to be creative with a design. It's unmistakably a piece of technology from the story's time period, but it's not a specific model. The artist has created one that could stand alongside existing models, and fools the reader into thinking, "Hey! This is real."

Pro Manga Example

1. I draw a rough sketch from my memory. I care only about the overall shape.

2. I start to tighten the pencils. I focus on details.

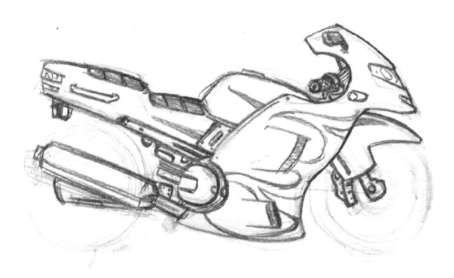

3. After pencils, I start to ink. I add more details.

CREATING TECH DIGITALLY

Start with a few pencil sketch ideas, either drawn directly in Manga Studio with a tablet or on paper and scanned in. Here's how to choose a final sketch and use the tools that Manga Studio provides to turn that sketch into believable technology.

We chose mecha, as they're a manga trademark and come in infinite sizes and variations. Here are several different varieties. We've narrowed it down to this one, as it has a striking look.

Pro Manga Example

1. I start by drawing thumbnails.

2. Once I find a thumbnail that I like, I proceed by drawing a rough inside Manga Studio EX. To do this, I need to open up a new page. Click on **File → New → Page**. I keep the page at **600 DPI** and set the Page Size to **A4**. I uncheck **Inside Dimensions** since I don't need them.

3. Once the page is open, I want to lay the paper horizontally instead of vertical. I can do this by going to **View → Rotate and Flip → Rotate 90 Degrees CW or CCW**. I start drawing the rough using the **Pen tool.** I name this layer "sketch." I set the **Layer Opacity** to **50%**. Open the **Layer Properties** window (**Window → Properties**) and set

the **Opacity box** to **50%** or change the Opacity percent box in the Layers window (if it's not open, go to **Window → Layers**).

4. I create another layer named "sketch2" and set the opacity to 50% as well. I keep polishing the thumbnail to a point where I can see the details. Once this layer looks detailed enough, I make the previous layer invisible, by clicking the **eye icon** on the left side of the layer in the **Layer** window.

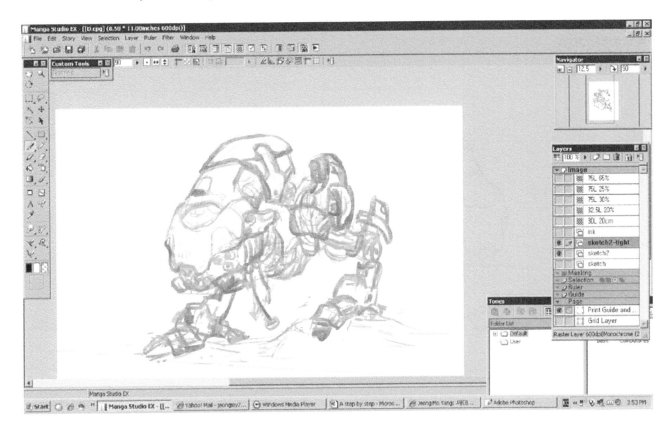

5. I create another layer and name it "ink" and I start inking using the **Pen tool**. Once I finish inking the entire mech, I make the sketch layer **invisible** as well, so the only visible layer is my inked layer.

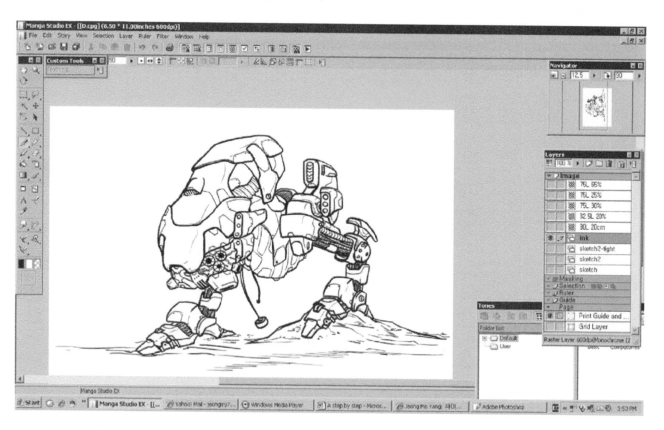

6. I start toning the lighter part of the mech first. I use the **Lasso tool** to select the area I want to tone. Once the area is selected, I *drag and drop a light grey screen tone* into the image. Screen tones are found in the **Tones** window. If you don't have your **Tones** window open, go to **Window → Tones**. The screen tones I use frequently are found in the **Tones** window. Inside the **Tones** window, go to **Default → Basic → 1 Screen → 1 Dot → 75L.** After I drag the tone into the image, I deselect. I use the **Erase tool** to erase all the grey screen tone that extends beyond the mech. I also use the **Erase tool** and erase some of the gray screen tone within the mech to add highlights.

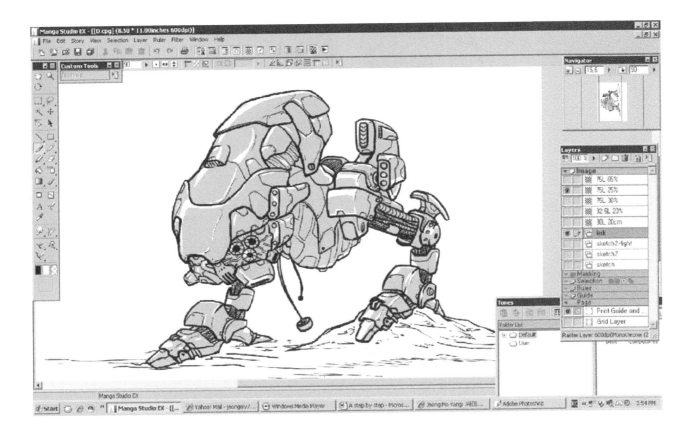

7. Now, I tone the darker areas of the mech. This time, I use the **Magic Wand tool** to select the areas that I want to tone. I select multiple areas by holding down the **SHIFT** key. Once the areas are selected, I drag and drop a **darker screen tone**. I use the **Erase tool** to add highlights.

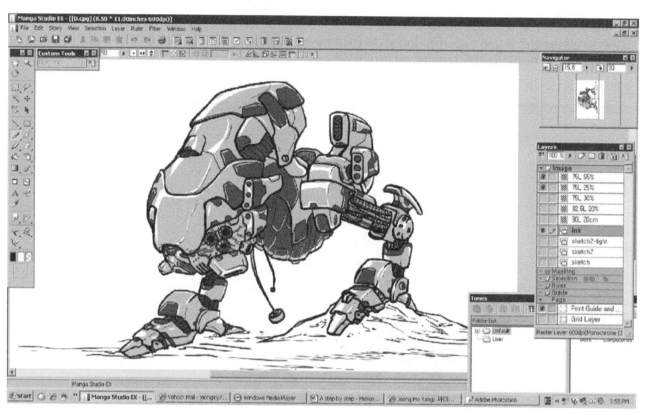

8. I use the **Lasso tool** to select the area I want to shade. Once I select an area, I drag and drop a *dark screen tone* into the selection. From here, I prefer to use the **Pen tool** to tone other areas I want to shade, instead of using the Lasso tool again and again. The Pen tool will draw with whatever the tone of the layer is. Make sure to deselect the selection before using the Pen tool.

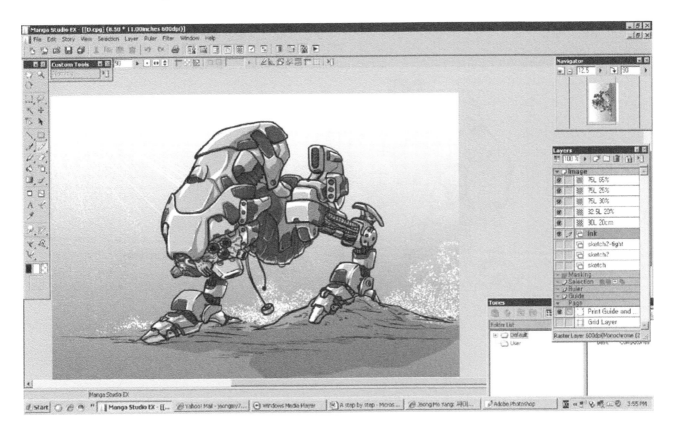

9. To add the background, I use the **Magic Wand tool** and select the background. I drag and drop a **screen tone**. I use the **Erase tool** to erase and add the special effects.

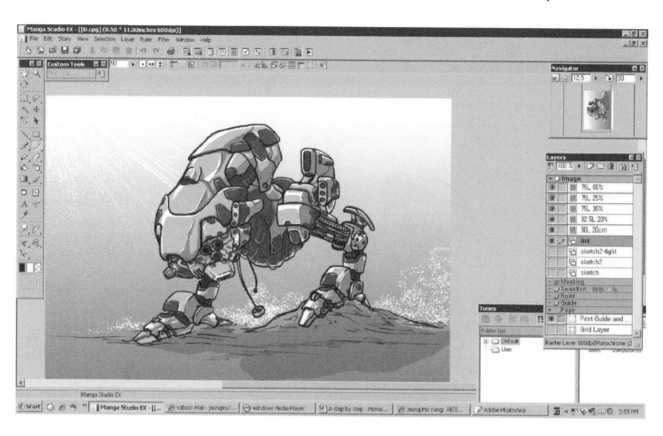

10. Done!

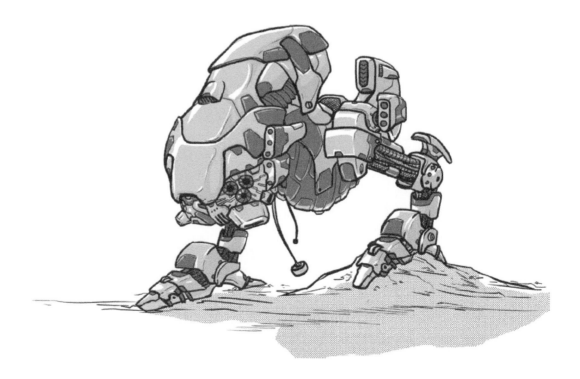

Sound Effects and Lettering

Truth be told, the lettering in a lot of manga, especially translated manga, is an afterthought at best. That doesn't mean it has to be for you. Quality lettering, including captions, speech balloons and dynamic sound effects, can make or break your manga. With the help of the tips in this chapter, your manga will be well on its way to the "make" category.

ENGLISH VERSUS ANOTHER LANGUAGE: COOLNESS FACTOR

Though OEL manga is, by definition, scripted in the English language, many OEL manga-ka have chosen to do some lettering, especially sound effects (or SFX), in another language. That other language is sometimes the manga-ka's nationality, and sometimes not. There's a coolness factor inherent in doing sound effects in Japanese or Korean, so often nationality doesn't matter!

The artist for *Professional Manga*, Jeong Mo Yang, is of Korean heritage. Yang has chosen to hand-letter all the sound effects in our example manga, *Other Side of the Tracks*, in Korean, and the results are fascinating!

Here's a page full of all of the sound effects Yang designed. If we had chosen to do the SFX in English, the results would have been far less interesting.

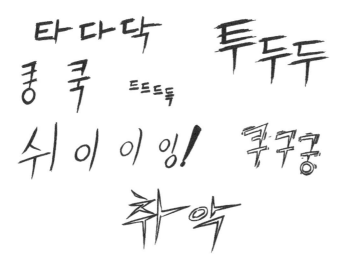

105

BIG AND BOLD: SFX PARTICIPATING IN THE ACTION

Manga is unique among all comics in that sound effects are everywhere, and they often participate in the action in a way. The design of the sound effect is a response to what is happening in the panel.

Let's take another look at one of Yang's sound effects.

See how the sound effect appears to be shaking? Now, let's see that sound effect in context:

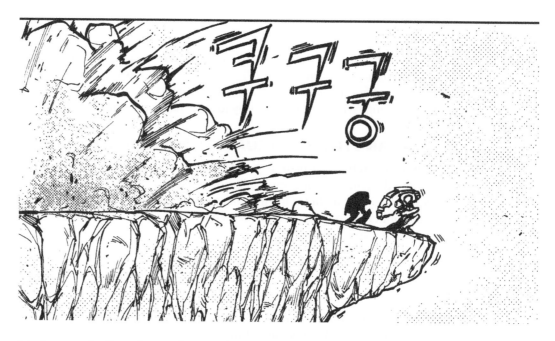

It's the sound effect of an explosion, the Korean equivalent of "BOOM!" The shockwaves from the explosion is so big, that it rattles the very sound effects themselves.

99 BLACK-AND-WHITE BALLOONS

Unlike Western comics, different manga-ka take wildly different approaches to captions and speech balloons. We counted at least five different ways that creators do thought balloons, for example. Here are the different types of captions and balloons we used.

A caption with no border and a stencil-looking font. A great choice for an establishing shot.

A typical speech balloon. The double balloon means that there's a pause between sentences as Keil looks at his status indicators.

An electronically modified voice uses a speech balloon with an electrical border.

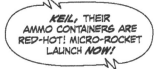

Since Keil and Jeyne's mecha look the same, we gave their balloons different looks to distinguish them. Keil's is square and Jeyne's is round. This one has no tail because Jeyne's mecha is off-panel at the time.

A character shouting uses a speech balloon with a mildly jagged edge.

One of many manga variations on the thought balloon, this version has a severely jagged edge and no tail. Some manga use haloed balloons, while others use cloudy balloons with round dots that point to the listener—the method used throughout the Western comics world.

107

THE CARDINAL RULES OF GOOD MANGA LETTERING

Professional letterer Johnny Lowe did all of the non-SFX lettering for *Other Side of the Tracks*. Through studying his methods, it's easy to determine what the right way is to do things. Here are several rules for lettering correctly and professionally:

1. Find quality fonts on www.blambot.com or Comicraft's www.comicbookfonts.com. Keep in mind that though some of the fonts are free, using them for a commercial enterprise such as manga requires a license. Two of the best choices for manga lettering are Tokyo Robot on Blambot and Monologous on Comicraft's site.

2. Lettering in OEL (unless the pages are flipped, Japanese style) should always be from left to right, top to bottom across the whole page. A reader should not be led to accidentally read one balloon before another.

3. Many fonts come with alternate characters that look slightly different. In words that use the same letter more than once, switch to that alternate character to give the lettering a more natural, hand-lettered look.

4. Be sure that any use of the word "I" standing alone or as part of a contraction is the capitalized I with hats or serifs on the top and bottom. Without these serifs, the letter I is too close in appearance to the lowercase "l" or the number "1".

5. When using **bold** (or **bold** + *italics*) to emphasize words, don't overdo it. **Some** writers go **nuts** with **this** and **bold** nearly **every** other **word**, and it just doesn't read well at all! Just bold the word that's stressed the most when spoken aloud, and move on.

6. Make plenty of room in the balloon for the lettering and space around the lettering. The letters should not come close to touching the balloon edges.

7. Don't letter past the Safety Zone on the page, or risk having edges of balloons and captions cut off. See Chapter 14 for more on the Safety Zone.

8. The script, the art and the dialogue should all have the same speaking order for characters in the conversation. The writer should design the scripts from the beginning so that people are speaking in the order they will be drawn. Otherwise, it's really hard to do the balloon tails correctly.

9. In panels that have a lot of dialogue, the writer and artist should have left enough room. If there's not enough room, and it's too late to fix it in the art, then coordinate with the writer to condense the dialogue or move some of it to the next panel.

Pro Manga Example

Finally, here's how to make speech balloons directly in your manga with Manga Studio.

CREATING A SPEECH BALLOON MANUALLY

Step 01

Select the **Ellipse Marquee tool**. Create the ellipse of desired size with the mouse.

Step 02

On a new layer for the balloons, select the **Paint Bucket tool**, make sure the foreground color is black, and click on the balloon to make it black.

Step 03

Go to **Selection → Reduce Selection** and select a width. This will be the width of your speech balloon's edge. Click **OK**.

Step 04

Select the **Paint Bucket tool** again and make the foreground color white, then click on the balloon again.

Step 05

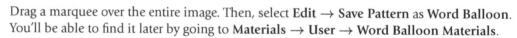

Drag a marquee over the entire image. Then, select **Edit → Save Pattern** as **Word Balloon**. You'll be able to find it later by going to **Materials → User → Word Balloon Materials**.

Finished!

Viola! A speech balloon.

CREATING A SPEECH BALLOON AUTOMATICALLY

Manga Studio EX comes with an auto speech balloon tool that's really easy to use. First, type in the text you want with the **Text tool**. When you're done typing, you'll notice a new Word Balloon tab in the Layer Properties window. Click on this tab and click on Fit Text. A balloon will automatically appear around your text. Save this balloon using Step 05 above.

CREATING A TAIL FOR THE SPEECH BALLOON

Step 01

Go to **Materials → User → Word Balloon Materials** and drag one of your custom speech balloons to the page.

Step 02

Double-click on the layer and the **Word Balloon** menu will pop up. Click on **Add Tail** and a square will appear in the balloon.

Step 03

Drag the square to where the endpoint of the tail needs to be. Make sure there is space between the end of this tail to the edge of the object speaking.

Step 04

Adjust tail and line width to the desired values and click **OK**.

Finished!

Viola! A speech balloon with a tail. Now, select the **Text tool** and letter away.

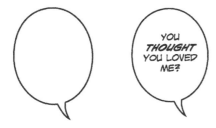

SOUND EFFECTS AND LETTERING: FINAL NOTE

Remember, the goal isn't to look as good as your favorite overseas or OEL manga. The goal is to look better! Designing quality sound effects and lettering go a long way toward stepping over lesser works. Make sure your project is the best-lettered and most professional project.

Other Side of the Tracks

Other Side of the Tracks is the short manga story that serves as an example in this book. It's written and drawn by its co-creators, Steve Horton and Jeong Mo Yang.

Other Side stars two young soldiers, Keil and Jeyne, who pilot a pair of beat-up mecha. Keil and Jeyne approach the war they're fighting in from completely different points of view: Jeyne enlisted, but Keil was drafted. As the story opens, Keil and Jeyne are backed up to the edge of a cliff, surrounded by enemies!

Other Side is part of a larger war story and its creators plan to develop it further in other venues, following the publication of this book.

Following this 20-page manga is the second half of *Professional Manga*, which examines panels from the story in detail and uses these panels to develop manga storytelling methods. Feel free to refer back to the *Other Side* story in order to examine these specific panels in their proper context.

In the meantime, here are a couple of sketches that Jeong Mo Yang created while developing *Other Side*. Enjoy!

112

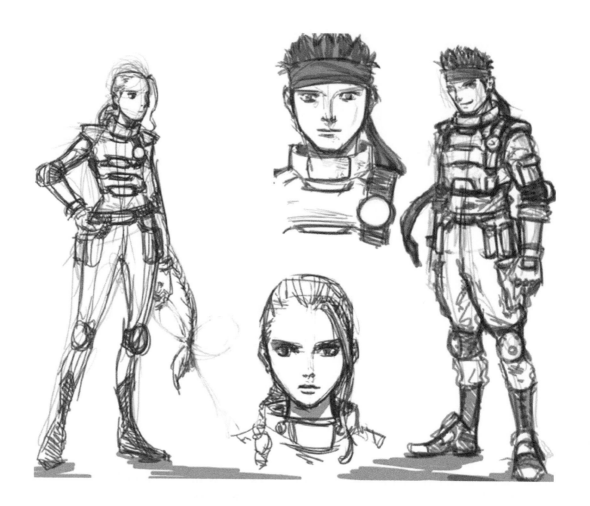

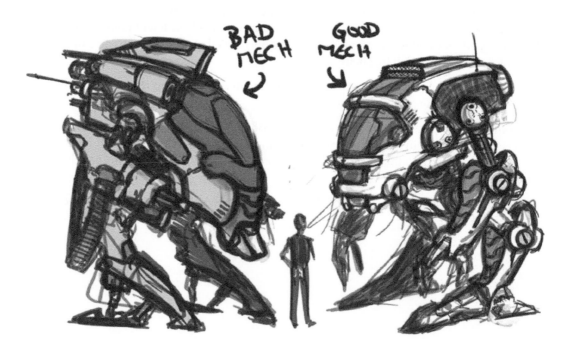

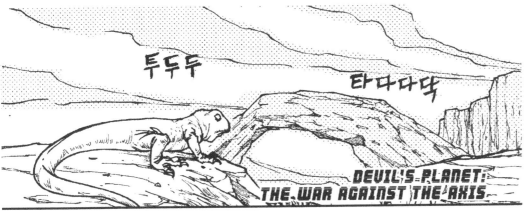

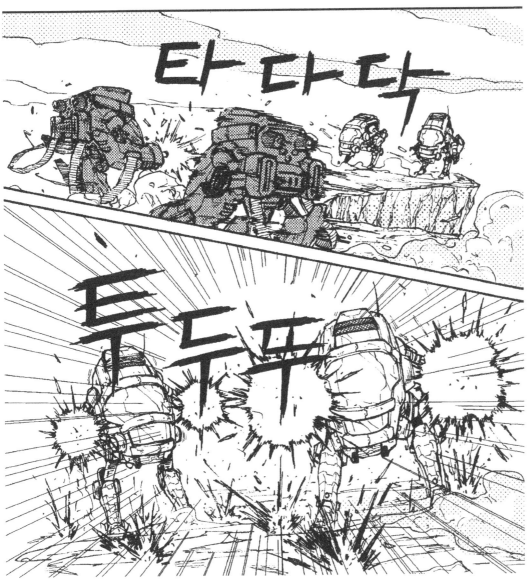

114

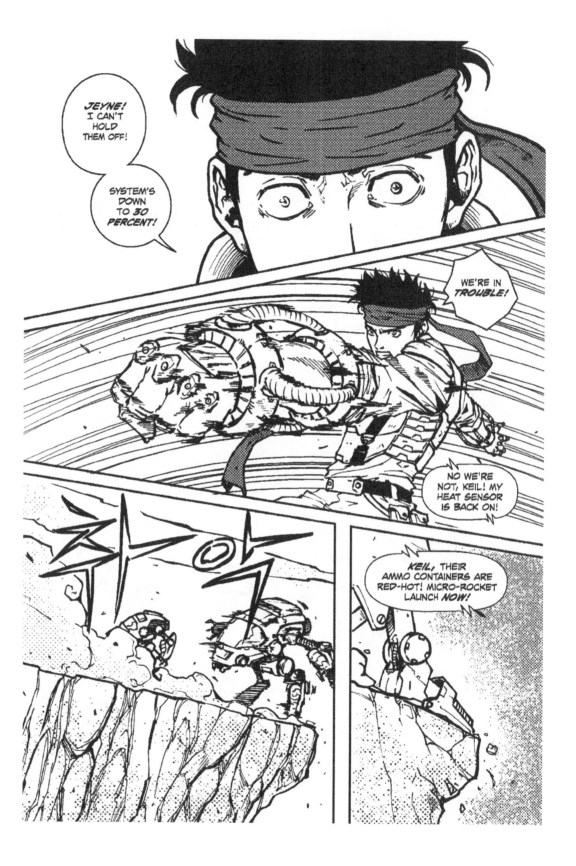

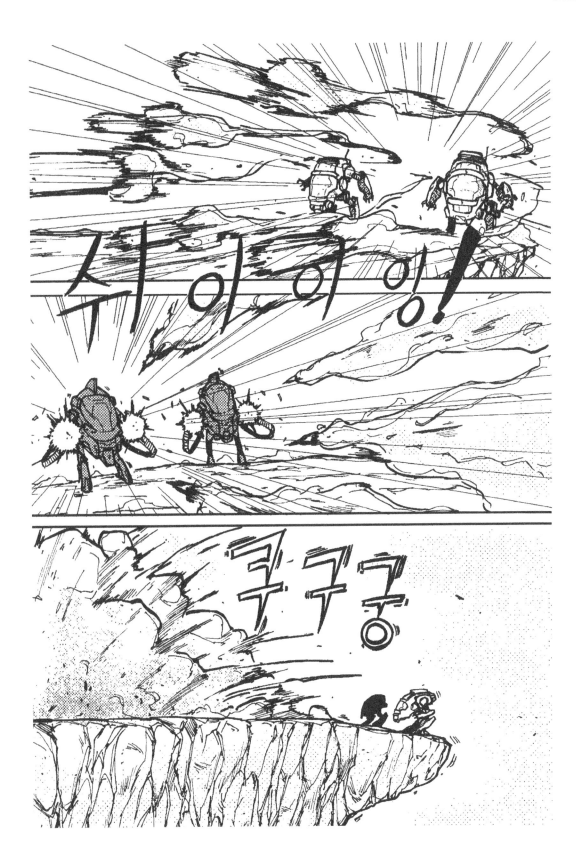

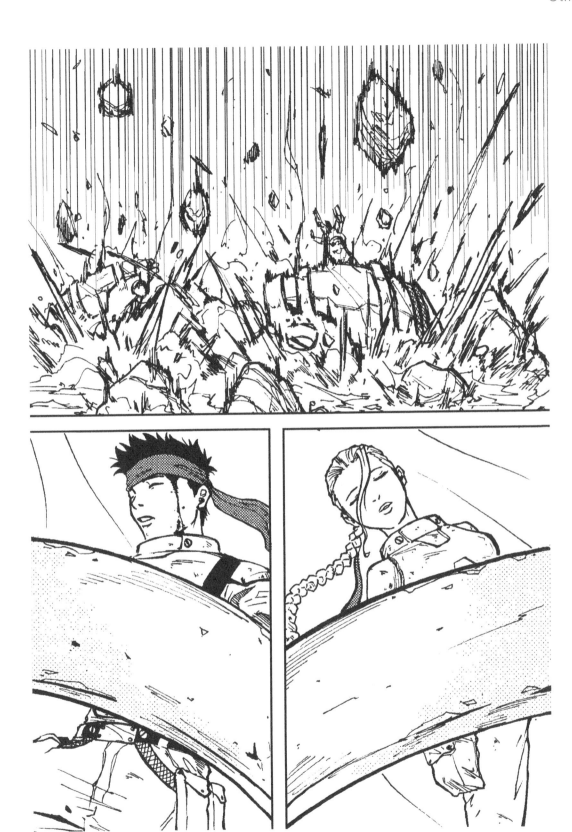

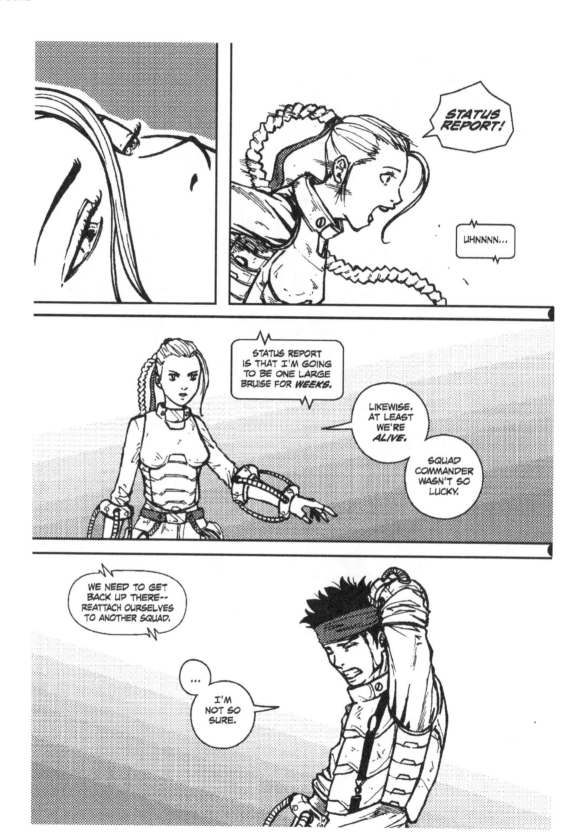

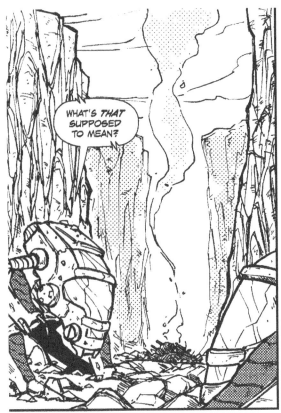

WHAT'S *THAT* SUPPOSED TO MEAN?

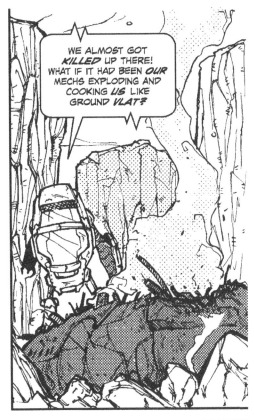

WE ALMOST GOT *KILLED* UP THERE! WHAT IF IT HAD BEEN *OUR* MECHS EXPLODING AND COOKING *US* LIKE GROUND *VLAT?*

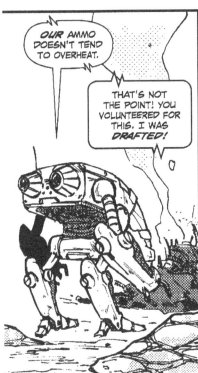

OUR AMMO DOESN'T TEND TO OVERHEAT.

THAT'S NOT THE POINT! YOU VOLUNTEERED FOR THIS. I WAS *DRAFTED!*

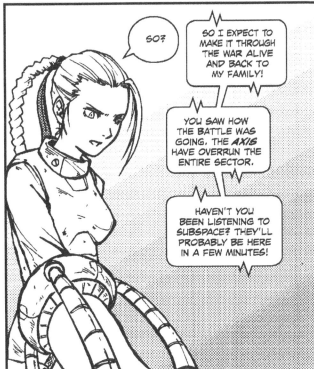

SO?

SO I EXPECT TO MAKE IT THROUGH THE WAR ALIVE AND BACK TO MY FAMILY!

YOU SAW HOW THE BATTLE WAS GOING. THE *AXIS* HAVE OVERRUN THE ENTIRE SECTOR.

HAVEN'T YOU BEEN LISTENING TO SUBSPACE? THEY'LL PROBABLY BE HERE IN A FEW MINUTES!

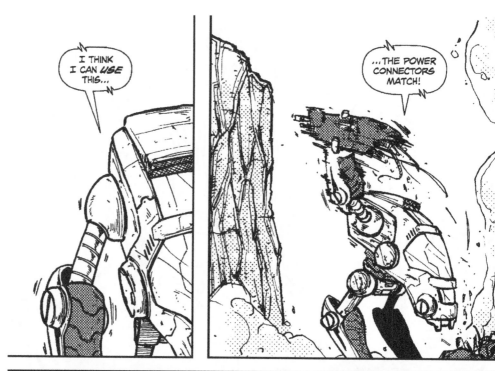

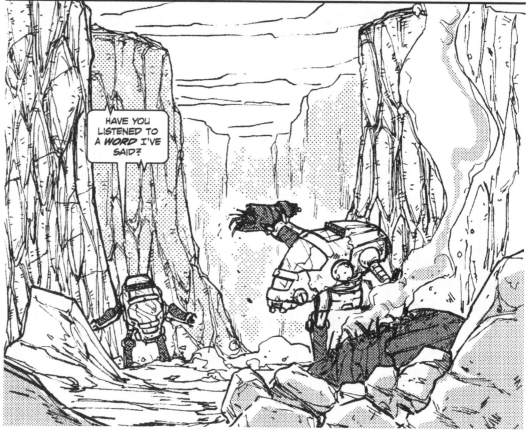

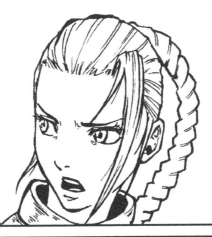

I HEARD YOU. YOU WANT TO RUN *AWAY*. WELL, *RUN AWAY*, THEN! *DESERT*, FOR ALL I CARE!

I SIGNED UP TO FIGHT. IT'S WHAT I WAS BORN FOR. IT'S WHAT MY PARENTS RAISED ME FOR.

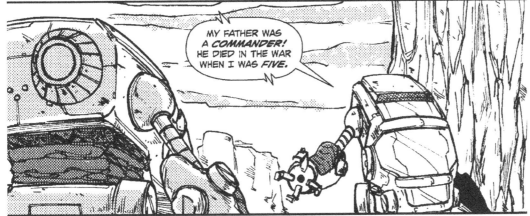

MY FATHER WAS A *COMMANDER!* HE DIED IN THE WAR WHEN I WAS *FIVE*.

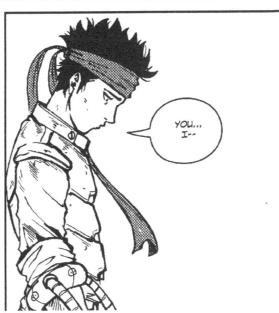

FIGHTING IS ALL I KNOW. ACTUALLY, I *DO* KNOW ONE OTHER THING. I'M GOING TO DIE DOING THIS. BUT I'M GOING TO TAKE AS *MANY* AXIS WITH ME AS I CAN!

YOU... I--

122

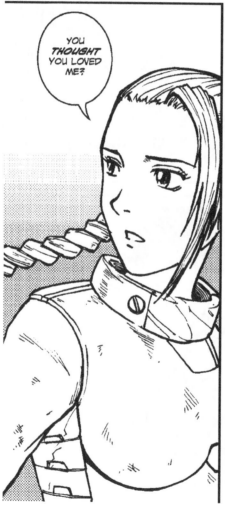

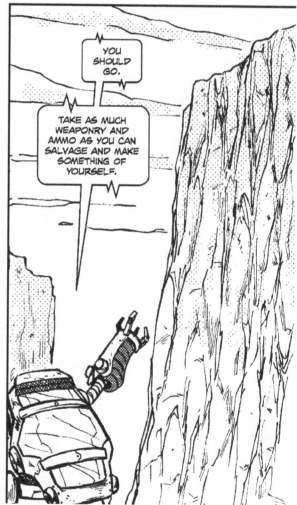

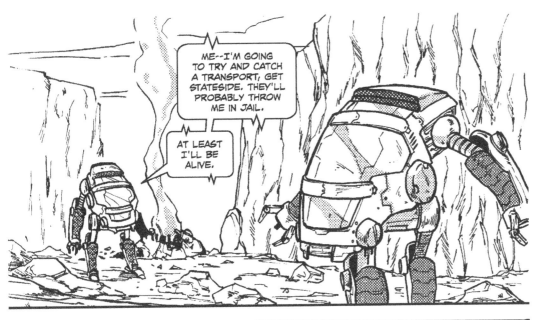

124

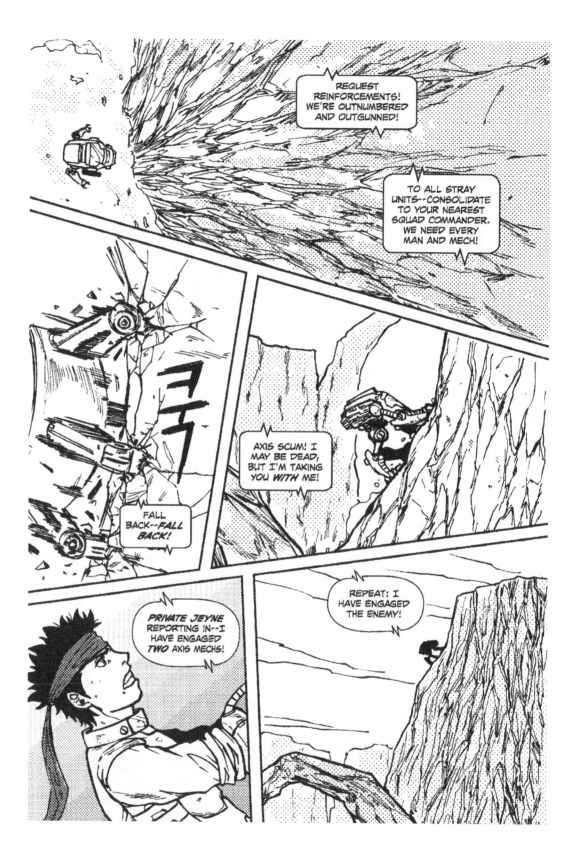

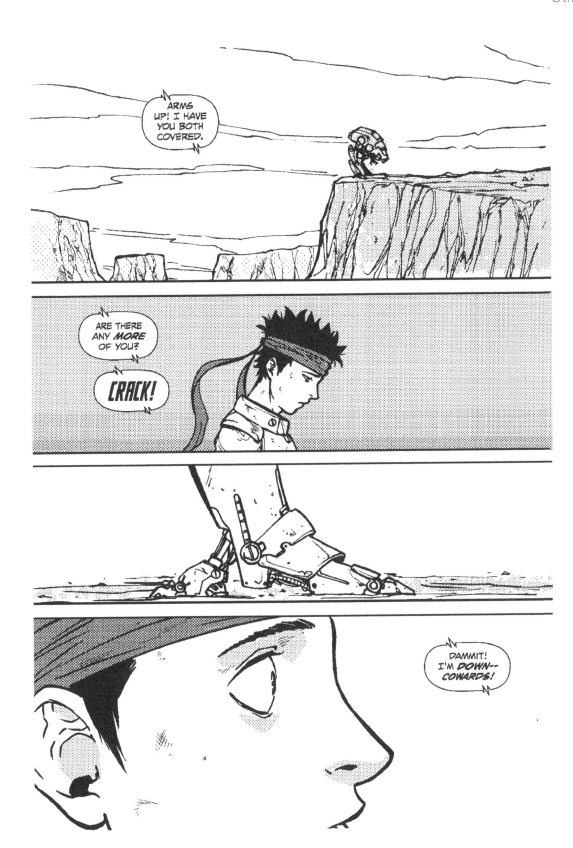

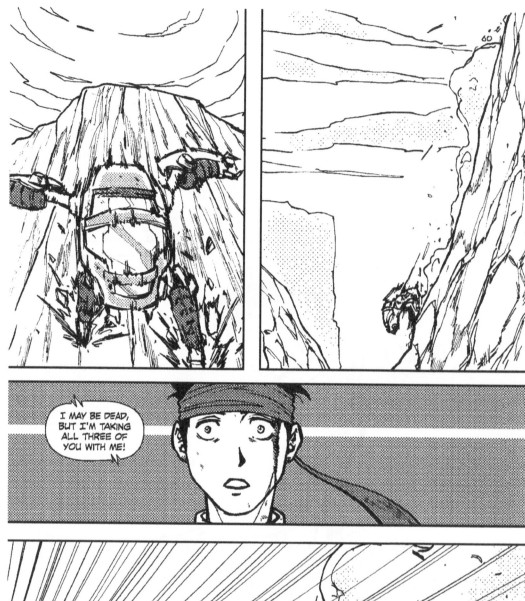

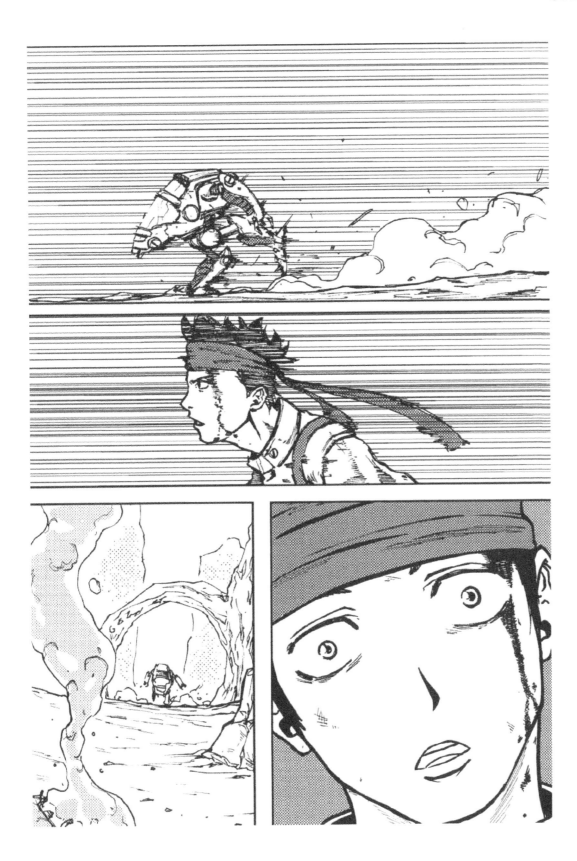

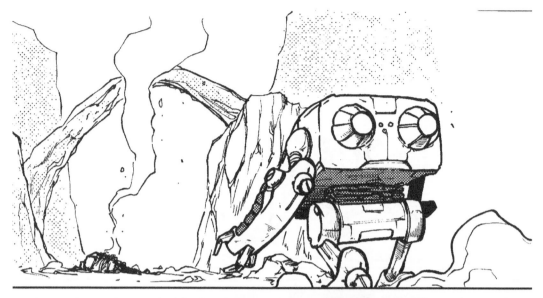

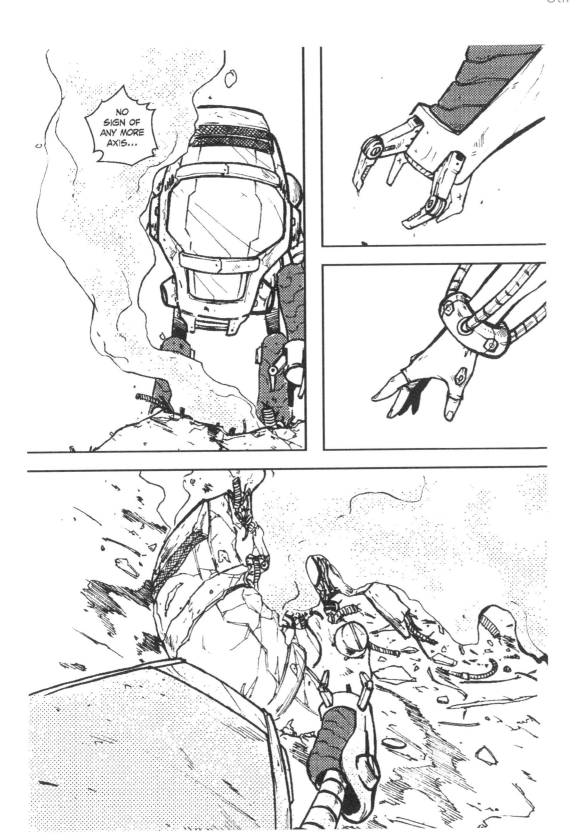

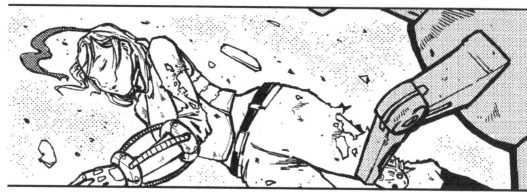

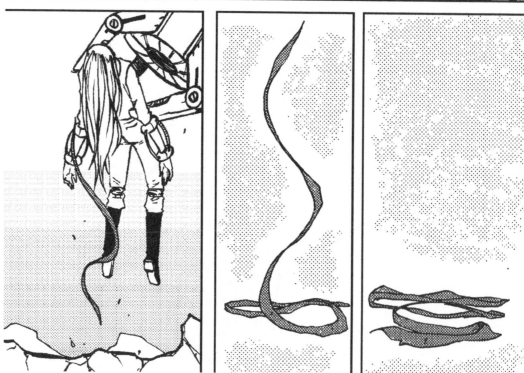

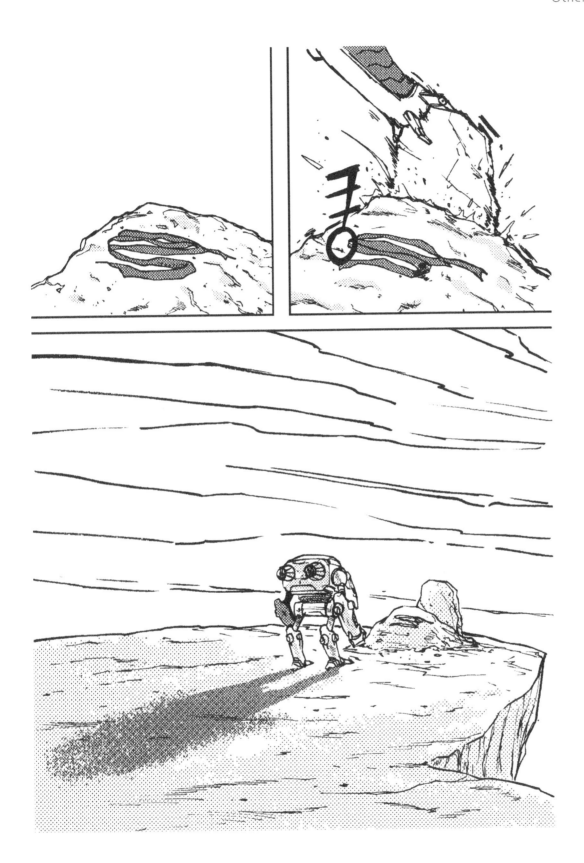

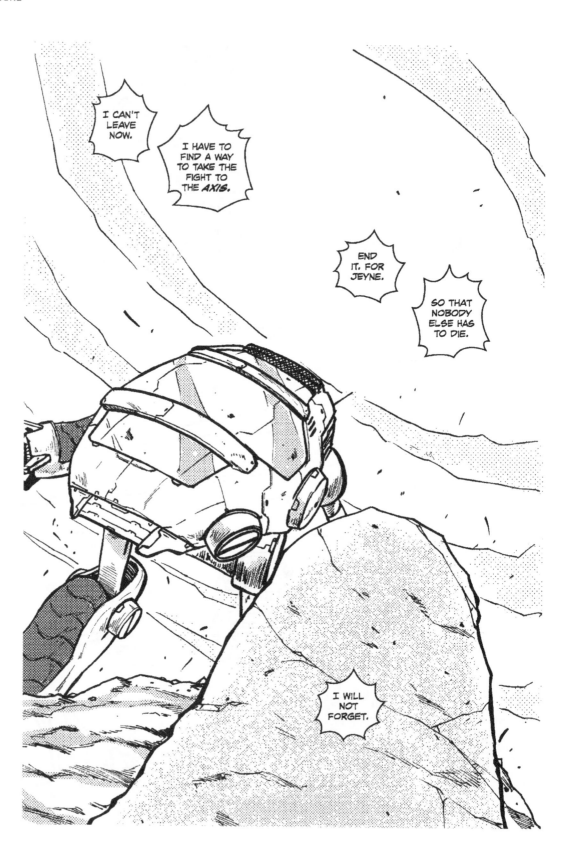

Single Panel Elements

The primary component of manga storytelling is what goes on within the borders of a single panel. To use a film analogy, you're acting as the cinematographer. The cinematographer chooses camera shots, framing, angle and lighting. In other words, what happens in a single manga panel. The director then uses these elements to tell his or her story effectively—from one panel to another, which we'll talk about in Chapter 11. The analogy doesn't fit exactly, sure, but it works for our purposes. Using the same terminology that film does also makes it easy to communicate, even if there isn't any camera. We're going to first put on that cinematography hat and discuss the choices you can make within a panel, and why you should make those choices.

ESTABLISHING SHOT

New scenes usually start with an establishing shot. The establishing shot is a depiction of the outside of a house, a car, or other setting. In our manga example, *Other Side of the Tracks*, the setting is a desert with rock formations similar to those found in Arizona.

The purpose of an establishing shot is to orient the reader and give them a sense of where the scene takes place. Beginning a new scene without this shot leads to confusion and disorientation, so it's highly recommended.

Establishing Shot Dialogue and Captions

In that first establishing shot panel, it is perfectly acceptable to start the scene's conversation. Often, this is done with speech balloons without a tail, indicating that the speakers are inside, rather than outside. Though the reader may be momentarily unsure of which balloon belongs to which person, these balloons can bring the reader into the conversation from the very beginning of the scene.

An establishing shot in a location unfamiliar to the reader can be accompanied by a caption that explains the location, and perhaps also the time and date. Maybe even the world the scene takes place on, if you're going the science fiction route.

Coming Back to That Same Scene

When returning to the same location as an earlier scene, an establishing shot is still advised. Don't just repeat the identical shot from earlier, either. Consider a different angle or frame

for this version of the building or whatever setting it is. One idea is to show the repeated establishing shot closer up, as the reader will be familiar enough with it not to need that wide shot for identification.

In this case, the earlier setting caption need not be repeated. It's up to you if you think it will confuse the reader by its absence.

Pro Manga Example

Here's an establishing shot from *Other Side of the Tracks*—page 1, panel 1. There are rock formations and the sun is bright. Artist Jeong Mo Yang even adds a lizard in the foreground for a nice touch that really drives the setting home.

CLOSE ON: BREAKING THE ESTABLISHING SHOT RULE

Once you're an expert at establishing shots—you've used them and you're familiar with their proper placement—it's now time to break that rule. One of the most popular methods for starting a scene apart from an establishing shot is the "Close On." It's used like this in a script: "Close on a mechanical hand grasping a twisted piece of machinery." A Close On tightly frames an important object in the scene. What it does is focuses the reader's attention on that specific object, person or bit of action. In the very next panel, the camera pulls back to reveal the entire scene and the context for that action.

Close On can also start a scene with the character's eyes, especially if they display a strong emotion. In the next couple of panels, we learn why that character is feeling this way.

The Close On method is quite a bit more disorienting than the establishing shot and shouldn't be used every time. This method is still useful, though, for the following reasons:

Supported with some dialogue or a sound effect, this shot can be linked to the previous scene. See Chapter 12, "Page to Page" for more on linking.

It disorients the reader a bit and makes them immediately move on to the subsequent panels to figure out what's going on. The following panels must show what is happening.

It's a cool effect to start on someone's eyeballs in a tense situation!

It lets you focus on the thematic element in a scene, to call attention to a specific object throughout the scene.

Yes, Close On can be used independently of the establishing shot, at any time. It's often used to end a scene for dramatic effect.

Careful with all the zooming in and out, though—the medium shot should still be your bread and butter.

Pro Manga Example

In Page 12, Panel 2 of *Other Side*, we use the Close On trick to focus on Keil's mecha as it drives itself into the rock face. In Panel 3, we pull further out to witness the mecha climbing up the rock.

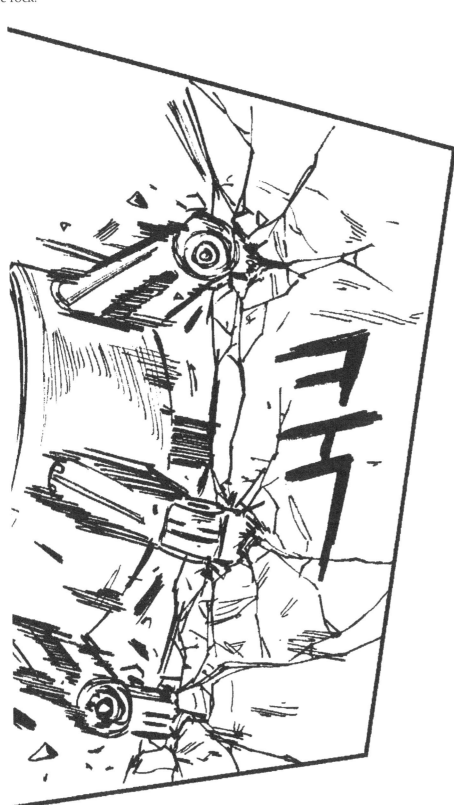

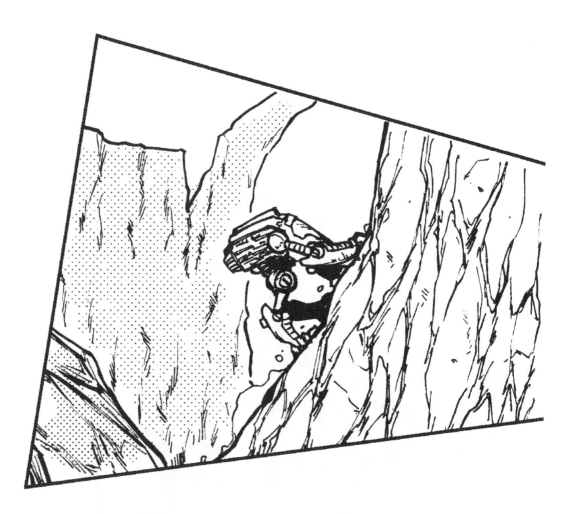

THE REST OF THE SCENE

After the establishing shot, you'll be concerned with how you frame the action. How a particular panel is framed can be important for effect, emotion and mood. Framing a scene closer focuses the attention on specific characters or elements and blocks out parts of the scene that are extraneous. Framing a scene further out is good for crowd scenes. Framing a shot in between is the default, and is used most often.

Therefore, there are three basic shots you'll be making use of: the close-up, the medium shot, and the long shot. There are also angles and views to consider within those shots.

CLOSE-UP

The close-up is where your imaginary camera focuses and zooms on a particular person or object in a scene. For a person, it's usually the head and shoulders, or in the case of an extreme close-up, the eyes or the mouth. A close-up is useful to frame a panel on a person speaking or manipulating an object. If a person has another person by the collar and is yelling at them, a close-up of just those two angry characters focuses the reader's attention on them without distractions.

A close-up can sometimes be followed by a panel with the same shot, but further out. For example, you draw a close-up of a person cutting through a pane of glass. In the next panel, you pull out to continue the conversation between the thief and his cohort.

Pro Manga Example

In this panel from *Other Side* (Page 2, Panel 4), we've closed in on the mecha's foot as it's backed up all the way to the edge of the cliff. A few pebbles are scraped off the edge. This close-up really drives home the point that the protagonists are really backed up against the wall—except that there's no wall, and only one way out. That way happens to be really far down!

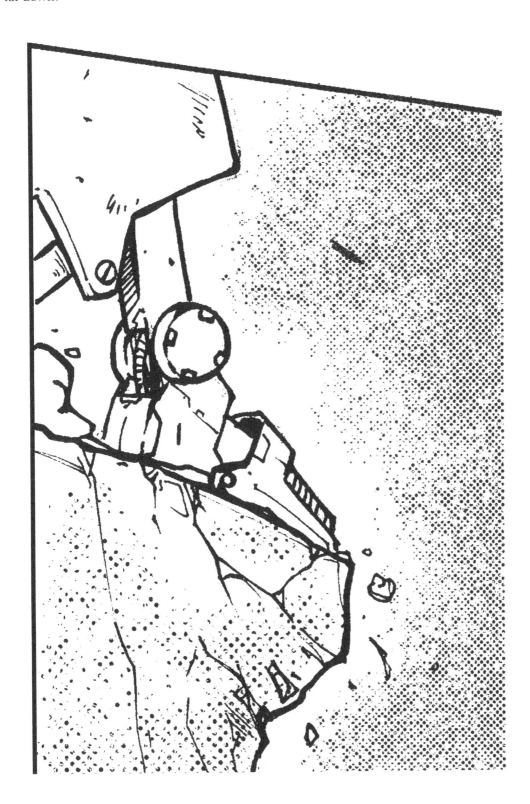

137

MEDIUM SHOT

The medium shot is the standard bread and butter shot. In the case of a person, it's usually a head-and-shoulders shot. The medium shot is the most frequently used, but constant use of the medium shot, or any shot, can make your manga sterile and boring. Medium shots are neither too close nor too far and can either include part of the background, or drop it as manga frequently does.

Pro Manga Example

This medium shot of Keil from *Other Side* (Page 6, Panel 4) is from the top of Keil's head down to his waist. Note that there is space above his head, and the head isn't cut off by the top of the panel. This panel does a good job of leaving enough room for dialogue, while also giving the figurework enough room to breathe in the panel. If this panel had been framed any closer, we might not have been able to tell that Keil's arm is up over his head.

LONG SHOT

Long shots take in much more of the action. A person in a long shot would be visible from head to foot and could take up most of the panel, or be as tiny as a dot. These shots help re-establish the scene and the position of the characters in it. The long shot can be used to show where two characters are in a room, or increase the chaos of a crowd scene. You might use a long shot after an escapee gets away from the police in a crowded parade. To show the silence of a quiet afternoon, you might show a long shot of the meadow while your character sits under a tree at the edge.

In a long shot, it is still often advisable to consider carefully the contrast of the characters in order for them to stand out in the scene. You don't want your readers playing *Where's Waldo*. Making the characters a darker or lighter shade is a good way to identify them. It can be easy to lose the characters if they are small and surrounded by a complicated background.

Pro Manga Example

This is a long shot from Page 13, Panel 1 of *Other Side*. Keil's taking a break from his long mountain climb and listening to Jeyne on subspace chatter. This shows where Keil is on the mountain so the reader will be updated on his progress. It also creates a natural break in the action. The reader naturally pauses longer on this panel as a long shot than he or she

would if it were a close-up because of the amount of negative space. If it were a close-up, we wouldn't know that he had completed his climb.

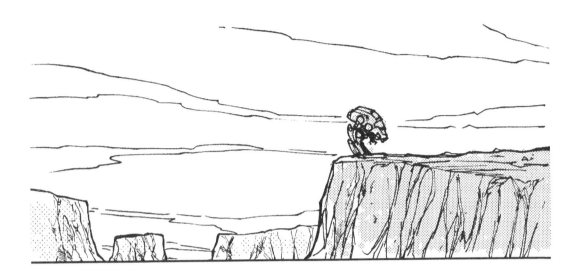

LOW ANGLE, HIGH ANGLE

The angle of a panel is where the imaginary camera would be in reference to the focus object—often a person. The angle of a specific panel matters. A low angle is when the audience is looking up at an object from a low vantage point. The low angle creates a sense of importance and can be used to emphasize a great importance or power of a character. Low angles can also be used to make a threatening character seem more powerful compared to a fallen character. Think of a villain holding a gun over a kneeling hero. We focus on the power the villain wields by using a low angle and looking up at him over our hero.

High angles are the opposite—when the audience is looking down on an object from above. By looking down, the high angle creates a feeling of diminished power. A character that has just been beaten by his adversary, for example, would look more defeated just by moving the camera above his head. The previous example of a gun-wielding antagonist fits here too, but this time we focus on our hero. From above he looks helpless.

Pro Manga Example

This is a low-angle example from *Other Side* (Page 4, Panel 4). Keil, Jeyne and the enemy mecha are falling from the top of a cliff, after the impact from the micro-rockets has cracked the cliff into pieces. If we were in the scene, we would be at the bottom of the cliff looking up. This low angle emphasizes the immense height they've fallen from, while at the same time allowing the characters to be in the foreground. A shot without a normal angle would simply show they've fallen without dramatizing the cliff.

139

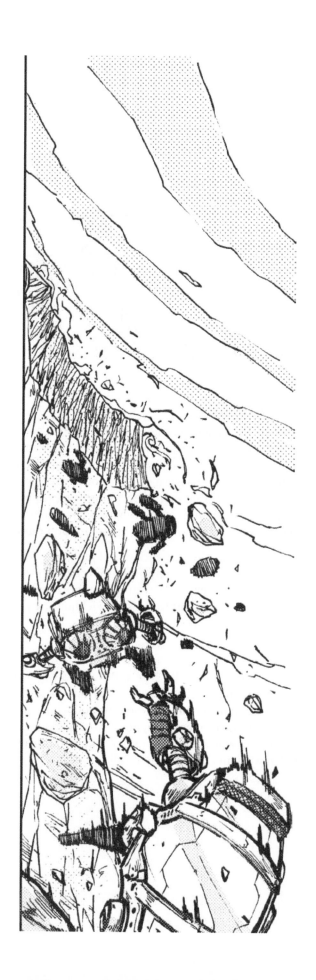

BIRD'S EYE VIEW AND WORM'S EYE VIEW

A bird's eye view is a scene from way up in the air as though flying over the scene. This type of shot is often a cityscape, seen at an extreme angle to show the placement of buildings. This point of view is usually looking straight down or close to it. These sorts of views are good for establishing shots, if it's important to know the lay of the land. Think of it as a map view.

A worm's eye view is similar to low angle, but taken to an extreme. It's from the point of view of a worm, looking up at a great height. It's used to accentuate something tall and make it look even taller.

Pro Manga Example

Here's a bird's eye view example from Page 12, Panel 1 of *Other Side*. From the above, near the top of a great rock formation, we're looking straight down on Keil's mecha. The climb looms above him. The bird's eye view emphasizes this challenge by showing the reader how small Keil's mecha is compared to the rock formation.

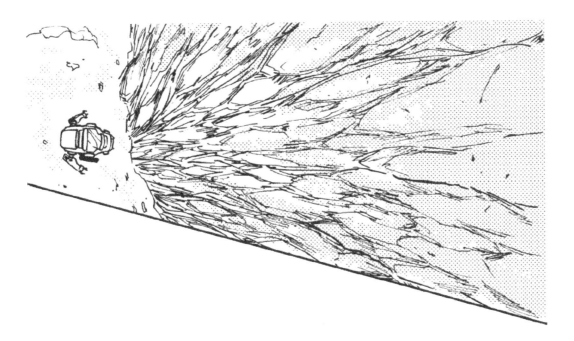

141

SINGLE PANEL ELEMENTS: FINAL NOTE

The choices you make in regards to establishing shots, angles and views go a long way toward making your manga clearer, more readable and more professional. Before telling a story from panel to panel, it's important that each individual panel looks the best it possibly can.

Panel to Panel Storytelling

Nearly as important as how a single panel is composed is how you design the composition of a page, and the transition between one panel to the next. This panel-to-panel work is where you really tell your manga story and how it comes alive.

PAGE COMPOSITION

When you lay out a manga page, the number of panels you put on it goes a long way toward determining pacing, mood, excitement and feel. In general, manga has fewer panels per page and thus takes longer to tell a story than its western counterpart. One reason for that is format, as many manga go on for multiple tankōbon volumes before arriving at an ending. See Chapter 14, "Formats & Sizes," for more information on the types of formats you'll be writing for.

143

Panel composition ranges from the single-panel, or splash page, to nine or more panels. Most manga tops out at six-panel pages and uses splash pages rarely, with most pages falling somewhere in between.

SPLASH PAGE

This single-panel page is often used to open or close a chapter, or will sometimes appear throughout the story when an especially dramatic or exciting moment takes place. The climax of the story is often a splash page, as is the denouement (see Chapter 13 for more on these and other writing conventions). Splash pages should be used sparingly to highlight the most compelling elements in your story. Overuse tends to slow the pace too much, since fewer different things can happen to the same objects in one panel versus many panels.

For a change of pace, a splash page can have one or more inset panels. If a splash page is acting as an establishing shot (see Chapter 10), then an inset panel can serve as a close-up of the characters inside the setting, and the story can get a head start on the dialogue going on in there.

THE SIX-PANEL GRID

A good starting point when composing a multiple-panel page is to begin with six panels of equal size. You could just do the page like this, but that'd be static and boring. To make

the page you want, remove panels and panel borders down to 5, 4, 3, or 2 panels in various combinations. (Some manga even do circular or slanted panels.)

A bigger panel is good for a long shot, establishing shot, or for any shot that also needs a lot of room for dialogue. Also, the most important or exciting moment on a page will often be larger. In general, the larger a panel, the more time passes in the audience's perception.

A panel smaller than a six-panel page panel is good for a Close On or Close Up (see Chapter 10). In general, the smaller a panel, the quicker it takes place. So quick actions work better in small panels.

How many panels should go on your page? It depends on many factors. The amount of dialogue and back-and-forth between two or more characters can push the panel count up. A fast-paced action scene can push the panel count down, to make room for large, impressive action panels. It also depends on what kind of story you're telling. A drama with a lots of dialogue and emotion tends to have more panels per page, punctuated by an occasional splash page during the big break-up scene, for example. An action-oriented fight manga generally has fewer panels per page as the story speeds through one or more long fight scenes, with little dialogue.

You might be asking yourself: How can a fight manga seem faster with fewer panels? Didn't we just say that that the larger a panel, the more time passes?

The answer is that this type of manga seems faster because of the dramatic way in which it's drawn. It's like how slow motion in a movie actually seems to increase tension and the pace of a scene. It creates a fascinating effect, because although every key moment, or beat, in a fight scene may have one or more panels devoted to it, it still feels faster than the fewer pages of a Western style.

Pro Manga Example

Here are several *Other Side of the Tracks* pages, the number and shape of the panels, and why we made the choices we did.

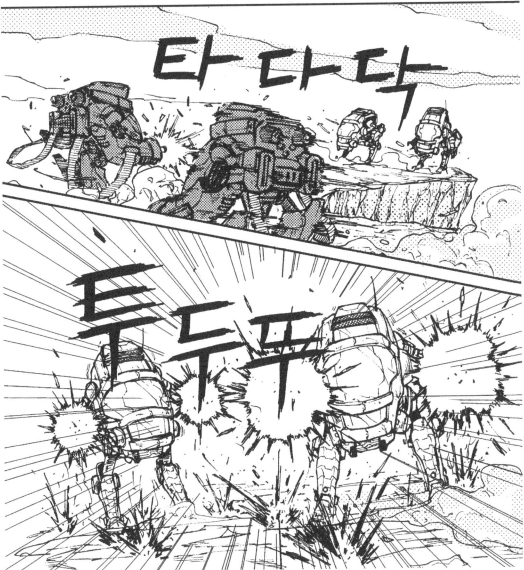

This is the three-panel layout starting with the establishing shot. The second panel is a long shot to show the action. Having the panel large allows the reader to understand the placement of the mecha in the background. The third panel is an angled panel border to accompany the chaotic action scene. The reaction shot is large, because it's our first good look at the mecha.

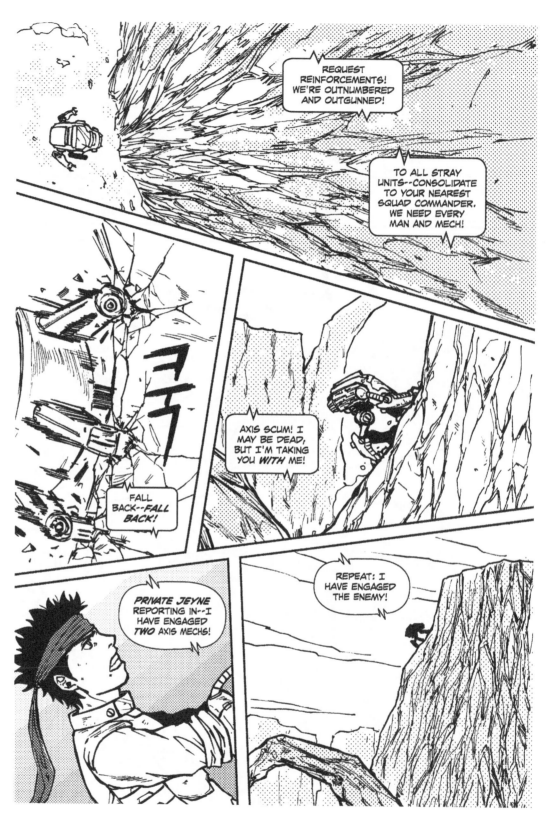

One of the most complex pages in *Other Side*, is a five-panel montage sequence of Keil climbing. By varying the angles and shots, we made his mountain climbing more compelling. The close-ups and varying long shots help drive in how intense the climb is. If it was a single panel, the strain wouldn't be obvious.

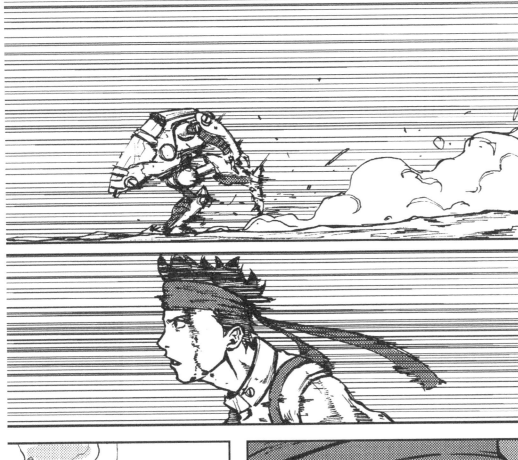

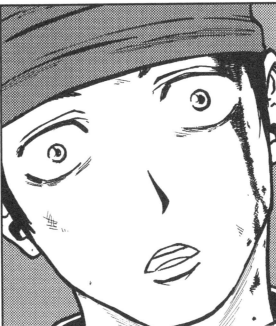

This four-panel page begins with two panels in a strip across the top, in parallel (see the "Panels in Parallel" section) and then turns to a long shot followed by a close-up. This page sets up the reader to question what is going on, by building up to the final reaction shot before showing what Keil is reacting to.

148

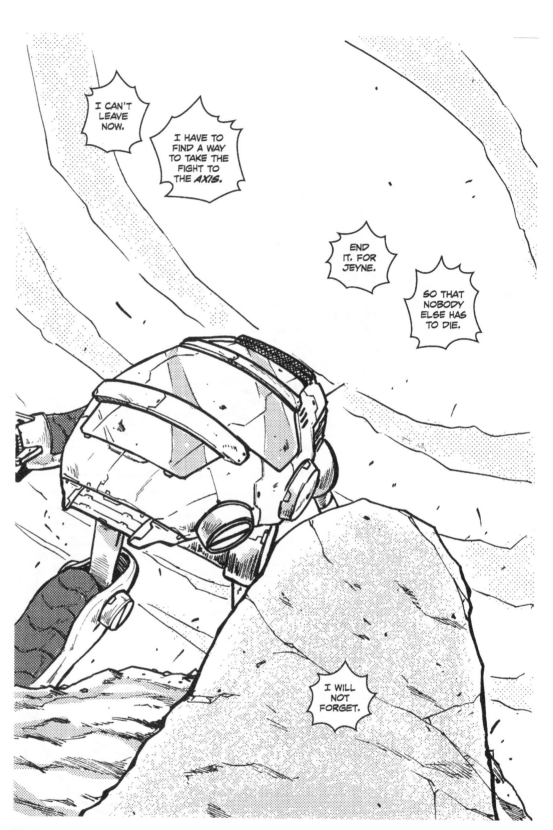

The lone splash page in *Other Side of the Tracks*, this is the denouement, or unwinding part of the scene, after the climax. Making the denouement a splash page gives it time to breathe and gives it finality.

PANEL-TO-PANEL TRANSITIONS

In the previous chapter, we touched on following up specific panels with specific other panels. Here are more examples of that.

CLOSE ON TO PULL BACK

When using the Close On method, the panel immediately following it is often a medium shot that includes the object in the Close On panel, but with more scene around it to give it context.

Pro Manga Example

Here's one example of Close On to Pull Back from *Other Side*.

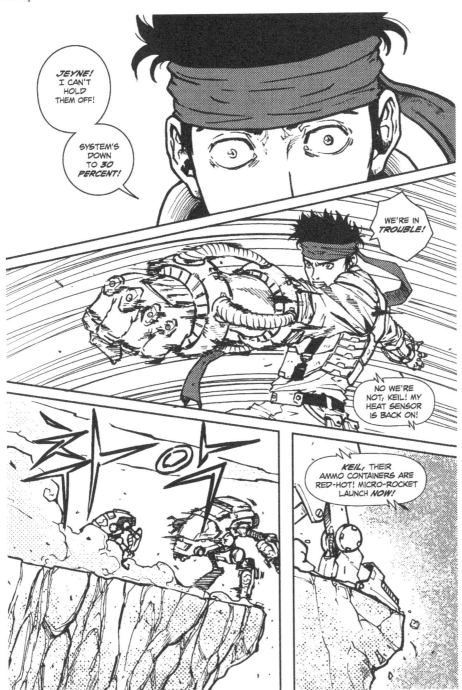

149

In the first panel, we close on Keil's eyes as he begins to panic. This is out first glimpse of Keil in the entire story. In the next panel, we pull back and get a good look at Keil's environment.

LONG SHOT/MEDIUM SHOT TO CLOSE-UP

When a something surprising happens to a character in a long or medium shot, it's often a good idea to follow with a close-up of the character's reaction. You can even spread out the realization over the entire page, pulling the camera in closer and closer, as if the character can't believe what he or she is hearing. Often, the character deciding to act on this stimulus is reserved for the top of the next page—in Chapter 12, "Page-to-Page Storytelling," we go into ending a page with a shock or surprise and following it up with action on the next page.

Pro Manga Example

In this pivotal moment from *Other Side*, subspace chatter reveals that Jeyne has engaged the enemy. We begin with a long shot as Keil is listening to this. In the next panel, she has

150

The camera moves in closer to Keil as the tension increases.

her gun arm trained on two mecha, but things go bad very quickly, as she's ambushed by two others. Keil's straining to listen to what happens. In the next panel, there is no radio transmission as the panel closes on Keil's foot, signifying that he hasn't taken a single step since this started. In panel 4, Jeyne comes back online, but she's down, radioing her final words. Keil's eyes go wide as he finally figures out how bad the situation is.

ALTERNATING BETWEEN SPEAKERS

When in a dialogue-heavy scene between two speakers, the panels will often alternate between them. Care should be taken that these alternating panels contain characters in the same order or orientation. In other words, a character in a conversation on the left of the panel should stay on the left throughout the conversation. If that character is suddenly on the right—the camera is shooting from the back instead of the front—the reader can get thrown for a loop. Keeping characters in the same orientation is called the 180-degree rule. In general, characters should be oriented the same and the camera should rotate around the speakers less than 180 degrees.

Also note that characters in a panel should be drawn in the order that they speak in the script. Otherwise, the letterer has to do unsightly gymnastics to make it work. And letterers doing gymnastics of any kind is not pretty.

Pro Manga Example

Here's a back-and-forth conversation between Keil and Jeyne that keeps the 180-degree rule in mind.

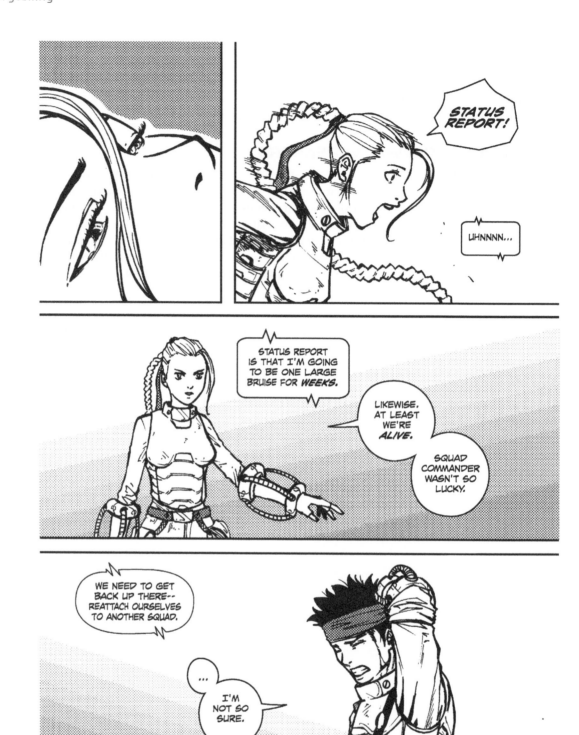

Jeyne stays on the left, and Keil stays on the right. It's clear that they're talking to each other.

PANELS IN PARALLEL

Sometimes when you have two identical panels side by side, you use them to parallel similar events or situations in the same scene. This is done to draw comparisons between the two events—both similarities and differences. Three examples: two characters about to square off, two characters standing apart from each other because neither wants to be the first one to approach, or two characters unconscious by a similar method.

Pro Manga Example

Just after Keil and Jeyne have fallen to the canyon below them, there are two identical, parallel panels showing Keil and Jeyne unconscious in their respective mecha. This also happens to be the first panel where we see Jeyne, so although the situations are paralleled, the character's looks (and, as it turns out, their personalities) are very different.

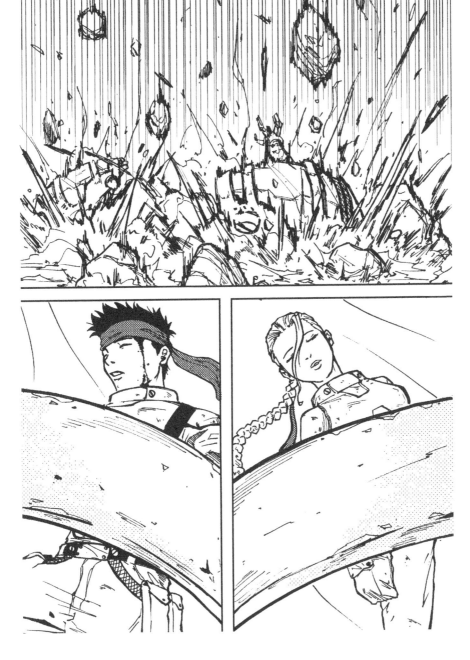

Both Keil and Jeyne were knocked unconscious in their mecha. By having them side by side in similar panels, it is clear they are in the same situation.

PANEL TO PANEL: FINAL NOTE

Mastering the art of panel composition and panel-to-panel flow will make your stories read more smoothly and help the reader stay emotionally invested in your story. The less chance of the reader being jarred out by bad storytelling, the better.

Page-to-Page Storytelling

We discussed single panel composition, then panel-to-panel flow, and now it's time for the really advanced stuff: telling a story from one manga page to another. First, we'll talk about transitioning between one issue or volume to another, then delve into scene changes.

SERIAL-TO-SERIAL

If you're writing for an anthology magazine, the transition between the end of the previous chapter and the start of the new one is important to write well. You want to build in a good cliffhanger, and then resolve it right away rather than opening on a new scene. Why? It's a month between chapters, and fresh on readers' mind is going to be the final events of that last chapter. They're going to want to know how it all turns out. Now, after you resolve that scene, feel free to move on to the subplot.

VOLUME-TO-VOLUME

When transitioning from one tankōbon to the next one, it's up to you whether you pick up immediately after the events in the previous book or sometime later. If you hadn't intended to write a sequel, but sales, popularity or your changing mind dictate one, then consider not starting where the old one left off. You're starting at the denouement, or unwinding sequence, which is a really dull place to being a story. If you intend a sequel all along, and are certain there will be one before Volume 1 is even finished, then you'd be structuring Volume 1 to take advantage of this fact, ending not with a denouement, but a cliffhanger! (See Chapter 13, Writing Conventions, for more on denouement and cliffhanger). In this case, as in the magazine serial, by all means, pick up exactly where Volume 1 left off! Readers have waited months (or even a year or more) to find out what happens. The last thing you want to do is disappoint them.

THE PAUSE THAT REFRESHES

The act of flipping a manga page builds a natural pause in the flow of the story. Many storytellers use the between-page pause as a place to build suspense. For example, a cliffhanger will be set-up at the bottom of a right-hand page. The next, left-hand page will begin the hero's attempt to escape it. Or, to throw things off, the next page will begin with a new scene elsewhere—continuing the subplot.

Timing your pages so they naturally end on suspense is a challenge. Not every right-hand page should end that way, but some should, even in a romance story without any action per se. The dramatic confession, the big reveal and the person saying something they shouldn't have—all often find their home at the bottom of the page. The start of the next page is where the scene changes or the payoff happens, depending on how you have your story structured.

Some writers use that page-to-page transition to pass time in the same scene. One example is if a character is knocked unconscious and wakes up in the same scene, but hours later. (It might be dark instead of light outside.) Or, two characters romantically fall asleep together and on the next page, they wake up (or one of them wakes up and the other is gone!) Or, a guy is waiting for his date to show up. On the next page, 45 minutes have gone by and she's still not there.

Keep in mind that if you intend for something important to happen during that intervening time, don't skip over it between pages and have the characters talk about it. The important moments need to be shown, not told.

SCENE TO SCENE

For the sake of this discussion, we're going to assume that you end all scenes at the bottom of a page and start new ones at the top of a new page. This isn't always the case. Some of the best writers in the business will start new scenes mid-page, especially if they've got a good storytelling reason to do so.

However, that's a rule that should be broken once you've mastered it. For now, a new scene requires a page turn.

LINKING

Going from one scene to another can get ugly and pull the reader out of the story. Here are a couple of dialogue and visual tricks, called *linking*, that can make that transition much smoother.

DIALOGUE LINKING

Two scenes can be linked by creating dialogue links. At the end of one scene, a character will say something that is either directly repeated, paraphrased or the opposite. What dialogue linking does is reinforce the story parallels between two scenes, and can connect the main plot and a subplot. Dialogue linking is often, but not always, used for humorous effect, or to break tension. For example, a girl ends a scene by saying, "I can't stand that guy!" Then, the next scene has the guy telling his buddies, "She wants me." Or, a character threatening another character ends a scene by saying "I'm going to give you the worst beating of your life." In the next scene, two people are playing video games and one says "I'm going to give you the worst beating of your life," but smiling this time. The parallel between the two otherwise different scenes is obvious with dialogue linking.

If the two phrases are identical, you can even trail off the previous scene's dialogue and have the new scene's character inadvertently finish the sentence. For example: in scene 1, a character says, "One thing's for certain…" and in the new scene, in a totally different situation, a character says, "He's not going anywhere!"

This dialogue linking helps keep the reader engrossed and gets them used to a new scene (especially a new scene with brand new characters). That's not to say you should use dialogue linking every time a scene changes, as that would get tiresome. If it looks forced, cut it.

VISUAL LINKING

There are ways to link scenes visually as well. You could end a scene with a photograph or painting, and start the next scene with the subject of that photograph or painting. You can end a scene with a close-up of an object, and then start the next scene with that same object, or a similar object in a new context. Or, a character could be knocked out in one scene, and wake up in a new scene, in more-or-less the same position, but tied up. Creating visual metaphors is one of the finer points of storytelling.

Pro Manga Example

In this two-page sequence from *Other Side of the Tracks*, Jeyne's signature ribbon floats down from her lifeless body, alluding to the fact that now she's gone, so the ribbon has no place on her anymore. On the next page, the ribbon is in the same position, but is now on top of Jeyne's grave as Keil smashes in a makeshift gravestone.

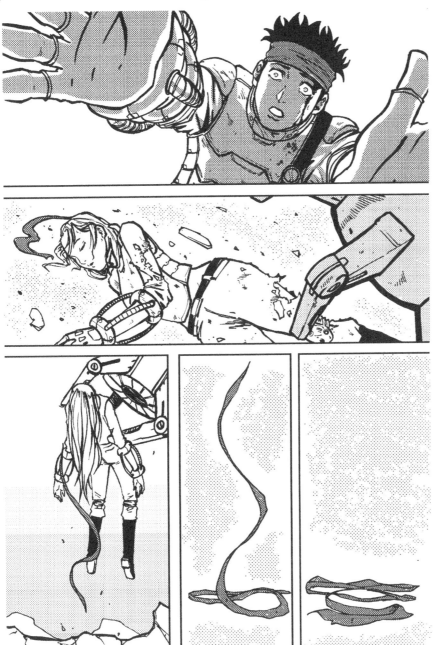

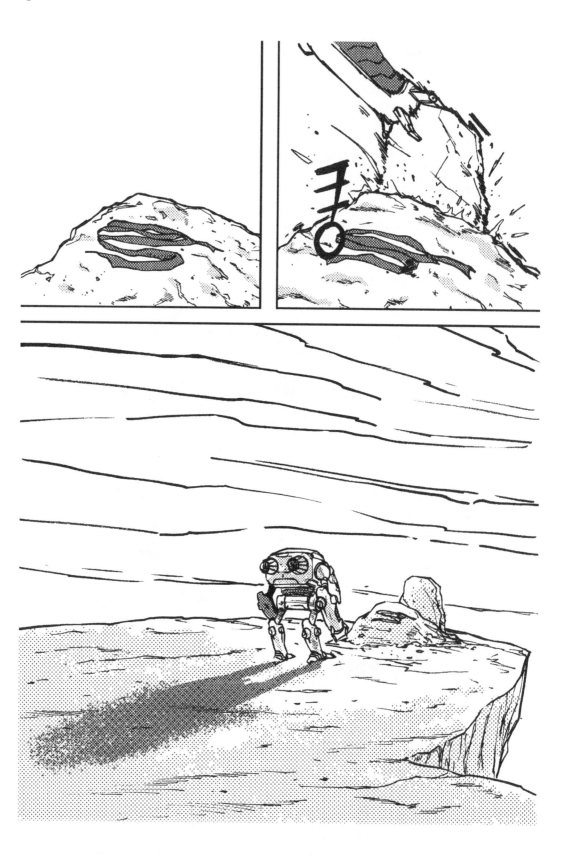

This ribbon symbolically links the two scenes together and gives them emotional weight. We can infer that Keil placed the ribbon there as he might place flowers, to show affection for the departed.

PAGE-TO-PAGE STORYTELLING: FINAL NOTE

By smoothing out scene changes using linking techniques, using the page-turn as a dramatic pause or to pass time, and transitioning between serial chapters and book volumes effectively, your stories will be more fully realized. All remnants of amateurish or newbie storytelling will be swept away. You're in the OEL business to tell stories, have fun, increase your writing an artistic skill, and earn a living. Mastering these and other techniques will make all that easier.

Writing Conventions

All dramatic writing has patterns. Unfortunately, one drawback of knowing these patterns well is the ability to spot them at will in television, movies, plays, and so on. Fortunately, it is still possible to switch off this knowledge and enjoy the show. When writing dramatic fiction, especially good manga with quality storytelling, though, it's important to both know of and be able to use these patterns. Constructing consistent, believable and interesting stories demands it. These patterns, such as the three-act structure, are easy to learn but difficult to master. Ignore them at your peril, because your story will suffer the consequences.

THE THREE ACTS

Most works of fiction follow the three-act structure. In the first act, the characters and setting are introduced and the ultimate goal of the story is described. In the second act, the characters strive for that goal and run into conflict. This act is usually the longest and the conflict continues to build to the third act's climax. In the third act, the goal is reached, the characters react to this, the conflict is resolved, and there is a resolution of some kind.

Often, writers will not be consciously aware of this setup-conflict-resolution sequence while writing, and it will come naturally. Most writers, though, will need to force their stories to fit this way. Locking your story into this structure, at least at first, will serve to tighten it up and prevent too much meandering. Knowledge of the three acts will also help you reach your ending in time. Nothing's worse than running out of pages before a definitive ending!

More advanced writers, with knowledge and experience of the three-act structure, can then decide to bend the rules a little bit, especially when writing in nonlinear fashion. What's that? Think of one of the best examples: the movie *Pulp Fiction*. This movie is shown out of sequence, so that scenes where characters die are shown to us before scenes where characters are alive and well. Though there are examples of three acts within each little vignette, there's no overall three-act structure: director Quentin Tarantino has broken it in pieces.

Unfortunately, this led to many directors attempting the same style and nonlinear storytelling and failing miserably. Again, stay grounded in the basics before you get too adventurous. The structure should rule all. That's not to say that there isn't a lot of room for creativity. Structure sounds like such a rigid word, but really, all it's doing is keeping your plot from leaking out of the edges.

Pro Manga Example

Other Side of the Tracks, the manga short story at the center of this book, is an excellent example of three-act structure. The first five pages are Act 1, the introduction. Keil and Jeyne are two mecha pilots in the eye of the hurricane, recovering from a brutal war skirmish. Both pilots are about to head back into the fray once more. The next six pages are Act 2, the rising conflict. Keil wants to go AWOL and attempts to convince Jeyne to leave with him. We discover Keil has feelings for Jeyne that are not really reciprocated. The arguing escalates and Keil leaves on his own. The next nine pages are Act 3. This act ends with a climax: Jeyne rejoins the combat and is destroyed. Keil, who has changed his mind and tries to catch up, witnesses the destruction. The final two pages of Act 3 are the resolution. Keil realizes that his leaving caused Jeyne's death, and vows to not only fight on, but also do what he can to end the war—for her sake and his own!

THE STORY ARC

If one set of three acts can be called a story, then multiple related stories are called a story arc.

The entire series should have a solid, cohesive continuing arc. When the series is over, this overall continuing arc should end just like a shorter arc would. The longer the series, the more frequently the shorter arcs are used as mini-stories, while advancing the long-term arc all the while. These shorter arcs have a beginning, middle, and end and the same three-act structure as a longer arc.

Since most Japanese manga consists of short stories of about 20 pages in length, each of these chapters contain one or more acts that make up the story. When the story is collected into tankōbon, it then contains one, or sometimes more than one, complete story arc.

For example, in *Love Hina*, the main character's ultimate goal is to track down his long-ago sweetheart, whose face he can't remember and whom he promised to find someday. That's the overall story arc. The shorter arcs are about him dealing with the girls who live in the place he manages, determining if one of them is, in fact, his sweetheart, making it to college, and so on. Picking one story arc, there are several stories involved in his quest to make it into college.

When a series spans multiple volumes, it's also easy to spot this structure across the entire length of the series. There's one big, gigantic story arc across the entire life of the series, several shorter arcs that make it up, and lots of stories that make up each arc.

Since you'll likely be writing directly for the tankōbon format and will very likely not know if your series will span more than one volume at first, you'll want to have one complete set of three acts in your book, with one or more story arcs fully resolved by the end. That's not to say that you can't leave the ending or part of the story open for a possible sequel.

If your series makes it that far, feel free to introduce a new arc in Volume 2, even if you end up picking up threads in Volume 1 that readers thought had been resolved. Again, if you left things at least somewhat open in Volume 1, you'll have an easier time. One of the major complaints about the *Matrix* movie sequels is that they seemed to follow unnaturally from an original movie that had a satisfying, definitive ending. If you and your editors agree that the first volume was a complete story, and it'd be weird to pick it up again, don't! Start over with something new.

Pro Manga Example

Other Side of the Tracks contains a single story arc, told from beginning to end in 20 pages. There are hints that this story is part of a much larger tapestry, but it also works as its own specific story with no connection to anything else.

RISING ACTION

The concept of rising action is simple. The biggest and best action moments, the most dramatic conflict, the awesome twist in the story—these things should not be frontloaded toward the start of the book. Save them for toward the end, and build up to your book's most awesome moments with a series of still cool, but lesser setpieces. Your story's climax should be ideally the biggest or most interesting thing that happens in the entire thing. Rising action, then, means that a series of story happenings occur that become bigger, more interesting, and/or more exciting as the story goes, until the biggest thing happens near the end.

Not at the end, though—after the climax comes a bit of the story at the end, called the resolution. Often the resolution can be only a few pages, or it can be an entire chapter or volume all on its own. In anime terms, the final episode or two episodes of the series almost always contain the resolution.

Pro Manga Example

Other Side of the Tracks has an easy example of rising action. It's a quiet period in between war skirmishes, and the action rises to an argument between the two combatants. The action rises further when Jeyne joins the fighting and climaxes when she is killed. The final act involves the consequences of the action, which has already risen as far as it will go.

THE MAIN PLOT AND SUBPLOTS

Every story arc should have a main plot running through it. This main plot takes your characters from the starting point to their eventual end. Everything that services the ultimate goal of the story is part of the main plot. The subplot is a side story that is sometimes tangentially related to the main plot, sometimes critical to the main plot, and sometimes seemingly unrelated to the main plot altogether (until later, when we find out that the subplot was not told in isolation). In other words, often a story arc's main plot will have been previously introduced as a subplot in a prior arc. These subplots then become the main plot of the current arc.

163

A story arc can often continue a main plot that started in an earlier arc and will end in a future arc. This particular arc, though, concerns itself mostly with a specific, standalone subplot. Let's use an example from television. The TV show *Supernatural* generally has two kinds of stories. The creature-of-the-week story has a supernatural-based mystery that Sam and Dean must solve. Often bits of dialogue or a single scene will pay lip service to that season's main plotline, but the goal of the episode is to defeat the villain. The other type of story is the plot story, which advances that season's main plotline a certain distance. While there may be one or more creatures in this story, the point is to advance the characters inexorably toward the season finale.

Most series have several subplots that "boil up" to become main plots throughout the series. Some subplots never "boil up" to a main plot, but must still be resolved in their own way at some point during the story.

In manga terms, a story arc where the subplot is the main focus is like the creature-of-the-week story on television. The story arc that advances the big main plot from point D to point E is like the plot story on TV. Note that there is some crossover. The subplot story, as mentioned before, will have dialogue or other bits of the main plot in it. The main plot story will often include what's called a teaser scene at the end that introduces the subplot for the next story arc. Juggling the main plot and subplots effectively, without losing track of either one, is a challenge. It helps to use index cards or outlines to force yourself to move plots along. Don't be the guy or gal who introduces a kick-ass subplot and then forgets to follow up.

CLIFFHANGER ENDINGS

A cliffhanger ending is where the protagonists are caught in some kind of conflict or dilemma from which there seems no solution or escape. If things progress as they naturally would, the characters would die or suffer irreparable harm. It seems as if an extraordinary effort is required for the characters to get out of the situation, and the solution is not immediately apparent.

Speaking in terms of the three acts we just mentioned, the cliffhanger ending can happen anytime during Acts 1 and 2, and one final time during Act 3's climax. Usually, the cliffhanger ending happens at the end of a book's chapter, or at the end of the comic book in that format. Serialized stories in an anthology, especially, are a natural fit for the cliffhanger ending, as there is a natural wait between that segment of the story and the next chapter, and a good cliffhanger ending will make the reader want to pick up the next anthology just for your story.

Feel free not to overdo the cliffhanger, though. If you reach the end of an issue or the end of a chapter and a cliffhanger doesn't naturally present itself, try a different sort of ending. It's possible to even fit a dramatic subplot resolution at this point in the story. It's all in how your story seems to work for you. Don't force something in here that doesn't fit.

MANGA SCRIPTS

While working out your story arc and plots, it's important to learn to write in comic script format—especially when working as part of a team. Even single manga-ka have found it helpful to go ahead and script out the story, in order to give themselves some structure before the drawing pencil hits the paper.

Manga scripts are similar to scripts written for television, movies, or plays. Take a look at this script excerpt from *Other Side of the Tracks*. Note that you'll find many examples of camera angles and shots that we covered in Chapters 10 through 12.

You can find many other good examples of scripts at the following address:
http://homepage.mac.com/dmcduffie/site/Scripts.html

Other side of the tracks

Page 8
Panel 1:
Cut back outside to Jeyne's mecha. Crouched over the enemy mecha, she rips the gun arm off the mecha she's searching with the sound of tearing metal.
Panel 2:
Jeyne's mecha looks back at Keil standing over her, holding the gun arm in her mecha's hand.
Jeyne: I think I can use this. The power connectors match!
Keil: Have you listened to a word I've said?

Page 9
Panel 1:
Close on Jeyne's face. She's angry.
Jeyne: I heard you. You want to run away. Well, run away, then! Desert, for all I care!
Panel 2:
Cut outside. Jeyne's mecha has already stood up. She slams her own fist against her chest, knuckles out.
Jeyne: I signed up to FIGHT. It's what I was BORN for. It's what my parents RAISED me for.
Jeyne: My father was a COMMANDER! He died in the war when I was FIVE.
Panel 3:
Jeyne's mecha's palms are out.
Jeyne: Fighting is all I know. Actually, I do know one other thing. I'm going to die doing this. But I'm going to take as many Axis with me as I can!

Panel 4:

Cut to Keil's face. There are tears in his eyes.

Keil: You - I -

Page 10

Panel 1:

Big panel. Pull out to show Keil is slumped down in his harness, his head and arms limp. Leave a lot of room for dialogue.

Keil: That's not me. You're so different than me.

Keil: I – We've know each other for three months, but I never knew all this –

Keil: I just want to get through this and get back to my life, not die shooting.

Keil: I thought I loved you. I never said it till now, but …

Panel 2:

Reaction shot of Jeyne in her cockpit. She's surprised.

Jeyne: You thought you loved me?

Panel 3:

Back outside. Keil's mecha is pointing up at the cliffs.

Keil: You should go.

Keil: Take as much weaponry and ammo as you can salvage and make something of yourself.

Formats & Sizes

In Japan, brand-new manga is usually released as one of several different stories in magazine-sized anthologies, tailored to a specific gender, age group or subject matter. The best of these serial stories are then collected later in digest-sized books called *tankōbon*. These books are the most familiar format to us stateside. In fact, there's really only two magazine anthologies published in the U.S.: *Shonen Jump* and its sister *Shojo Beat*, both from Viz. Both of these reprint only the most popular series from Japan. The vast majority of the huge U.S. manga industry consists of tankōbon. Instead of reprints of stories that we're already familiar with, tankōbon represents brand-new stories for the vast majority of the audience.

Although many original English language manga publishers use this digest format, other publishing houses, mainly imprints of big names such as Random House and Scholastic, opt for a larger, more traditional graphic novel size when publishing manga material.

Your format of choice will therefore depend in large part on which publisher you end up with.

THE COMIC BOOK: PROS AND CONS

Manga-influenced art is found all over the big Western comic book publishers such as Marvel or DC. Covers and some whole interiors are done in this style, and therefore you may be called to work on a book done in traditional comic book style. In this case, rather than working on your own creator-owned story, you'll be doing what's called work-for-hire in a shared universe.

Alternatively, if you're doing a creator-owned manga, choosing this comic book format for your work is not the wisest idea. The vast majority of consumers who purchase comic books in comics specialty shops are interested in a traditional Western superhero style. Black-and-white art, and especially black-and-white manga art, is a huge turnoff. Going the comic book route can hamstring you before you truly begin. Therefore, it behooves you to seek out the graphic novel format instead. Manga fans eschew comic book stores and buy almost all their manga from bookstores, which might carry one spinner rack of comics, but several shelves of graphic novels (mostly manga). Original English-language manga has the best chance to succeed in this environment, because it gets to the people who read it.

167

THE BLEED AND THE TRIM

Before we discuss manga page sizes, it's important to define a couple of terms.

The **Safety Zone** is where all the important things on a manga page go. Any speech balloons and captions, and important drawings need to be entirely contained within the Safety Zone. Why? Printing presses are not an exact science. While ideally the art should be chopped exactly on the trim line, often the actual line is slightly inside of that. Since it's extremely unsightly for speech balloons and captions to be cut off in the final printed page, this safety zone becomes very important.

The **trim** is where the publisher intends for the paper to be cut. Everything outside of that trim is lost, as that's where the printing press chops the pages to make the book.

When you open up a manga book and the art goes all the way to the edge of the paper rather than stopping at a panel border, that's called **full bleed**. Any art that you want to go to the edge of the physical paper must go to the bleed. Because printing is not precise, you won't be able to decide exactly where that paper edge is, so be careful of the edges in the bleed—it could all get cut right off! Also, you must draw that image past the trim to the bleed, or you could have strange white art that doesn't bleed off the page if the printer misses.

FORMAT AND PAGE SIZE

The size of the art page, whether physical or digital, is informed by the format. A manga story done directly for a tankōbon or an anthology magazine starts out with A4 paper size, the traditional manga page size, which is 210 mm × 297 mm, or 8.3″ by 11.7″. This is about one and a half times larger than actual print size. Different publishers then ask for different measurements within this standard page size. Some manga art boards come with blue rulers already on the page that don't show up in scans (called *non-repro blue*). Here's a word of caution, though: the rulers on most manga art boards are not the same as what TokyoPop, for example, uses for their books.

Here's an example: Blue Line Pro sells their own A4 manga boards with 182 × 257 "bleed" and 150 × 220 "trim" rulers. However, TokyoPop uses 199.5 × 292.5 mm bleed and 190.5 × 283.5 mm trim, (plus the 171 × 264 mm "safety zone"), which will require either re-ruling on the boards yourself, or some modification once the page is scanned in. You're probably better off buying blank A4 boards and ruling them yourself based on TokyoPop's measurements. (All of the *Other Side of the Tracks* art at the center of this book is drawn using TokyoPop measurements.)

Note that this is considered 1.5× TokyoPop's standard size. After the pencil and ink stage, TokyoPop requires the art be reduced to standard size for toning and lettering. That standard size is 114 mm × 176 mm safety zone, 127 mm × 189 mm trim and 133 mm × 195 mm bleed. Of course, you can always do the entire process at standard size, but working larger smoothes out the line and is often kinder on the hand of the artist.

Figure 1 is TokyoPop's standard size, taken from the mechanical guidelines on www.tokyopop.com.

MECHANICAL GUIDE

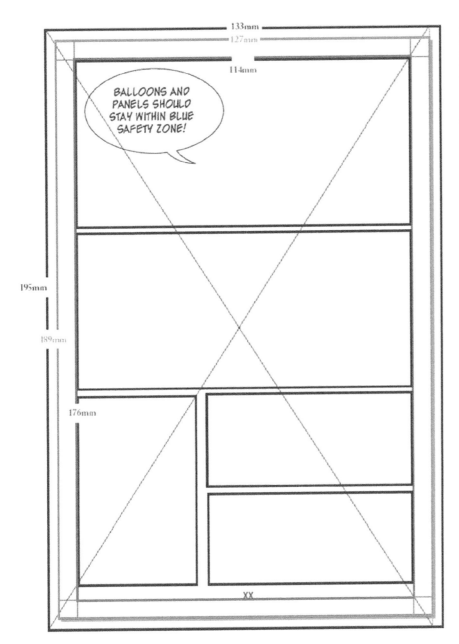

Bleed area: If you want your art to bleed off the edge of the page, make sure you draw up to the solid black line. Also make sure important images are within the blue area so they aren't lost when the page is trimmed.

Trim: Anything outside of the red line will be cut off at the printer.

Safety zone: Keep all important imagery inside of this blue area. Remember to allow room for page #s (at least every 10 pages).

169

Alternatively, a manga story done for a U.S. comic book uses comic book dimensions. The board size is 11 × 17″. This is also 1.5 times larger than "standard size," so the bleed is 10.375 × 15.75″ and the trim is 9 × 13.75″. When reduced down to standard size, this becomes 6.875 × 10.5″ bleed and 6.625 × 10.25″ trim.

Figure 2 is a template for U.S.-sized art pages. The red is the bleed; the yellow is the trim; and the white is the live area, or "safety zone" to continue TokyoPop's terminology. This template is taken from the mechanical specifications on comics print-on-demand site Ka-Blam (www.ka-blam.com).

MANGA STUDIO PAGES

If you're creating manga entirely digitally, here's how to make page templates in the correct dimensions in Manga Studio.

MANGA STANDARD SIZE

From the **File → New Page** option, go from the Custom Page tab to the Page Templates tab. Click the **New Page Template** button. Name your new template and change the units to millimeters. Make sure the DPI is 600 DPI or 1200 DPI if you can handle it, as you can always export in a lower DPI, but you won't be able to make it higher later. Under **Page Size**, put 210 for width and 297 for height (or just select A4). Check the **Inside Dimensions box**. Under **Finish Frame**, put 127 for width and 189 for height (Finish Frame is the trim size.) Under **Basic Frame**, put 114 for width and 176 for height (Basic Frame is the "safety zone."). Finally, put 3.3 for Bleed Width to create the correct bleed size.

MANGA 1.5× SIZE

Open a new page template and change the units to millimeters. Under **Page Size**, put 210 for width and 297 for height (or just select A4). Check the **Inside Dimensions** box. Under **Finish Frame**, put 190.5 for width and 283.5 for height (Finish Frame is the trim size.) Under **Basic Frame**, put 171 for width and 264 for height (Basic Frame is the "safety zone".) Finally, put 3.3 for **Bleed Width** to create the correct bleed size. Remember not to tone at this size. Tones must be done at standard size.

WESTERN STANDARD SIZE

Open a new page template and change the units to inches. Under **Page Size**, put 11 for width and 17 for height. Check the **Inside Dimensions** box. Under **Finish Frame**, put 6.625 for width and 10.25 for height (Finish Frame is the trim size.) Under **Basic Frame**, put 6 for width and 9 for height (Basic Frame is the "safety zone".) Finally, put .125 for **Bleed Width** to create the correct bleed size.

WESTERN 1.5× SIZE

Open a new page template and change the units to inches. Under **Page Size**, put 11 for width and 17 for height. Check the **Inside Dimensions** box. Under **Finish Frame**, put 9 for width and 13.75 for height (Finish Frame is the trim size.) Under **Basic Frame**, put 8 for width and 12 for height (Basic Frame is the "safety zone".) Finally, put .166 for **Bleed Width** to create the correct bleed size.

ONE VS. MULTIPLE VOLUMES

Before even starting on your manga, you may want to consider whether you believe the story will span multiple volumes. TokyoPop, when pitching at the professional, non-contest level, asks you to outline your story as a three-volume series. That's three tankōbon at around 180 pages each, for a total of 540 pages of story! That's a lot of room to tell a manga story and make it as epic as you want. Though it is rare that an OEL manga will run longer than three volumes, there are more exceptions all the time.

Then again, you may feel that your story naturally has a beginning, middle and end within the span of a single tankōbon. That's OK. Just try not to kill everyone by the end. Leave things open, and you may change your mind and craft a sequel later, especially if the manga is a hit!

When creating a story for an anthology or comic book format, it's extremely likely that yes, your story will span several issues. In the anthology's case, you may have only 8 to 20 pages to try to make some point or make a bit of progress in your story. In the comic book's case, you have 22, roughly equal to one "part" of an anthology (or one "part" of a tankōbon). Writing serially rather than directly to the tankōbon means that you'll often have to build in more cliffhangers, shorter scenes or other story modifications, so that readers are satisfied with the bite size you've given them rather than an entire, lavish volume.

Going to the other extreme, many Japanese manga have dozens, or even 100 or more, tankōbon volumes, as these stories originally ran for years and years in the anthology magazines. That's why, in the Western world, Naruto tankōbon now come out monthly, at the same pace as a comic book. There's an enormous amount of Naruto material out there, and it's extraordinarily popular worldwide, so why not?

FORMATS & SIZES: FINAL NOTE

All the different dimensions and sizes can get extremely confusing. The easiest way to work it out is first decide whether you're producing for the OEL or the Western market. If you're producing OEL, get some quality A4 paper, download TokyoPop's specifications and draw a set of rulers. If Western, buy some Strathmore Bristol 300 11 × 17″ comic book paper with the rulers already on it, and you're all set. And if you're working with a specific publisher or printer, make sure that you're following the exact specifications. Of course, if you're producing your manga directly in Manga Studio and not scanning at any point in the process, it gets even easier. Just make a new page with the correct dimensions, and you're all set.

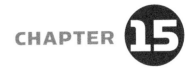

Pitching and Selling

So you've created your magnum manga opus, and you've done some scripting, some character sketches and a few pages of art. It's probably a good idea to stop here and find a publisher. Many publishers will want to see your initial material presented to them in a professional manner. This is called a pitch. Pitches almost never include your full 180-page creation, and there's a good reason for that. Many editors like to be involved from the starting point and help guide you toward a coherent plot, assist with pacing issues and offer suggestions on modifying character designs. Some editors, however, will be almost totally hands-off, and once your pitch is approved, you'll be on your own. At any rate, it helps to sell your idea before doing the whole book for another good reason: you're spending a lot of time on this, and you want to get paid for it. Who wants to do a giant amount of work and not get paid? You've got to put food on the table.

A professional pitch will vary between publishers, but TokyoPop, the king of OEL, has a good model that can be easily transplanted to other companies. There are several other publishers besides TokyoPop that take OEL submissions, though, and each one wants to see something different.

Always follow each company's individual submission guidelines and make sure your work will fit with what the company publishes. Do your research and show the company you've got what it takes.

TOKYOPOP

TokyoPop's standard submission guidelines can be found at http://www.tokyopop.com/corporate/submissions/511 and vary depending on whether you're a manga writer, manga writer-artist, or part of a team. There's also an additional route into the company through its Rising Stars of Manga contest. Finally, you can also submit art samples in order to work on someone else's idea, if you so desire. Producing art on a professional level can be excellent practice for launching your own idea.

The Standard Submission

Here's what you need to do to submit your own project through TokyoPop's standard submission channels.

173

Sequential Pages

If you're doing the art for the series, you'll need to put together four to six pages of sequential art. Sequential art is another way to say a manga page, with panels on it, and storytelling from panel to panel, as well as page to page. In other words, pin-ups or full-page character shots don't count. TokyoPop wants to know if you can handle backgrounds, mundane elements such as rocks and trees and mundane camera angles. TokyoPop wants to know if you can leave room for dialogue, if you understand the importance of long shots and close-ups, and if you can do mood and emotion. In other words, all the important stuff we covered in the second half of this book!

The art needs to be finished, in that it should be pencilled, inked, toned and lettered. This four to six-page sequence can come from any part of the book and should be one sequence—not six random pages from throughout the book.

Synopsis

This is where the series writer or writer-artist comes in. TokyoPop says you need a single synopsis page. You're trying to convince the editors that your idea is worthwhile, and it needs to fit on one page. Not only that, but you need what's called a "log line". Wikipedia says that a log line is a brief summary, "often providing both a synopsis of the [manga's] plot, and an emotional 'hook' to stimulate interest." This log line should be two sentences long, max.

The log line is the hook that should make the editor want to know more and read the manga. Breaking down everything that makes your manga awesome can be hard. Try to focus on the themes, ideas and conflict of your manga instead of just summarizing. Short and strong will always sell your idea better than long and convoluted.

The synopsis is the place to go on about everything that actually happens in the book.

Three-Book Plan

TokyoPop then wants you to write a plan, one to three pages long, that talks about how your idea would work in three tankōbon, 160 pages each. TokyoPop likes concepts that work as multi-book series rather than standalone volumes, though each individual volume needs to stand alone and should have a clear beginning, middle, and end.

Character Bible

Spend another page talking about each of your characters. Remember that all good stories have an antagonist. You need some driving force against your characters succeeding. This character bible should have names, backgrounds, and other important details, as well as information about how the characters grow and change throughout the story.

Character Designs

This one's for the artist again. TokyoPop wants one to three pages of character designs. These are poses and head shots from multiple angles showing off your characters. They like you to focus on the three most important ones. Try two of the main characters and the chief antagonist.

Marketing Points

Lastly, TokyoPop wants you to give them five marketing points. Among these five points can be reasons why they should publish the manga, info about competing stories, and an explanation of the target audience.

This is where it's important to do your research. Make sure that your manga fits the audience and manga that TokyoPop publishes. It is acceptable to compare your manga to movies

and other media in order to give TokyoPop an idea of the target audience and the tone of your series. It's equally important, however, to talk about how your manga is original and different.

TokyoPop also wants you to include a Submission Release Agreement with your submission. The agreement can be found at the submission guidelines website mentioned earlier.

THE SHOOTING STAR PROGRAM

Once your OEL project is accepted, TokyoPop used to go straight to a publication path. They do it a little differently these days. It's called the *Shooting Star* program. First, TokyoPop commissions the first three chapters from a proposal that it likes, and pays the writer and artist a flat fee to split. The three chapters go up on the web, along with submissions from several other creators. Fans on the website vote on their favorite, and the winner then goes on to do a full print tankōbon for TokyoPop.

Rising Stars of Manga

The previously mentioned submission info is for TokyoPop's standard submission process. There's also a talent search that TokyoPop runs once a year, that may be an excellent chance for you to break in. It's called *Rising Stars of Manga*. The submissions guidelines vary quite a bit from TokyoPop's standard submissions process, but it's just as valid a path into paying work for the company. Here's how this contest works.

The full submission guidelines are here: http://www.tokyopop.com/Rising_Stars_of_Manga/gopro/979142.html

Rising Details of Manga

For Rising Stars of Manga, you have to create an entire 15 to 20-page short manga story, with a beginning, middle and end. This short story can be a single "story arc" as part of a larger story, but it also has to stand alone as a complete work.

The 20-page short story at the center of this book, *Other Side of the Tracks*, fits the guidelines for a Rising Stars submission, as it is a complete story arc, but it's part of a larger story in the life of Keil.

Rising Stars submissions have to be free of really gratuitous violence and nudity. Implication is OK, but really blatant stuff will get your project disqualified. It's just not the kind of thing they go for here.

The book is rated Teen or Ages 13+ and the project needs to fit within these guidelines.

Also, it can't have been published anywhere before, or have appeared, say, on a website. It's probably not even a good idea to show off works in progress in public—keep it to your close friends or colleagues and make sure they don't go around posting it in forums and such. You'll be disqualified.

TokyoPop wants the primary language of the RSOM submission to be English. As long as an English speaker can follow the story, there can be elements of other languages. One common example of this is sound effects in Japanese or Korean. (The sound effects in *Other Side of the Tracks* are Korean.)

The mechanical specs are identical to the standard TokyoPop submission process. Send in your submission as a hard copy of A4 paper, with your submission within the ruled measurements specified by TokyoPop. Don't send originals—instead, make good photocopies.

If you're part of a team and not creating solo, that's OK, but TokyoPop requires you all to sign the entry form, and requires that each member of the team receive prize money exactly equally.

You Mentioned Money?

There are eight genres that are eligible for a prize. The best entry in each of the following wins $1,000: action, comedy, drama, fantasy, horror, mystery, romance and sci-fi. Also, online fans will vote one entry as the Online People's Choice, and that team will receive $500.

Everyone who wins in one of the categories can be in the Rising Stars of Manga anthology tankōbon that comes out every year in July. Also, they'll have the opportunity to pitch a full series to the TokyoPop editors.

You can always send submissions to TokyoPop without entering Rising Stars of Manga, but the contest is a great way to really get the attention of the editors and help stand out from the submissions. Remember, even if you don't win, entering can help get the attention of the editors, and they like to see dedicated people improve with each contest.

RSOM is annual, and runs from June to January each year.

The UK runs its own RSOM from April to September. Their prizes and rules are somewhat different, so check here for details about that contest: http://www.tokyopop.com/ Rising_Stars_of_Manga_UK/gopro/978523.html

Check either the U.S. or the UK website for all the forms and information you'll need to have in your submission. Remember to take advantage of the tools and techniques in this book, as they'll give your work that professional quality that will help you become a finalist.

Submitting Art to TokyoPop

If you'd rather just draw right now and create later, that's perfectly valid. While building up your skill set illustrating another creator's project, you'll become a better artist and become better equipped to do you own thing later on. Here's what TokyoPop wants in the way of art submissions. Regardless of the submission, you won't need to sign a release form, as it's not an original project, just a portfolio. You'll need to e-mail your submission to mangaka@ tokyopop.com, or mail it to:

MANGA SUBMISSIONS DEPT.
TOKYOPOP Inc.
5900 Wilshire Blvd. # 2000
Los Angeles, CA 90036

Pencils

TokyoPop considers the penciller to be the visual team leader. They're looking for artists who can handle panel to panel layout, pacing, good rendering of the art itself, anatomy, perspective, and backgrounds. This book covers all these topics, if you haven't figured that out by now.

Inks

Line weight and depth are important qualities to master as the inker. TokyoPop includes sample pencils to ink over at the aforementioned website. Send the inks as a JPG to mangaka@tokyopop.com with INK SAMPLE and your name in the subject line. The body of your e-mail should have your contact info and any pro experience.

Tones

TokyoPop wants toners that can work in tandem with the penciller and inker. Communication is key between every member of the team so that the tones are applied correctly. They've included a toning sample at the same website mentioned earlier, and completed tones can be sent as a TIF or a PSD file to preserve resolution to mangaka@ tokyopop.com with TONE SAMPLE and your name in the subject line. Again, the body of the e-mail should have contact information and professional credits.

SEVEN SEAS ENTERTAINMENT

Though Seven Seas Entertainment, who owns GoManga.com, has taken pitches in the past, off and on, right now they're off. However, they are taking art submissions—as in, you show them your portfolio and they give you art to work on that's not yours.

However, it is paying work, so while you're waiting for your dream project to get published, here's how Seven Seas wants to see your art submission.

First, you'll need to create an online portfolio on your own site or at a place like www. deviantart.com, or simply use an image hosting site like flickr.com to store scans of your work. With Flickr, you'll be able to give out an address of your collective images, called a stream. Seven Seas wants to see sequential art, rather than pinups, and it has to be pencilled and either inked or toned, or both. Then, go here: http://www.gomanga.com/submissions/

You'll have to agree to the submission release agreement, and then you'll get a submission form. Fill out all the information and provide a link to your Flickr stream or online portfolio. If you're currently doing a webmanga, give them a link to it. Make sure to be professional in the comments space and spell check. Hit submit. The process could take two months, and Seven Seas will only contact you if they like your stuff. Remember, this isn't a chance to pitch your own project, but it is paid work in the OEL Manga field.

RADIO COMIX

Radio Comix publishes mostly adults-only manga, so if that's an interest of yours, they're a good outlet for it. Radio publishes a mixture of comic books and tankōbon, but your initial submission will be to the anthologies, which are all comic books.

Here is a link to the actual submission guidelines: http://www.radiocomix.com/submissionguidelines.html

1. You'll need to put together a multiple-part story for an anthology and fully complete the first part. Page sizes are 6.875″ by 10.5″.
2. You can send in a CD or DVD with the digital files on it (in 400 dpi TIFF), but Radio wants hard copies sent with the disc.
3. Every page of the submission has to have your contact information on it.
4. Photocopies, not original art.
5. No e-mail submissions.

The anthologies that Radio publishes are Furrlough, which is anthropomorphic animals and is PG-13; Genus, which is also anthropomorphic ("furry") but is R to XXX; Milk, which is standard adults-only of the heterosexual variety; and Dangerous, which is an adults-only gay male anthology.

177

Send your anthology submission to:
Radio Comix: Submissions
PMB 117
11765 West Ave.
San Antonio, TX 78216

Note that it can take very long time to hear back from Radio, but they do offer compensation if your anthology submission is picked up.

ANTARCTIC PRESS

One of the pioneers of the OEL movement, Antarctic Press is still doing comic books and tankōbon today, and still paying. Here's how Antarctic wants their submissions put together.

First, here's where to go to see the guidelines from the horse's mouth:
http://www.antarctic-press.com/html/version_01/submissions.php

6. Send them 3 to 5 photocopied pages of completed work: pencilled and inked/toned. The website doesn't mention lettering, but trust us: you'll need it.
7. They want the manga style, not superheroes or funny animal cartoons. No-brainer.
8. Send in previously published material, if you have it.
9. If you're submitting an original series and not just art samples, begin with a single comic book story (22 pages or so), or a 3 to 4 issue miniseries (so 66 to 88 pages). Send in 4 to 5 sample pages from the story and a synopsis of the entire thing.

Mail your submission to:
ATTN: Submissions Editor
ANTARCTIC PRESS
7272 Wurzbach #204
San Antonio, TX 78240

Also, talk to Rod Espinosa while you're doing so. He's at rod_espinosa@antarctic-press.com.

IMAGE COMICS

Though Image Comics is ostensibly a Western comics publisher, they publish manga projects all the time. These comics will appear in traditional comics shops rather than bookstores, and some comics shops are resistant to manga as a style and black-and-white books in general. It's possible that, if considering an Image submission, you may want to color your project. Though color is outside the scope of this book, you may be able to find a good colorist for your project. Look around at places like www.digitalwebbing.com and www.deviantart.com and see what you can find. If you decide to go color, then you'll need to pencil and ink your project, but leave out all tones. The colorist will be doing that part.

You don't have to do an Image book in color. The publisher does do black-and-white books, but it's just another hurdle to overcome in comic shops.

Also, Image projects are generally comic books, but not always. You can do an original graphic novel through Image. Keep in mind that, though Image Comics does not take any rights to your work, it also does not pay you upfront. Any payment for the project would come on the back end, or after sales are determined. Image takes a flat fee out of the money the book makes, and the rest goes to you and your team. So it could be a lot or very little, depending on how your book does. Hence, doing an entire OGN upfront might not be wise, as it's an enormous amount of effort for something that won't make you income until a few months after the release date.

That said, Image is a great place to have a book, because of the aforementioned creative control. Holding on to the rights to your work cannot be overstated, especially if Hollywood wants to turn your book into a movie.

The Image Pitch

Here's what your pitch needs to look like for Image Comics. They're pretty exact, and substantial deviation from this format will kill your chances. So just do what they want. The word-for-word submissions guidelines can be found here: http://www.imagecomics.com/submissions.php

1. First, the cover letter. Put your name, e-mail address, snail-mail address, phone number and fax number (if applicable) on the first page, at the top. Talk a little bit about yourself and mention any previously published comics or manga work. Feel free to enclose a copy of said book, if it exists.

2. Next, you need a synopsis of the entire story arc or series, depending on whether you're pitching an ongoing series that goes on for many issues, or a limited series that ends after only a few issues. Don't get cute—tell Image all the secret endings and plot twists. Don't be afraid to spoil it. Image also doesn't like it when you frame plot points as questions. Image's example of what not to do: "What will Barney do when confronted with...?" Don't do that. This submission is for the editor and to sell the idea, not tease the reader. Though you have a full page to work with, if you can summarize the book more quickly, do so.

3. You need five pages that are totally pencilled, inked/toned, and lettered. These should be done pages. Send photocopies, not the art boards.

4. You don't have to color the pitch pages. If you want to do the book in color, get a colorist later on, after the book's approved.

5. You'll need to include a mock-up of the cover. Basically, take an image from the book and put a logo on it. You can create the original piece for the cover at this time, if you wish. The logo is important to Image, as it needs to be clear and readable from a distance. Keep it simple, yet professional. You may want to seek outside help on the logo front. There are a lot of great logo designers out there—post somewhere like www.panelandpixel.com to find one.

Once you have all that together, you can mail it in to Image at the submissions address:

Submissions
c/o Image Comics
1942 University Ave.
Suite 305
Berkeley, CA 94704

Before you do that, though, it's acceptable to send publisher Erik Larsen a summary and link to the art and cover. His e-mail is eriklarsen@imagecomics.com. Don't send him attachments—as mentioned in the Seven Seas section above, use www.flickr.com. Store your pages there and send Erik links to them. After awhile, Erik will write back, but only if he's interested. If he likes it, send in the whole thing. If not, them's the breaks — keep trying elsewhere or come up with a new project. Don't keep bugging him if you don't hear from him for awhile—the decision's been made. Either put together another new pitch or try another company.

THE BOOK MARKET

There's been a recent explosion in graphic novels from traditional print publishers. These graphic novels mostly target the bookstore market, although some comics & manga

179

specialty shops can order them as well. A significant percentage of these publishers are looking for manga style, so you're in luck on that front. The catch is that nearly all of them require a literary agent, and there's only a tiny handful of literary agents that specialize in graphic novels. (Though there are more all the time, and some traditional fiction agents are branching out into graphic novels.)

Your task will be to track down one of these agents and convince them that you're a skilled artist, writer or both, and he or she should take a chance on you. It helps to have previously published material, either in print or a webmanga. It helps to have a current, professional online portfolio. DeviantArt.com is a good place to put one, if you don't want to set up your own site.

To find an agent, you'll also need to have a project already in mind. Agents usually don't take people strictly on merit—they want a project pitched to them. Something they can immediately try and sell to the book market and make their commission.

That's right—commission. Agents make 15% of whatever you make, but without that agent, you have no way of getting the gig in the first place. It's a good trade-off.

It's sometimes important to have an agent even when going the comic publisher route. Though you seek out and submit projects yourself, agents can still assist with contracts and perform many other important tasks. Comic book editors often don't like talking to agents, though, so be prepared to do a lot more direct communication with a comic book editor than you'd do with a book editor.

Finding an Agent

Here are a few agents who specialize in graphic novels. We've included the website first, but some listings have an e-mail contact where a website is not available. Note that both writers and artists can contact these agents. Keep in mind that an agent should never, ever charge a fee upfront for any reason. If they do, look elsewhere.

Jenoyne Adams, Levine Greenberg Literary Agency www.levinegreenberg.com (All Types)

Michelle Andelman, Andrea Brown Literary Agency, michelle.literary@gmail.com (Children's)

Brendan Deneen, Objective Entertainment, brendan@objectiveent.com (All Types)

Jaimee Garbacik, The Literary Group www.theliterarygroup.com (All Types)

Judith Hansen, Hansen Literary Agency, hansenliterary@msn.com (All Types)

Denis Kitchen, Kitchen & Hansen Agency, LLC, www.kitchenandhansen.com (All Types)

GRAPHIC NOVEL PUBLISHERS

Once you've found a graphic novel agent, give him or her this list of publishers. Though the agent will have resources already, this list may augment the agent's and provide him or her with additional resources. Anything to make it easier for the agent to land your book somewhere.

ABRAMS
Harry N Abrams
http://www.hnabooks.com/category/home/87

CANDLEWICK PRESS
Candlewick Press
http://www.candlewick.com/

CHARLESBRIDGE
Charlesbridge
http://www.charlesbridge.com/

DARK HORSE
Dark Horse Books
http://www.darkhorse.com/

DISNEY
Hyperion
http://www.hyperionbooks.com/

GO MEDIA ENTERTAINMENT
GoComi!
http://www.gocomi.com/index.php

HACHETTE
Yen Press & Grand Central Publishing
http://www.hachettebookgroupusa.com/

Little, Brown
http://www.littlebrown.co.uk/

HARPERCOLLINS
HarperCollins
http://www.harpercollins.com/

HOUGHTON-MIFFLIN
Houghton-Mifflin
http://www.hmco.com/

MACMILLAN
First Second Books
http://www.firstsecondbooks.typepad.com/mainblog/

Henry Holt and Company
http://us.macmillan.com/HenryHolt.aspx/

Hill and Wang
http://us.macmillan.com/HillAndWang.aspx

Tor/Forge
http://us.macmillan.com/TorForge.aspx

METRO MEDIA
SelfMadeHero
http://www.selfmadehero.com/

NORTON
WW Norton
http://www.wwnorton.com/

PEARSON
Penguin Books
http://www.penguin.com/

RANDOM HOUSE
Crown Books
http://www.randomhouse.com/crown/

Del Rey
http://www.randomhouse.com/delrey/

Pantheon
http://www.randomhouse.com/pantheon/

Tanoshimi
http://www.randomhouse.co.uk/tanoshimi/

Villard
http://www.randomhouse.com/rhpg/villard/

SCHOLASTIC
Graphix
http://www.scholastic.com/graphix/

SIMON & SCHUSTER
Simon & Schuster
http://www.simonsays.com/

WALKER BOOKS
Walker Books
http://www.walkerbooks.co.uk/

Protect Yourself

It's important that you not be caught unaware by an unscrupulous agent or publisher. Many writers and artists in comics have fallen prey to bad contracts and lost control of their creations. Don't let it happen to you—use these tools to protect yourself.

Education

Check out the Graphic Artists Guild book *Pricing & Ethical Guidelines* for information about pricing information, sample contracts, negotiation, and ethics and business standards for graphic artists such as yourself.

Get Agreements in Writing

It's important that any deal with a publisher, agency, or even your creative partners be done in writing. If the publisher or agency insists on conducting a majority of its business on the phone, be extra wary. E-mail negotiations are better, as there's a paper trail.

Insist on any agreements be spelled out in writing, formally. That means don't take verbal agreements, and don't take off-handed agreements over e-mail. It has to be in an attached agreement or contract, and this contract has to be one that you understand. Make sure you actually read your contract when you get it and agree to all the terms. If you can't make sense of said contract, seek legal advice.

Even with creative partners, make sure there is some kind of working contract. Between the collaborators, it's best to make sure everyone has the exact same expectations of how work, money, royalties and copyright are going to be divided. It is imperative that your team has decided how it is going to operate and this is laid out in writing. It doesn't matter if you're best friends or not—clear communication will help keep it that way.

Co-authorship or joint authorship means that the creators share the rights of the manga. It could mean that if the manga is optioned, for say a movie, both creators would financially benefit. Unless one party or both parties has signed away those rights! Remember to make sure you always understand your contract.

Work-for-hire is subcontracting the work whether that's art, lettering, toning or even writing. One of the creators has a contract that states the terms of the work-for-hire and how they will be compensated. The work-for-hire contract usual involves signing away rights to the work, so the only financial benefits are those stated in the contract. That could be just a page rate (a specific amount of money per manga page completed) or involve royalties. That usually means the movie deal won't benefit the work-for-hire partner. Lettering and toning are often work-for-hire if you need to bring someone on for those specific jobs.

When bringing on a team member always create a contract even when you're just getting ready for a publisher. Remember, these are two very different ways of operating. The person hired for lettering a few pages should have a work-for-hire contract, or they may be able to come back later and claim partial rights and profits!

Here's a good creator's agreement that many people in the business use as a starting point: http://hollywoodcomics.com/collab.html

Pro-Bono Contract Advice

Contracts are difficult to understand for even the smartest of us. They're designed to protect all parties involved, but in the process can be full of legalese that's impossible to interpret.

Free or inexpensive contract advice is available through the Volunteer Lawyers for the Arts at www.vlany.org, dependent on your income. When you get to that all-important negotiation step, put in your details at that site, and hopefully, a lawyer will pick it up from there. It's not necessary to have an actual conflict or dispute before using these guys—just a contract that you can't decipher on your own.

While you're waiting to have your case heard, there are tons of resources available on that site, including a link to some excellent free contract advice at http://law.freeadvice.com/general_practice/contract_law/. This site spells things out in plain English and can really help you figure things out.

It's important that you do seek to educate yourself or find a lawyer, as you shouldn't sign any contracts—with anyone—without understanding them fully. If you do so, you could be signing away the rights to your creation, without your knowledge. Or, you could be entering into a bad deal with an unscrupulous agent. Don't let it happen to you.

After You've Signed With an Agent

So you've sent a query letter or proposal to an agent, and he or she likes it and signs you on. Great! It's now the agent's job to help you shore up your proposal. Often, the proposal you used to get the agent's attention and the one that will eventually go out to publishers are very different. Every agent has a different approach here, but he or she will have a lot of advice on how to shape your proposal so that publishers like it.

Once your proposal is in shape, the agent will then seek publishers in the graphic novel field to place your project. Again, show him or her the list of graphic novel publishers, as the list may have some that the agent didn't think about.

Once the agent submits your project and a publisher likes it, the negotiation begins. With your input, the agent will then work out the finer points of the contract with the publishers, such as deadlines, rights, and the all-important royalties and advance on royalties.

An advance on royalties is money that the publisher gives you throughout the time period that you write and draw the book. It's money that it expects to get back through book sales. After the publisher has paid itself back with enough sales, any additional money is paid out to you. This additional money is called *royalties* and is measured as a percentage of the

book's cover price. Sometimes, extraordinary sales past a certain threshold can net you a bigger percentage.

Note that almost all book publishers pay advances and royalties, as opposed to the comic book market which pays a page rate or back-end money.

Again, agents take a standard 15% out of any money that the publisher pays you. With all the work the agent does on your behalf, it's worth it. Hopefully.

You'll be bound by the deadlines contained within a contract. It'll be your job to hit those deadlines on time, as the publisher doesn't have to send you checks until you hit them. Missing deadlines can cause the publisher to refuse publication as well, depending on the contract, so don't do it. It's important, therefore, to request deadlines that you know you'll be able to hit. Be realistic, especially if this is your first 180-page manga. Remember to account for break time and time to recover if you get sick or other problems arise.

Once all the negotiation is played out, the publisher will present a contract to you and your agent.

If you're part of a team, the publisher will either have you all as co-authors, or one person will be the main author and the other creators will be work-for-hire for them. These subcontracts are put together by the agent. The co-authorship puts everyone on equal footing, which is nice. However, the work-for-hire allows the main creative force behind the book to fire members of the team that are not producing work. It's all about how you want to do it.

After You've Signed with a Publisher

Once you've had the contract looked at and have signed it, it's time to create. Set reasonable goals for yourself and your team every day in order to make each deadline and get paid. Don't overwork yourself and don't wait until the last minute. There are only so many hours in the day, so make them count.

Once a deadline is successfully met, the publisher will take a month or so to send a check to the agent. The agent will then write you a check less 15%, and mail it to you and the other members involved.

THE BOOK IS FINISHED

When that last deadline is hit, there will be a publication date set, an Amazon listing, and possible book tours and book signings to set up. Different publishers do things differently. The bigger publishers have more room in the budget to sent creators to conventions on their dime; still others will work out co-op relationships with convention organizers, or choose not to send you anywhere at all. It'll be up to you to get copies of your book on the cheap from the publisher and set up local book tours yourself.

Overall, though, it's out of your hands. The publisher will be concentrating on selling the book to book dealers and consumers. A certain level of self-promotion is required on your part, depending on the publisher. You can't just do nothing after the book is done—it's important to get yourself out there, even as you're working on the idea for your next book.

Another thing that comes with the territory is book reviews. Your manga will likely get good and bad reviews. Take each with a grain of salt. You created this book for yourself, ultimately, and it only matters what other people think if you let it matter. That said, it's sometimes good to read reviews and use the constructive criticism to help you become a better writer and artist.

If your book does sell exceptionally well and you start receiving royalties, it may sell out of its initial print run. In that case, it'll likely go to a second printing. Your contract will spell out what happens in the case of a new printing, so make sure you're up to speed if that happens. The good part is that perpetually selling books can net many royalty checks for the author. This cash flow will ultimately allow you to create your next idea.

The Next Idea

Often, a publisher that made a good choice in you and sold lots of copies of your last book will want to see your next one. Unless you have a first-refusal clause in your contract, you don't have to show it to them, but if everything went smoothly last time, it's a good idea. Note that if this new book's a sequel or tie-in to the old book, you're likely locked in to the original book's publisher. Either way, you'll have a fast track to another book with this publisher, and your agent can even negotiate a better deal this time around.

It's important to keep the same team together if at all possible, as a manga creative team that gels will produce better and better work over time. Still, don't be afraid to work with new people also. If a member of your team strikes out on his or her own, then a new face may be just what your new project needs. Be aware that a change in team between books can make a publisher skittish, so make sure you keep everyone in the loop.

185

Angle Generally, the word "angle" in a comic script is used when the viewer is looking down (high angle) or looking up (low angle) from the object in frame. Remember, the term comes from where the viewer (camera, audience or artist) would be relative to the scene. Low Angle can be looking extremely upwards, as in looking up at a tall building. High Angle can be looking extremely down on an object, as in looking down from the roof of a building.

Anime Japanese for animation. The animated cousin of manga, an anime can often be adapted from a manga of the same name. Alternatively, an original anime may become a manga later. Or, both the anime and manga can be adapted from a toy line or a video game. At any rate, if a manga title is popular, there's a good bet that an anime series or movie will be made out of it.

Antarctic Press The granddaddy of OEL manga, Antarctic Press is best known for its *Ninja High School* and *Gold Digger* series. Though continuing to purvey manga in comic book form, like many OEL publishers, Antarctic is slowly moving toward the tankōbon format.

Anthology Most manga in Japan premieres in oversized anthology magazines, usually geared toward a specific age, gender or subject matter. The best of these serialized stories are later collected into tankōbon and sold again. In the Western world, Viz has had some success with anthologies Shonen Jump and Shojo Beat, but for the most part, manga premieres directly in tankōbon rather than being serialized first.

Background Anything that's not a character or other foreground object is considered part of the background. Usually, the setting itself is the background.

Bird's Eye View A camera shot that could be from the point of view of a bird. It's an extreme angle looking down from a great height. Often an establishing shot or final panel in an act can be a bird's eye view.

Cliffhanger When a particular scene or act ends with a character in a bad situation without immediate resolution, it's called a cliffhanger. Cliffhangers are especially powerful when there's a wait before resolution, such as between issues of an anthology or tankōbon.

Climax During Act 3 of the story, the climax is the scene that the entire story arc hinges on. It's what everything builds up to. The point of the story, and the point at which all conflict comes to a head.

Close On A form of close up that either takes the place of the establishing shot or appears later in the scene, a Close On is an extreme close-up of a specific action-oriented movement, object or part of the body. The following panel is usually that same shot, but further out to give it more context.

Close-Up Exactly what it sounds like: a panel shot that's zoomed in. In a close-up, a person may be framed from the shoulders up, or closer. Extreme close-ups are done to draw attention to one specific thing in a scene. A close up of a pair of eyes is extremely common in manga.

Comic Book A comic book as defined here is 20 to 22 pages of story in a 6.625 × 10.25″ size package. As consumers became used to paying $9.95 for a tankōbon of manga in the U.S., manga started appearing less and less in comic book format and more and more in either the anthology magazine or the tankōbon.

Establishing Shot A film term used to describe a frame that includes an overview of an area where the action takes place. The first panel or two in a new scene is generally a good place to put an establishing shot, or a depiction of the setting where the scene takes place. This grounds the action in a specific place and is highly important. Sometimes the establishing shot is accompanied by a caption or even dialogue, the latter of which bridges it with the next panel.

Foreground Characters, vehicles, mecha, animals and other elements acted on in a scene are usually part of the foreground. Foreground elements are closer to the viewer than background elements.

Frame To depict the action in a panel in a certain shot at a certain angle is to frame that panel. It's important to frame a panel in a straightforward, but creative manner. When all else fails, just do a medium shot.

Horizon Line An invisible or visible horizontal line that represents the horizon in a drawing, this line may or may not be where the vanishing points converge.

Image Comics One of the leading publishers of creator-owned comic books and graphic novels in the Western world, Image Comics frequently publishes material in a manga style. One example is *Strongarm*, written by Steve Horton (the author of this book) and drawn by Dave Ahn and Rhodan Belo. Some manga-esque projects for Image go straight to book format, as that seems to be a better avenue for black-and-white material than the comic book.

Line Art During the inking step of a piece of manga art, the pencils are given weight and form. This is the practice of line art. Manga Studio comes with many custom pen tools, and more customs pens can be created. Different pens are used for different thicknesses and different levels of detail.

Linking The act of joining together two different scenes through the use of dialogue or a visual element. For example, a character can begin a sentence in one scene, and a different character in the new scene can finish that sentence so that it applies to both characters. Or, the characters in the old scene and new scene say almost the same thing in two different contexts. On the visual side, an object might remain static from one scene to the next while the background changes around it. All of these elements serve to bridge scenes more smoothly and cleverly.

Long Shot A long shot is a camera angle (or drawing angle) that is framed very far out from the objects in the scene. Usually this is done to fit a whole person or even a crowd into the panel, but a long shot can also emphasize the expanse of the background in relation to a character, among many other uses.

Manga Literally, Japanese for comics. Manga is sometimes referred to simultaneously as a genre, a medium, a style and an art form. Manga need not originate in Japan. Manga with roots in the Western world is often called *OEL* or *World Manga*.

Manga Studio Manga Studio is the Western localized version of the Japanese program Comic Studio. Manga Studio is owned by Smith Micro, who purchased the property from e-frontier in 2008. It's considered the program of choice for many professional manga-ka worldwide. Manga Studio comes in two flavors: Debut is the low-priced entry-level edition, and EX is the full-featured professional edition.

Manga-ka Japanese for manga creator. A manga-ka can be a manga writer, a manga artist, or often both at the same time.

Medium Shot A frame that includes a medium view of the object of the panel. In the case of a person, a medium shot is often the waist up. Using a variety of medium shots is a good way to show action without getting either too close or too far away. Using only medium shots removes emotion, context of the scene and drama. It's important to strike a proper balance.

OEL Short for Original English-Language manga, OEL describes any manga originally produced in the Western world, in English. Some of the best selling OEL manga in the U.S. includes *World of Warcraft*, *Van Von Hunter* and the reprint collections of the webmanga *Megatokyo*. TokyoPop is one prominent company that actively seeks out new OEL creators and projects.

Other Side of the Tracks The 20-page manga at the center of this book, *Other Side of the Tracks* is an introduction to a larger story about a galactic war and a resentful draftee who comes to realize his great importance in the grand scheme of things.

Panel Each bordered or unbordered frame on a comic page is called a panel. The most basic, atom-like element of a comic book page, a panel is where things happen, literally! What new writers have to come to understand is what a panel can't do—and a panel can't show the same person or object performing two actions in a row without cheating. Panels can be any size and need not be square.

Perspective Perspective gives art on a page a three-dimensional quality by drawing it at an angle that would be correct if it were viewed in real life. All objects on a page follow invisible perspective lines that travel to one or more vanishing points.

Photo Reference The use of a real-world photo to help you draw a specific object in a panel, photo reference is a tool that's meant to be used wisely. Excessive use of photo reference, especially when the final drawing strongly resembles the photo, is frowned upon and can be considered swiping (another word for art plagiarism). However, photo reference is still a valuable tool, especially when drawing as true to life as possible.

Radio Comix A veteran in the OEL business, Radio Comix is mostly anthropomorphic, or furry, manga. It also publishes a lot of adult manga. Either genre is open to submissions from new and established creators.

Point of View When the action in a given panel is from the point of view of a person, it's as if we're seeing the scene through his or her eyes or directly behind his or her head. On a page with heavy dialogue, point of view will often shift between one character and another. To avoid a jarring factor, it's important for characters to remain in the same spot in the frame relative to each other when switching back and forth between multiple points of view.

Rising Action The concept in which each key scene in a story arc is more dramatic, bigger or meaningful than the last key scene, leading up to the climax of the story arc.

Script A written format by which the manga writer communicates his or her intentions to the manga artist. Even going solo, the manga-ka can make use of the script format to help make his or her ideas more concrete. Manga scripts are similar to those written for other formats such as television and movies.

Seven Seas Entertainment Seven Seas Entertainment publishes both translated and OEL manga, with particular emphasis on the latter. Among its notable OEL manga are *Chugworth Academy*, *Aoi House* and *Amazing Agent Luna*.

Speed Lines Speed lines define any repeated sequence of lines as a background element. Speed lines can represent fast motion, epiphany, or the charging of energy, depending on their direction and point of origin. Speed lines are a common and useful tool in the manga toolbox.

Story Arc A story arc takes the characters and plotlines of a manga story from a definable beginning to a definable end. Most story arcs contain three acts that set up the problem, complicate it, and resolve it. Usually, a single tankōbon contains one story arc. Sometimes, though, a tankōbon can contain multiple arcs or even a portion of one.

Tankōbon Usually 5 × 7″ in size, a tankōbon is a digest-sized graphic novel. A large percentage of OEL manga is produced directly for the tankōbon format and sold alongside Japanese manga in bookstores and comic shops. Tankōbon contain approximately 180 pages of story, or the equivalent of 8 to 9 comic books worth of

material. Tankōbon are sold for between $9.99 and $13.99, making them one of the best values per page in all of comics.

Three Acts A story arc, if written well, generally contains three acts. In the first act, the goal is defined and obstacles or problems are discovered that inhibit that goal. In the second act, the path to that goal is complicated and threatened. In the third act, the goal is completed or advanced, the problem is faced and possibly resolved, and the plot moves toward the next story arc.

Technology An important element in many sci-fi and modern-day manga, technology is generally highly detailed and stands in contrast to the relatively simple human figures. Often, photo reference is used to get technology right. In the case of most tech, though, it is often more important to be consistent than be realistic.

TokyoPop One of the leading publishers of manga in the U.S. in general, TokyoPop also controls the lion's share of the OEL market. TokyoPop has an open submissions policy and also runs regular talent contests called Rising Stars of Manga. The road to becoming a successful OEL professional may, at one point or another, take you through TokyoPop.

Tones Because most manga is in black-and-white, dot patterns are applied to areas of the panel. These patterns, which vary in design and value, are called *tones*. While in the recent past tones had to be applied with sheets, scissors and glue, modern-day tones are done almost entirely on computer. One of Manga Studio's selling points is its ability to handle tones and its extensive collection of ready-made patterns.

Value Value refers to the lightness or darkness of a specific tone. The value of a tone can go a long way toward defining the mood of a particular panel. The higher the value, the darker the tone and the more serious the mood becomes.

Vanishing Point One or more invisible lines where all angles of all objects converge, when a drawing is done in correct perspective.

Worm's Eye View A camera shot that could be from the point of view of a snail. It's usually an extreme angle up from that low point of view. A worm's eye view can be used to emphasize the tallness or largeness of something.

Manga Studio EX 4.0

Due out in 2008, here are some of the new features found in Manga Studio EX 4.0. Remember, everything in this book will work with either Manga Studio 3.0 or 4.0. Check out MS 4.0 when it hits store shelves for a full list of new features.

- Photograph to Line Drawing Conversion

MS 4.0 can render a photograph and automatically convert it into line drawings and tones.

- 3D Tools

MS 4.0 can import a 3D drawing and manipulate it on the screen before converting it into a line drawing. Furthermore, a set of 3D drawings of typical backgrounds are included on the disc. Data from Smith Micro's Poser 7 and Shade software can also be imported.

- Super High Density Technology

MS 4.0 can perform automatic reconstruction when converting from a raster image to a vector image, such that no data is lost.

- Action Function

A macro feature has been added, so common tasks can be repeated with a single click.

- Successive Scanning

This allows traditional artists to scan in many pages in sequence quickly.

- Color Support

A more robust color engine allows for a greater amount of versatility, and allows you to easily paint with color blend, smudge colors, and use Dodge and Burn tools.

- Story Editor

The Story Editor lets you arrange and manipulate the dialogue in the entire manga before it ever goes on the page.

- Movie Guide

Included in the package are several movies that have video instruction from professional manga artists.

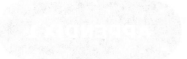

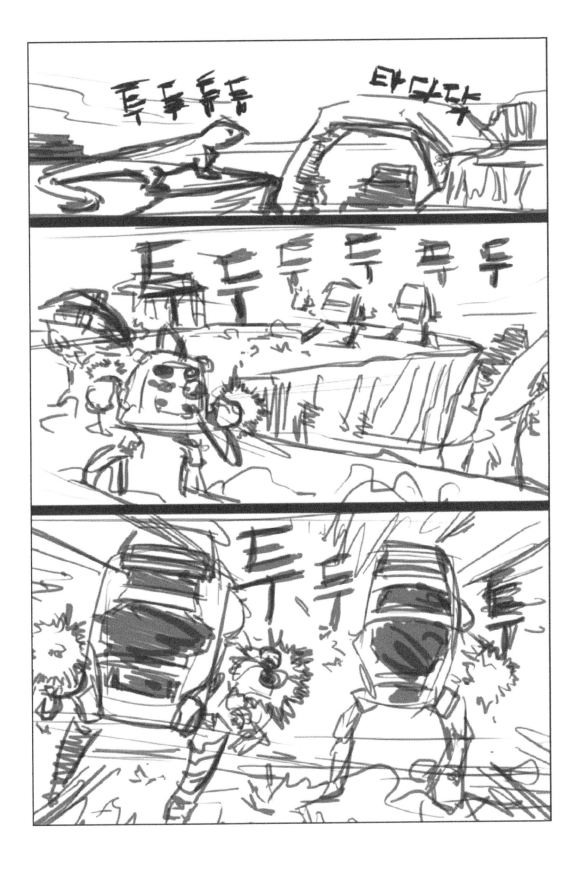

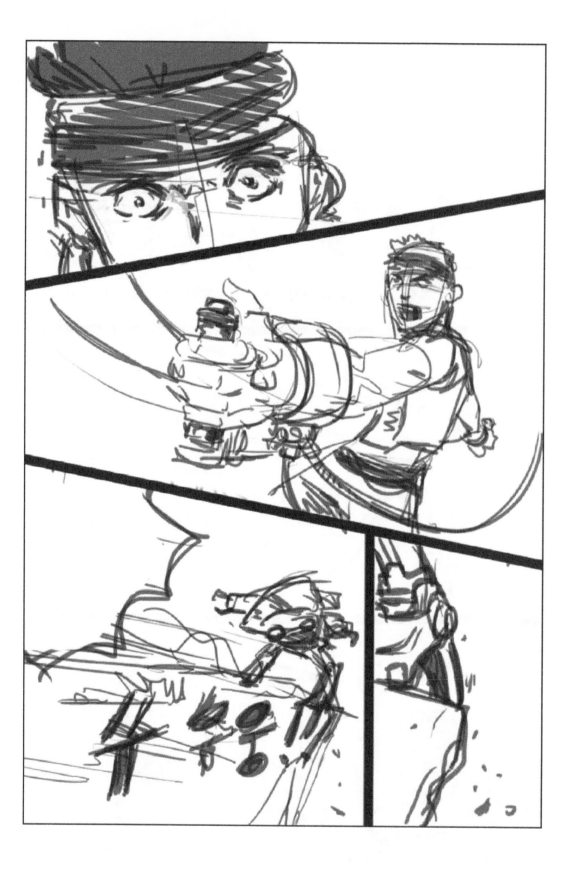

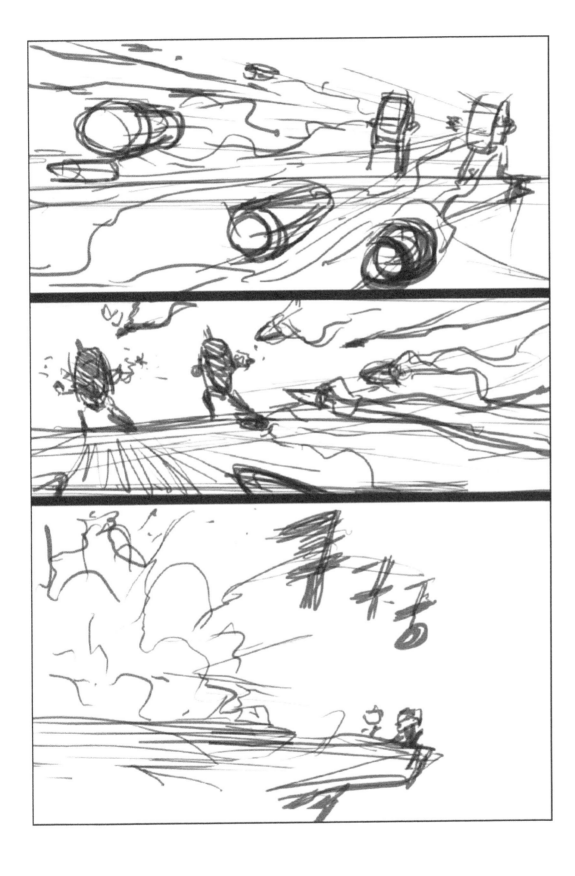

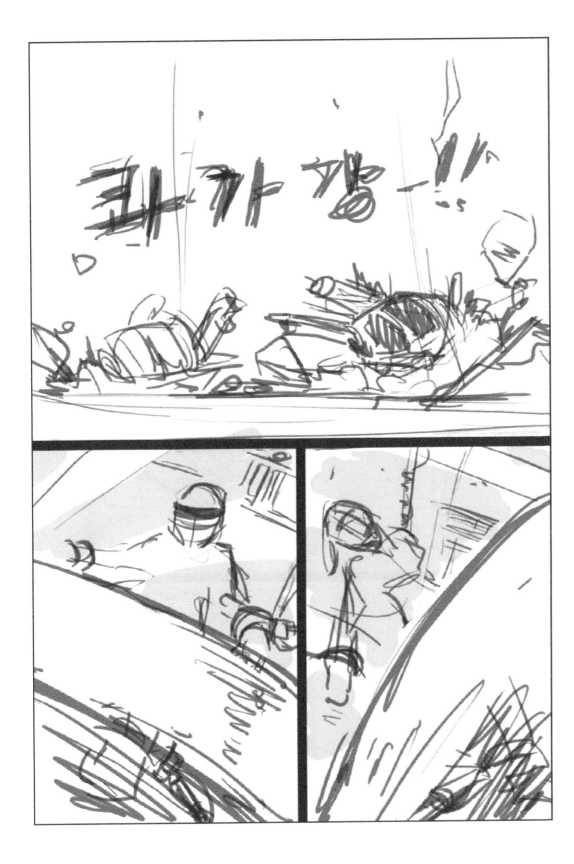

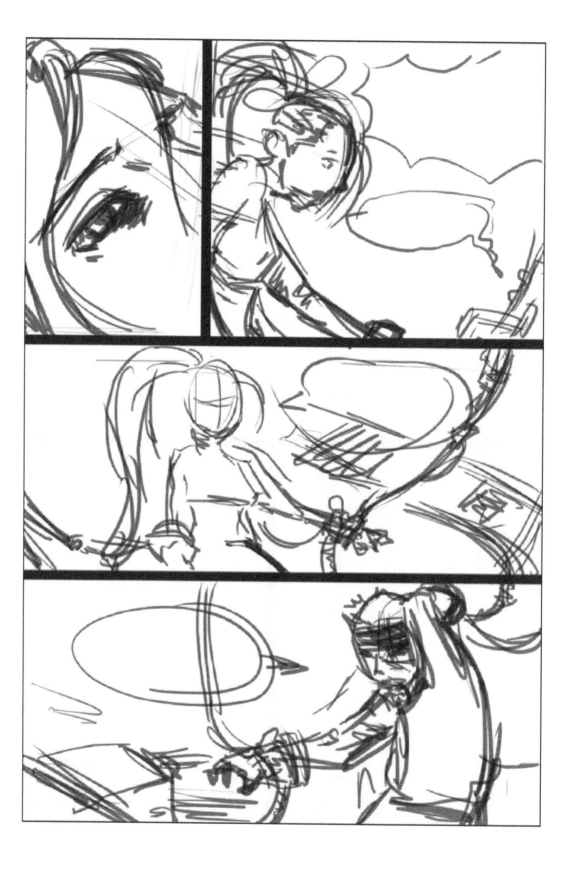

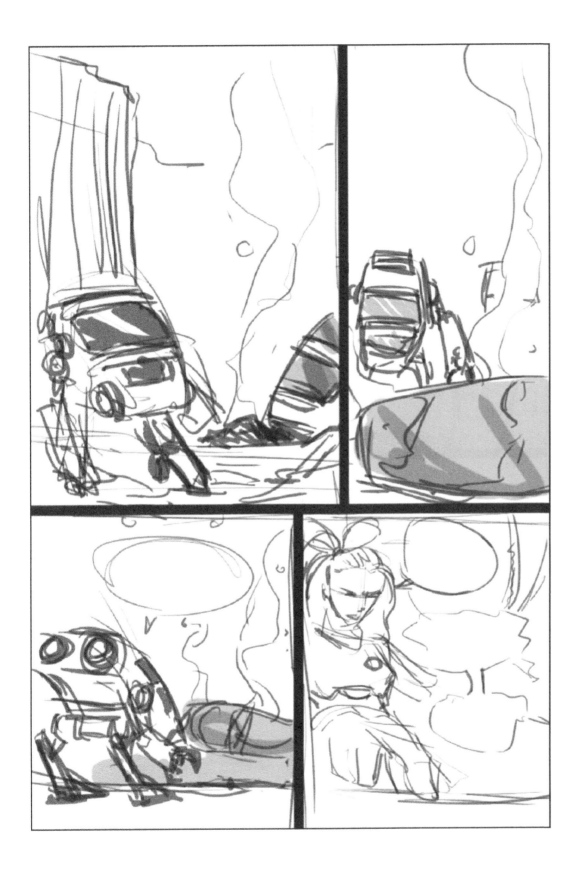

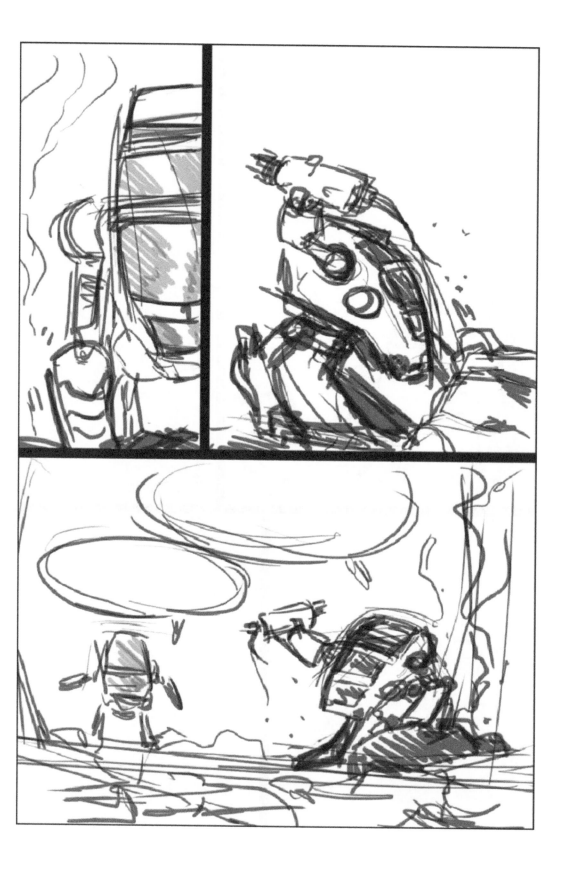

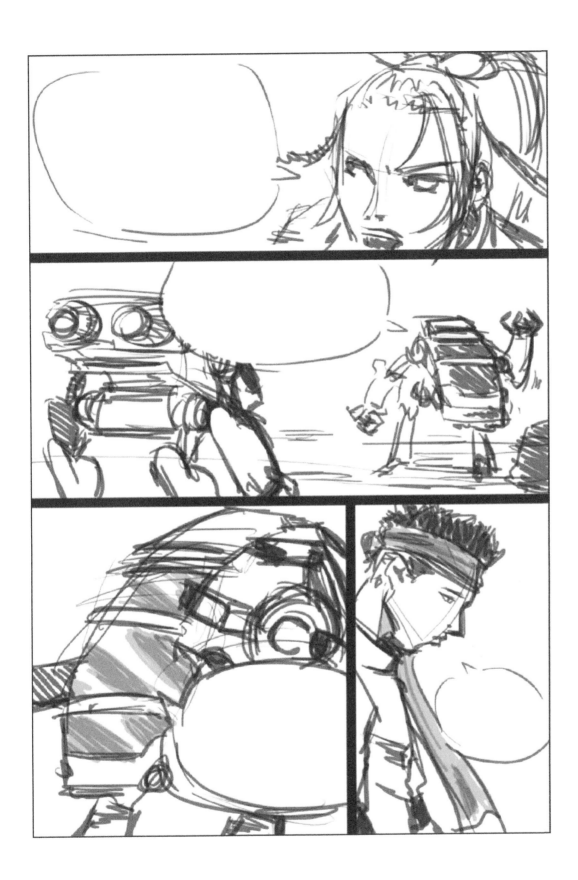

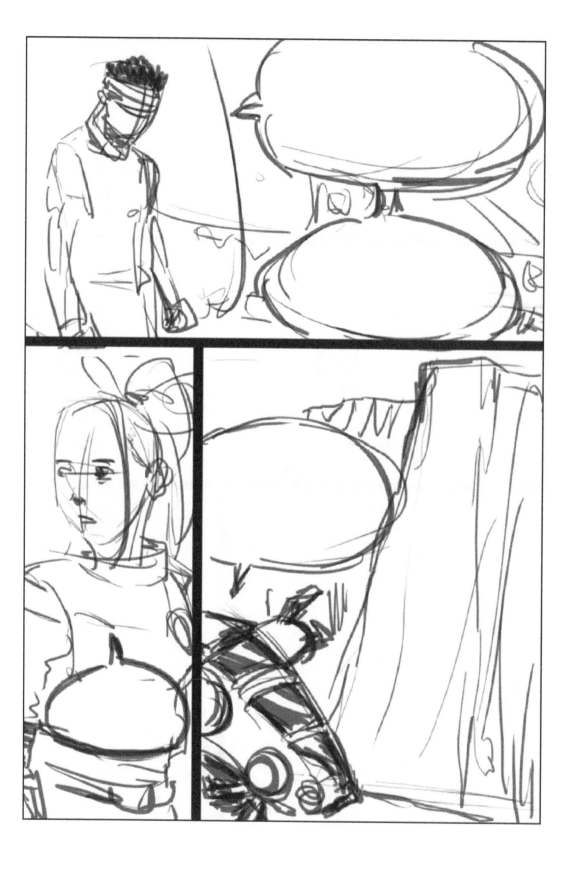

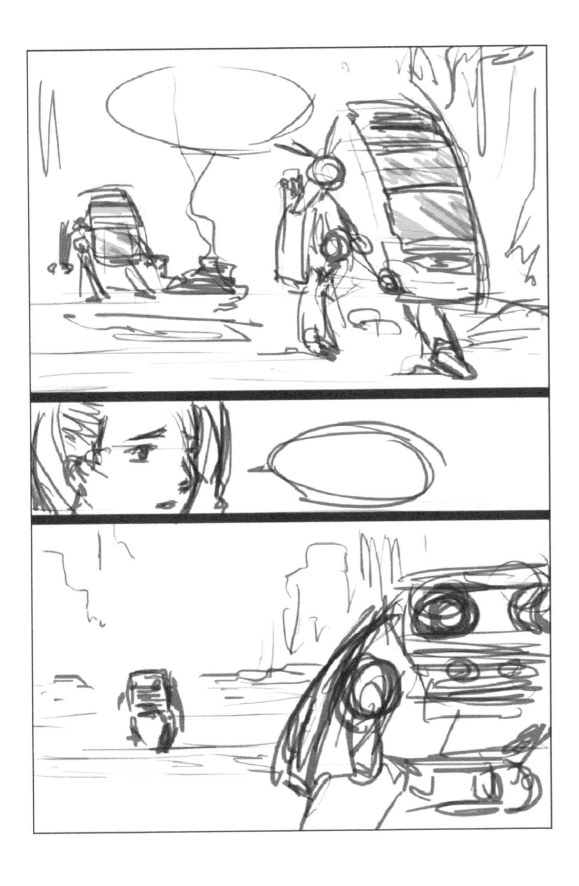

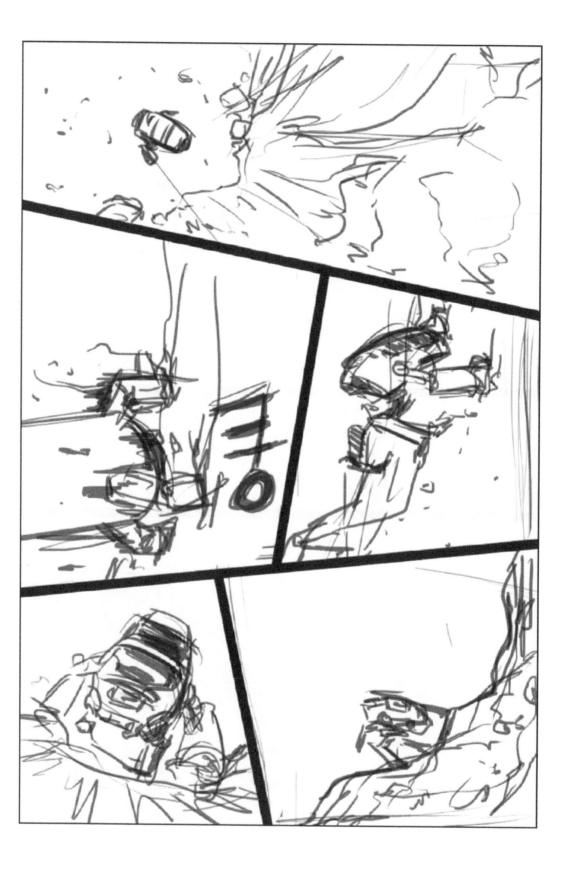

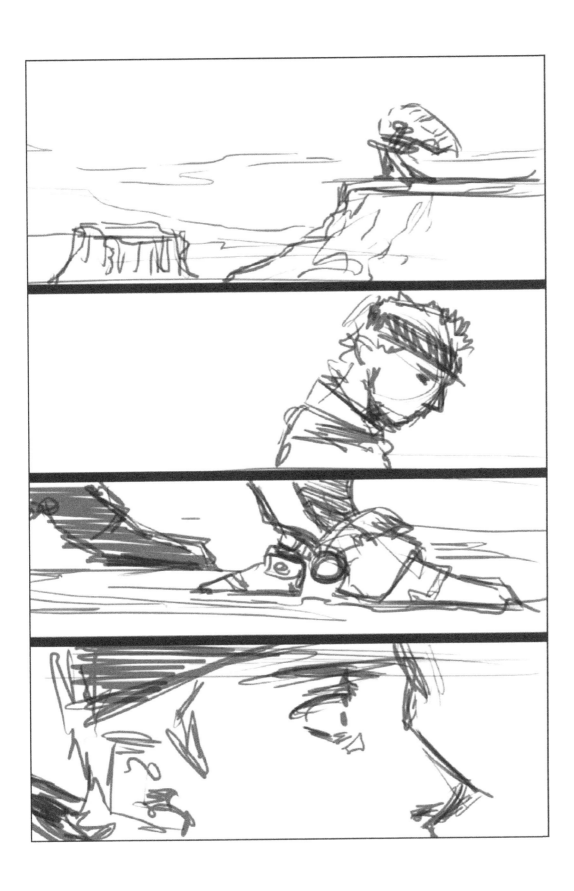

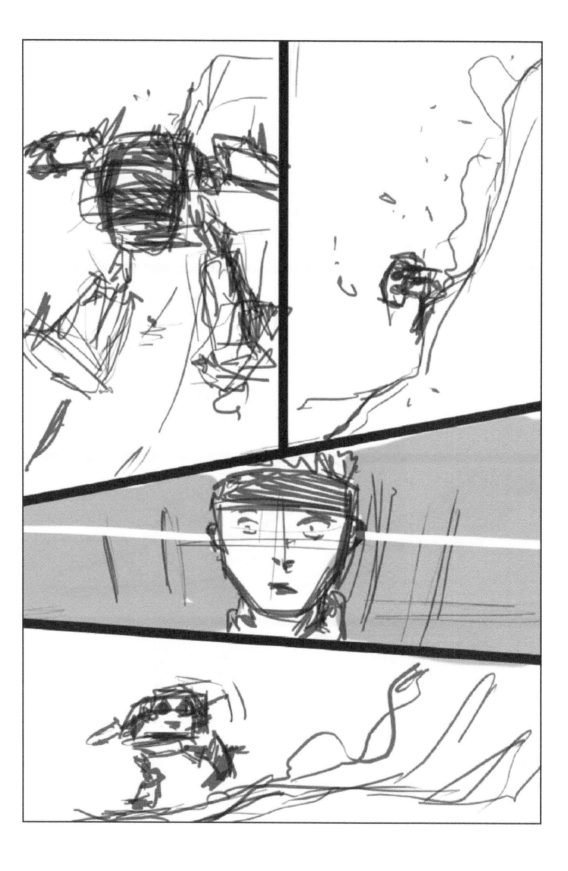

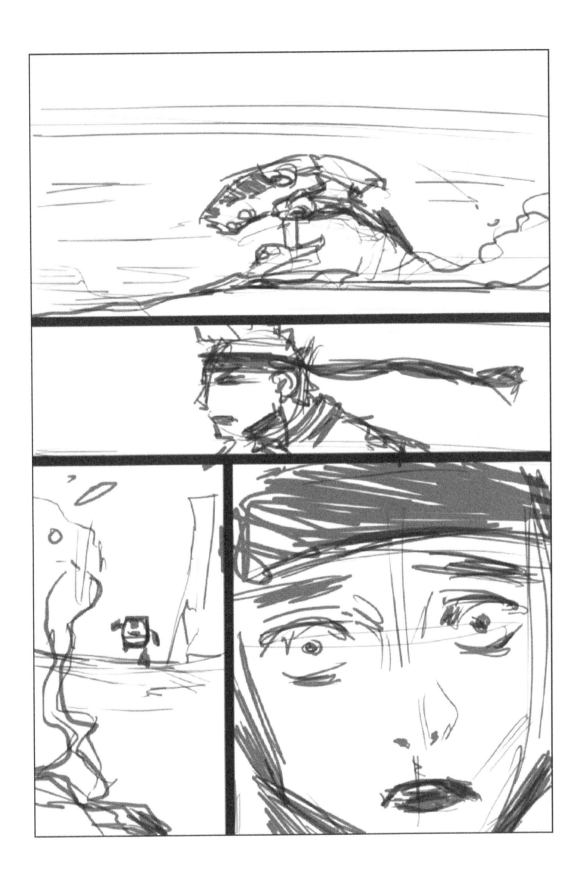

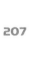

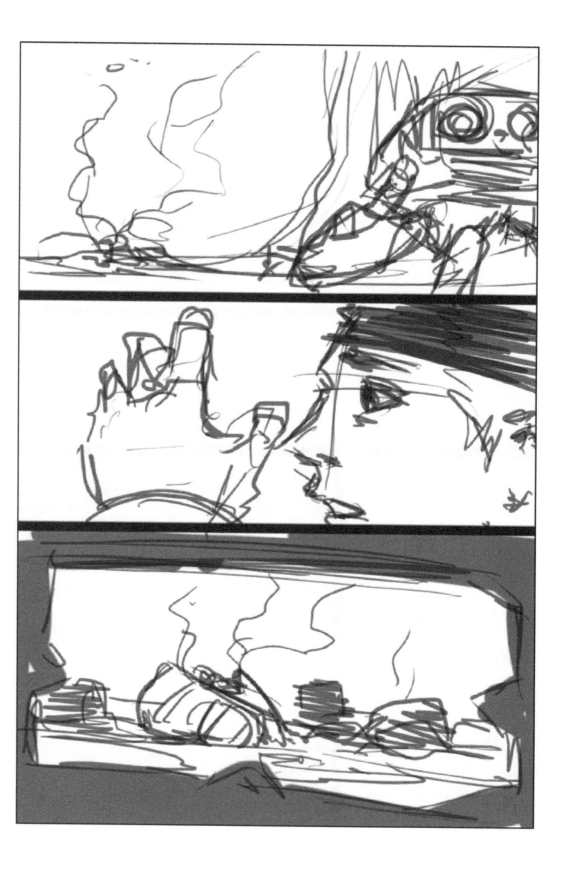

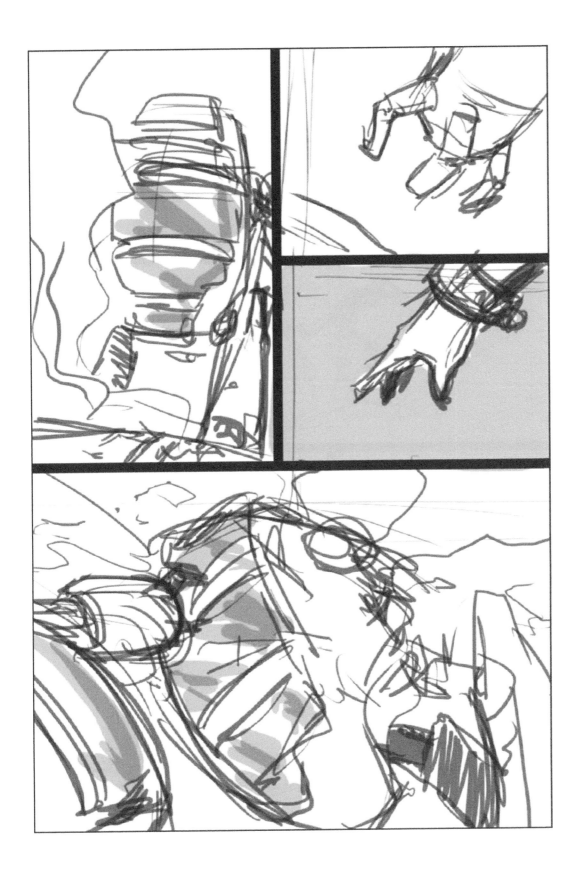

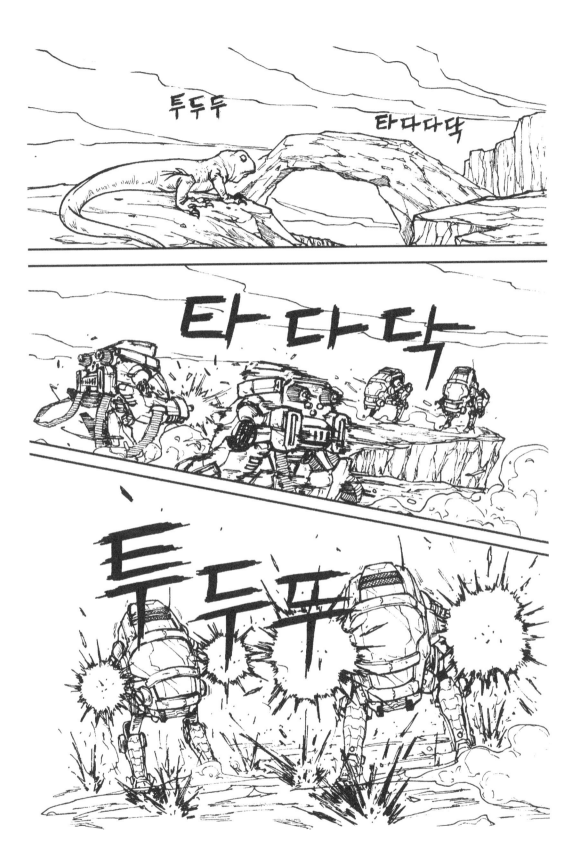

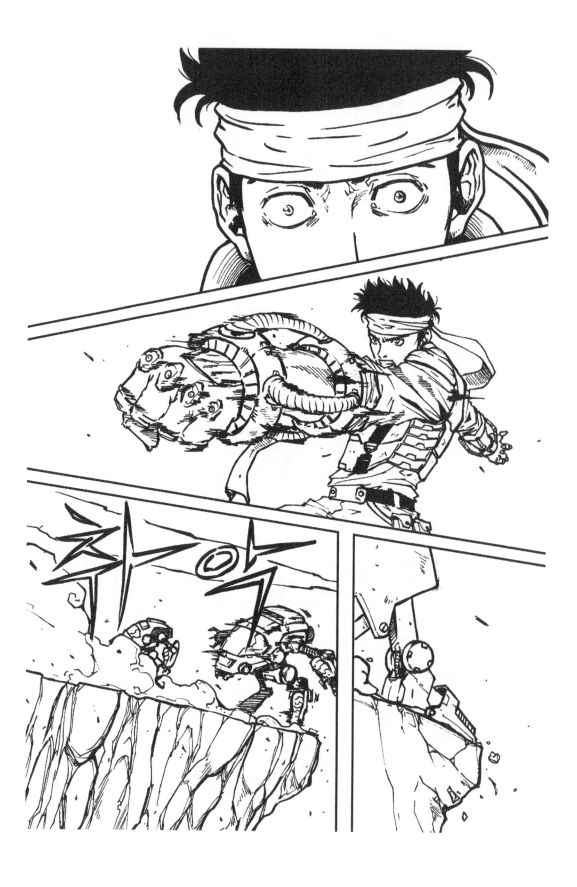

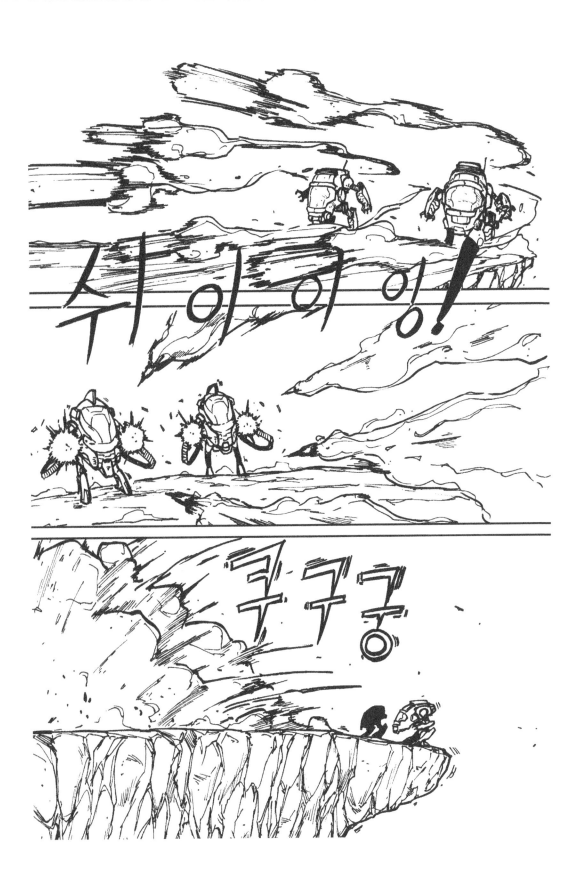

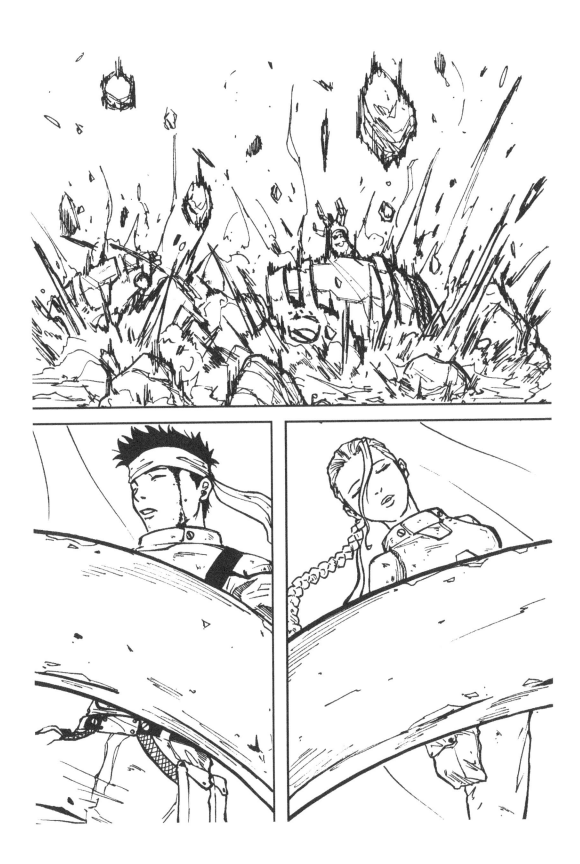

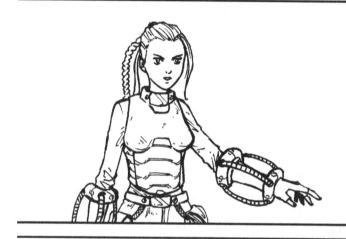
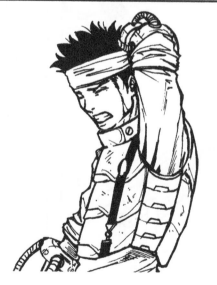

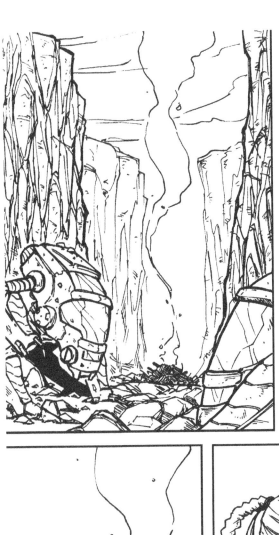
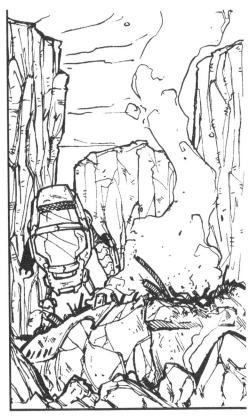
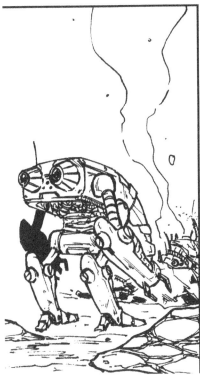
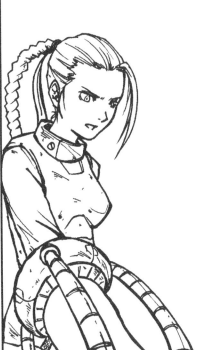

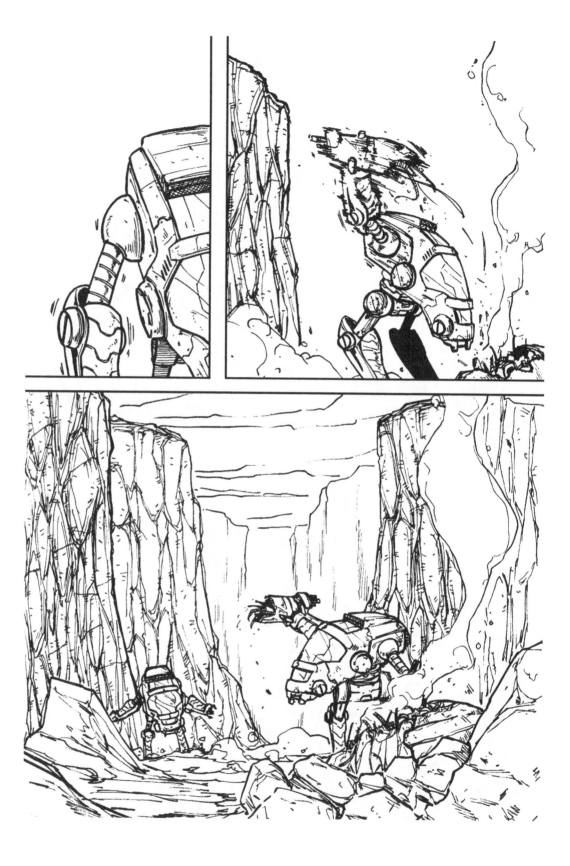

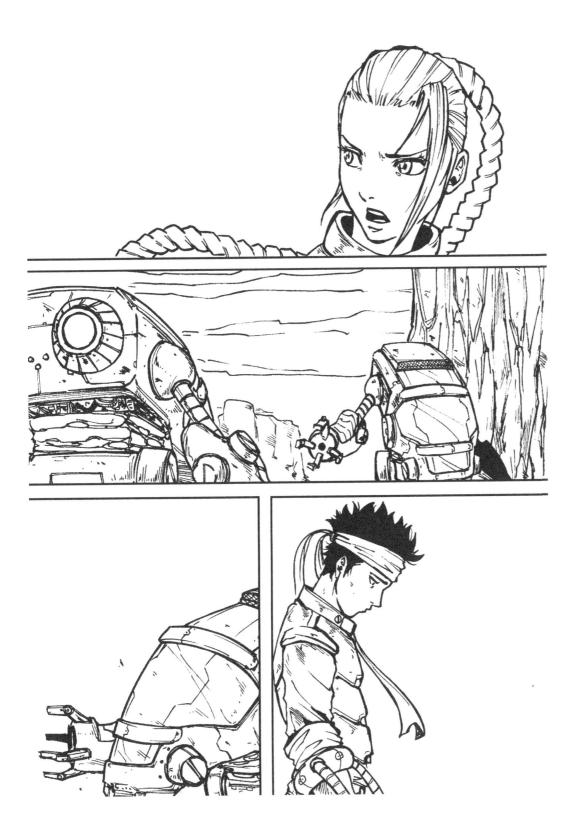

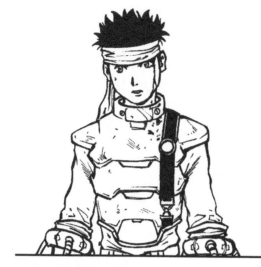

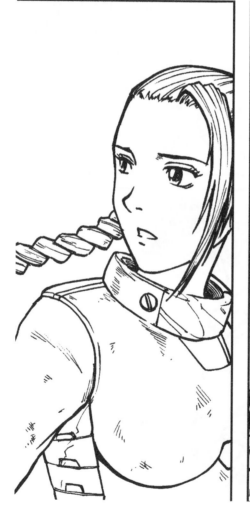

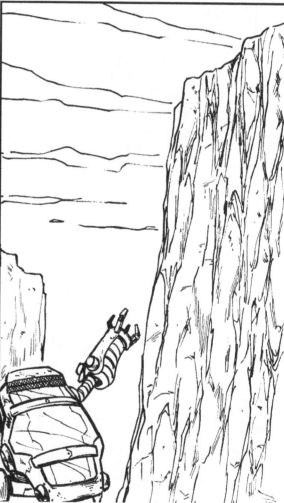

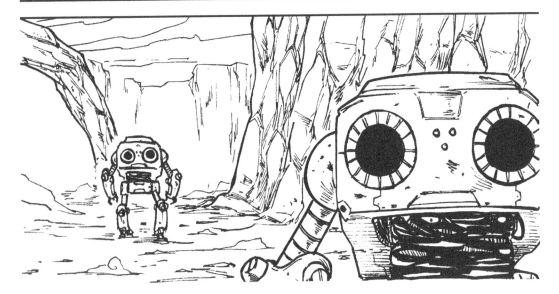

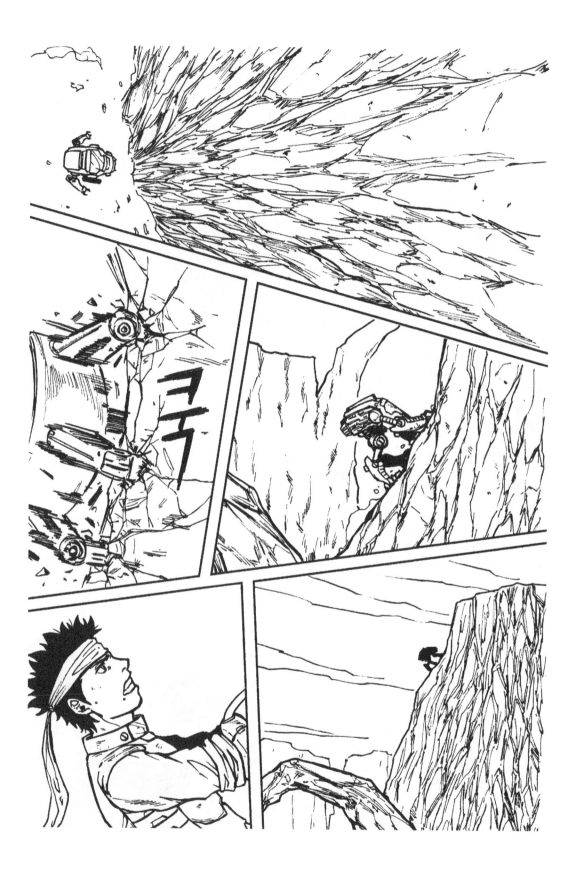

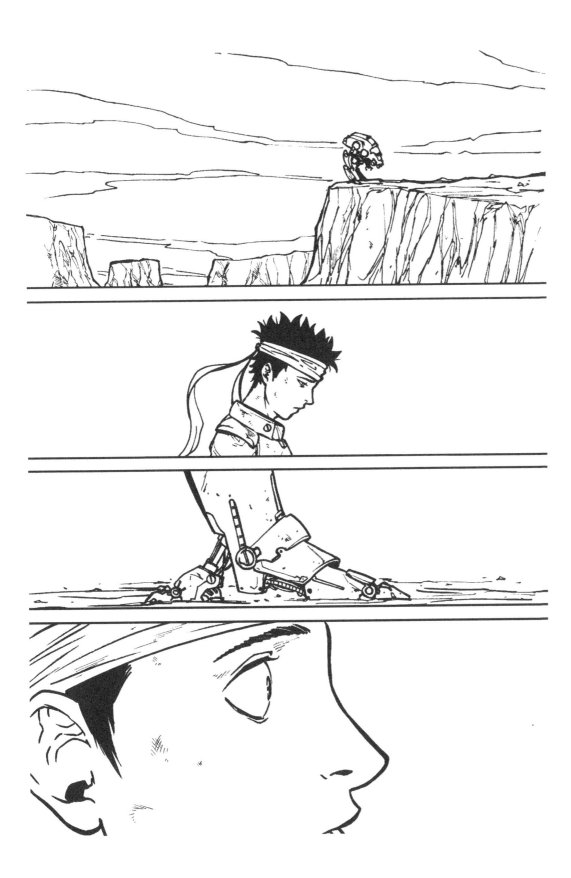

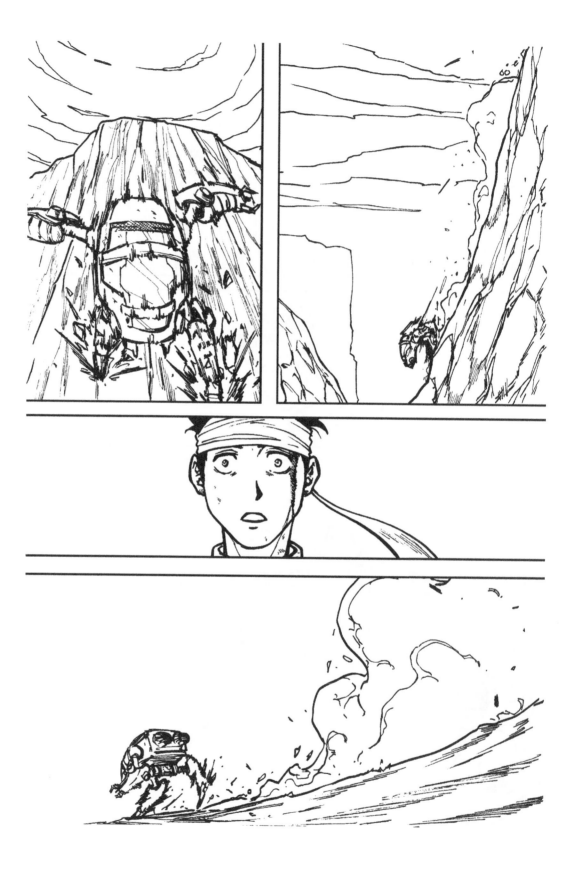

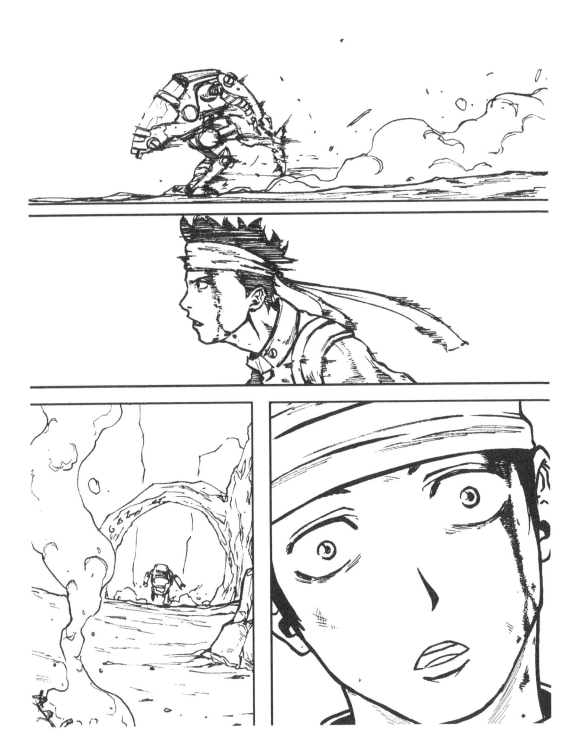

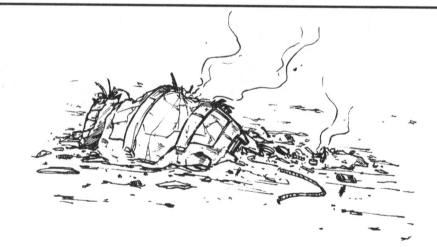

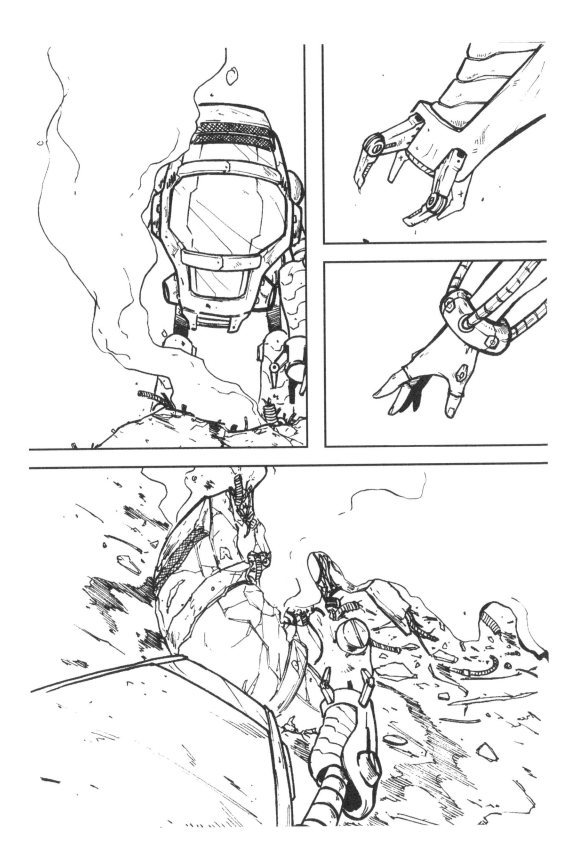

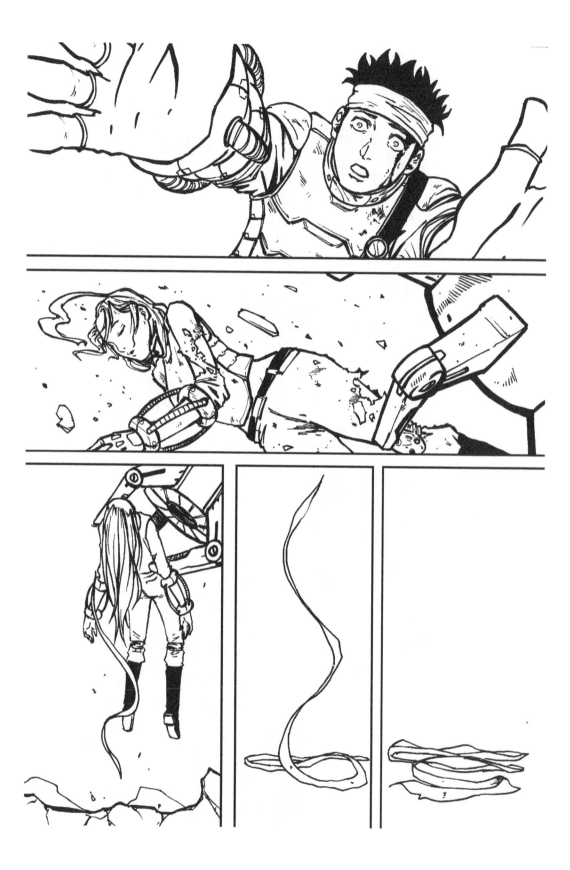

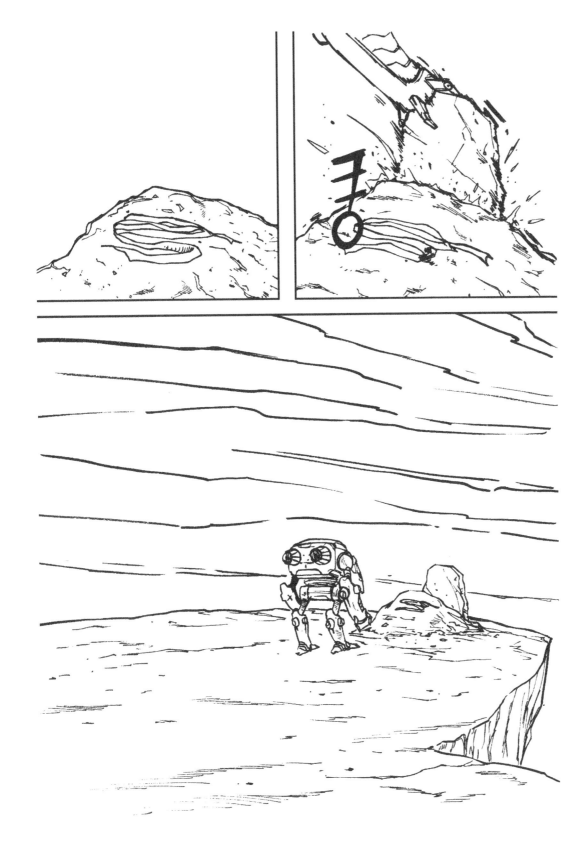

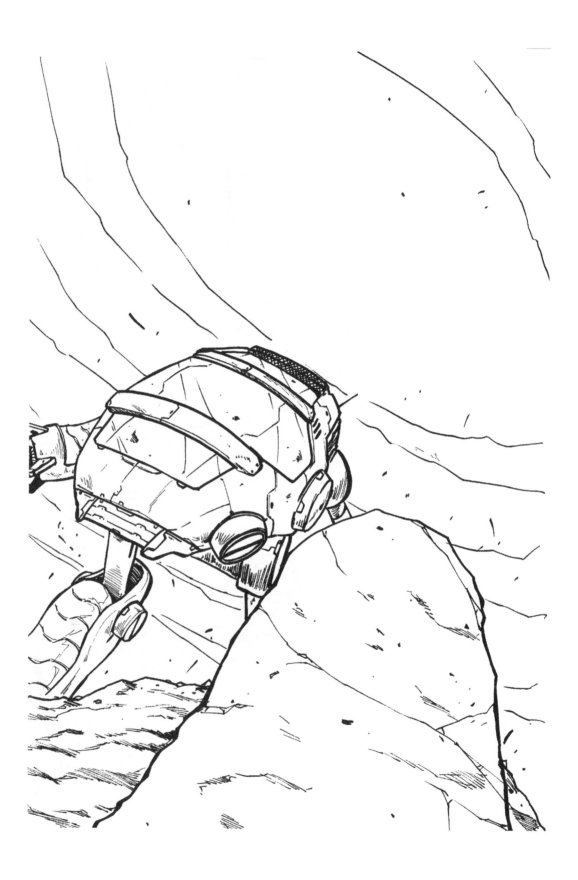

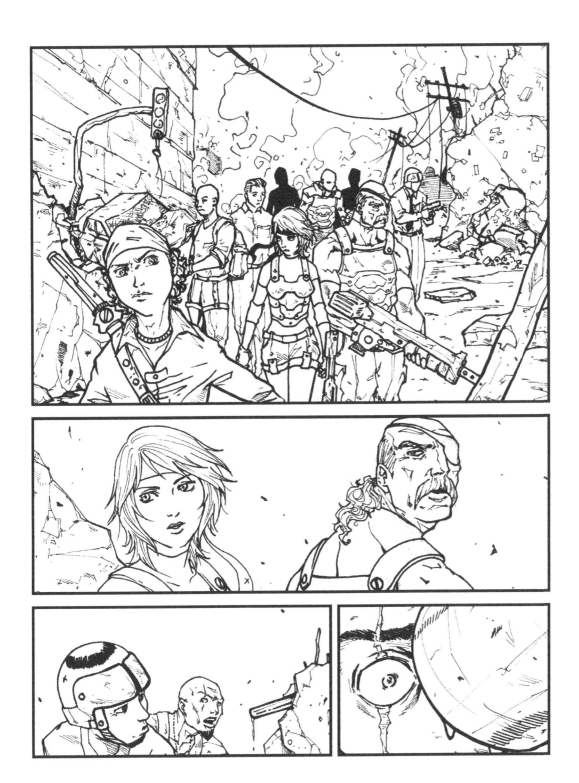

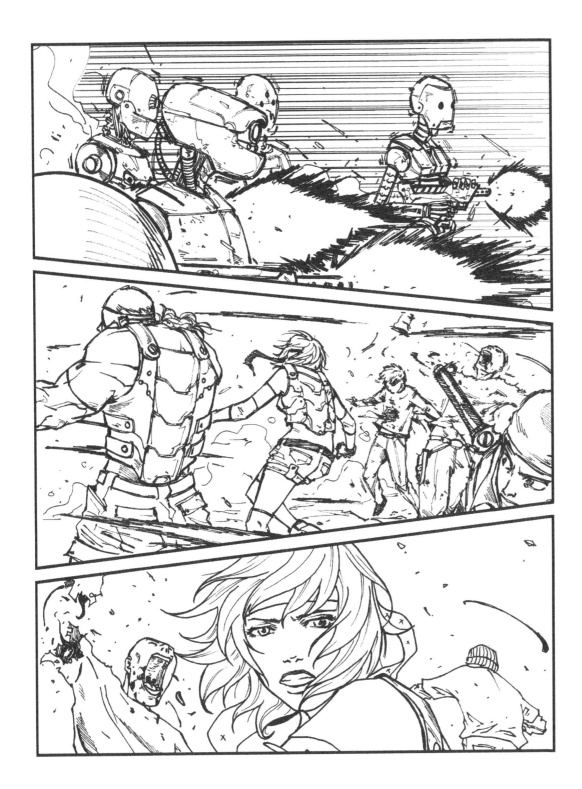

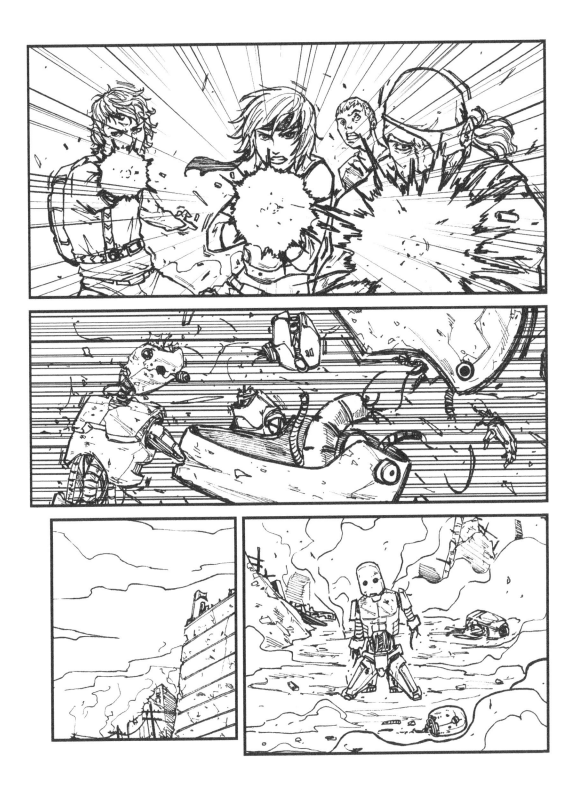

239

Printed and bound by CPI Group (UK) Ltd, Croydon, CR0 4YY

21/10/2024

01777093-0016